SHADOWS OF ANTIETAM

✝ ✝ ✝

Shadows of Antietam

✝ ✝ ✝

Robert J. Kalasky

The Kent State University Press Kent, Ohio

This book is dedicated to

Patricia, Caitlin, Kelsey, and Carleen Kalasky,

for all of their patience.

Library of Congress Catalog Card Number 2011047796

ISBN 978-1-60635-088-1

Manufactured in the United States of America

LIBRARY OF CONGRESS CATALOGING-IN-PUBLICATION DATA

Kalasky, Robert J.

Shadows on Antietam / Robert J. Kalasky

Includes bibliographical references and index.

ISBN 978-1-60635-088-1 (hardcover : alk. paper) ∞

1. Antietam, Battle of, Md., 1862 2. Repeat photography—Maryland—Antietam
National Battlefield. 3. Gardner, Alexander, 1821–1882. 4. Gibson, James F.,
b. 1828. 5. War photographers—United States—History—19th century.
6. United States—History—Civil War, 1861–1865—Photography. I. Title.

E474.65.K33 2012

973.7'33—dc23

2011047796

16 15 14 13 12 5 4 3 2 1

Contents

Preface

In the aftermath of the deadliest day in American history, photographer Alexander Gardner made history himself when he captured for the first time graphic images of Americans dead on a field of war.

Not long after the Battle of Antietam, on October 21, 1862, a dramatic new photographic exhibition entitled "The Dead of Antietam" opened at famed photographer Mathew B. Brady's New York gallery. On display was the horror of war—the bloated, blackened, and disfigured remains of men who just days before had valiantly sacrificed themselves for their personal beliefs, no matter which side they fought on—presented in the harsh reality made possible only through the relatively new medium of photography. New Yorkers lined up outside the Broadway gallery and were stunned by what they saw and with the stark realization that this might well be their own fate, or the fate of a husband, son, or brother. A *New York Times* reporter wrote on October 21, 1862, "The living that throng Broadway care little perhaps for the Dead at Antietam, but we fancy they would jostle less carelessly down the great thoroughfare, saunter less at their ease, were a few dripping bodies, fresh from the field, laid along the pavement. Mr. Brady has done something to bring home to us the terrible reality and earnestness of war. If he has not brought bodies and laid them in our dooryards and along the streets, he has done something very like it."

Gardner, who was the manager of Brady's Washington, D.C., gallery, and his assistant, James Gibson, are thought to have arrived on the battlefield on Friday, September 19, just after the Confederate army retreated. Assigned to the Union Army of the Potomac by Brady, the two spent the first days on the battlefield photographing the corpses of the soldiers and the damage inflicted on the local inhabitants. From late September through November, Gardner continued shooting photographs with the Army of the Potomac at Sharpsburg and at Berlin, Maryland, including recording President Abraham Lincoln's surprise visit to Gen. George B. McClellan in October. This work, however, primarily concentrates on many of the seventy-six images that Gardner and Gibson are known to have taken in the week after the great battle.

Gardner's achievement at Antietam was a milestone in American photographic history that set the standard not only for the photographers of that period but for all those to follow. The images of the dead of Antietam have been reprinted and reproduced countless times and, in the last forty years, have been intensely studied and examined. The first comprehensive study was conducted by William A. Frassanito, whose 1978 *Antietam: The Photographic Legacy of America's Bloodiest Day* identified the previously unknown locations where many of the images were taken and presented modern photographs taken from those same

spots. Frassanito's discoveries and analyses provided rich new visual and documentary information about the Antietam photographs, and my study begins with his work.

I was captivated by the book, and my photographic work at Antietam began simply as a hobby, as a means of building my own personal collection of pictures taken at the same sites located by Frassanito. But in the course of taking the photos, I found myself asking questions—When did Gardner and Gibson arrive on the battlefield? How did they gain access so quickly? Where did they begin their work? Why was there only one image of Union dead? On what days were the various photos taken? Where were the photo locations that Frassanito was unable to identify? I couldn't find answers to these increasingly nagging questions in any of the studies of the battle or the photographs.

For twelve years I roamed the battlefield taking my own photos at various times of the day to better determine what time of day Gardner took his images. I discovered that each of those original images contains its own unique shadowing and illumination. No matter whether it was clear or cloudy, or whether Gardner's images had distinct shadows or not, the sun lit each scene in a way that time-stamped it to a particular time of day. As I began to learn what time of day the images were taken, other revelations began to unfold as well.

As the years progressed, I became more obsessed with trying to put some semblance of order to the sequence in which Gardner, assisted by Gibson, took the photographs. Most of the original negatives still exist, and at first I thought I might be able to discover significant information in tiny hand-scratched numbers that appear along the edges of the stereo negatives. As I learned, however, these are Gardner's three-digit catalog numbers. Gardner released his own *Catalogue of Photographic Incidents of the War* in 1863 after leaving Brady's studio. At one time I thought that by following the numerical sequence of these catalog numbers I could locate the route that the photographers took through the battlefield. Unfortunately, this wasn't the case; for when I examined the images in order of the catalog numbers, it led me back and forth across the battlefield.

What is intriguing is the presence of another series of numbers, single to multiple digits, that were also hand-etched into the image and usually found along the borders of the image area or in the center between the left and right halves of the stereo view. A further investigation of these numbers revealed they also have nothing to do with the sequence of when and where the images were taken; they simply reflect how Gardner assembled his catalog. For example, plate 552 also has a number 3 etched on the glass, and it happens to be the third plate listed in his catalog, just as plate 569, with the number 20 found in the middle of the stereo image, is the twentieth listed (see fig. P.1).

But my shadow study proved far more fruitful and was ruled by a simple, concrete, scientific fact: the sun traverses the sky over the Antietam battlefield today the same way it did in 1862 when Gardner took his photographs. The sun rises in the east and, on a clear day, the early sunlight casts long shadows to the west. At midday, when the sun is directly overhead, shadows are shorter and cast to the north. In the late afternoon, as the sun begins to set in the west, long shadows are cast to the east. In 1862, as the sun beamed onto the scene through the camera lenses and burned it onto the light-sensitive, silver nitrate-coated glass plate, it provided the essential clues to rediscovering an accurate time of day it was taken through the shadowing and illumination of each scene.

While I could theorize as to when many of the photos were taken based on obvious shadows, I was able to pinpoint the actual times only by taking modern images at various times of the day and comparing the shadows in the vintage and modern images. To establish an accurate time for each photo, I had to show that not only was the picture taken at a certain time of the day but that it could not have been taken at any other time.

With enough strong sunlight, an object will leave a very dark and well-defined shadow, a silhouette. When an object is illuminated by the sun on one side, the reverse, or dark side of the object, it is in silhouette. In

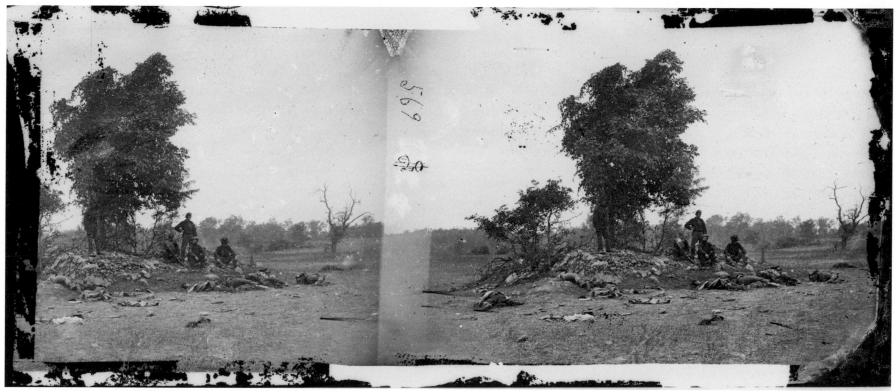

Fig. P.1: "View on Battle-field of Antietam." Courtesy of Library of Congress

this way, objects on the Antietam battlefield act as sundials that reveal the direction of the sunlight by how they are illuminated. Under cloudy conditions, when the sun's rays are diminished or obstructed, shadows will become lighter and less defined, or not even appear. Structures, such as buildings and bridges, in the Gardner photos that have survived the battle and ravages of time still cast shadows as they did in 1862. If there were no man-made structures in the images, I observed the trees to determine the direction of sunlight. Keep in mind that the trees in the modern photos are not the same ones in Gardner's pictures; those trees are long gone, with a few exceptions, such as the sycamore tree still standing at the Burnside Bridge. But new trees growing at or adjacent to

the image area have the same characteristics of illumination as those in the Gardner images and cast shadows in the same direction as the trees did in Gardner's pictures. But Gardner took some of his images when it was cloudy, and these contain no obvious shadowing. On taking my own images on overcast days, I discovered that, even then, the sun's rays created distinctively different illumination patterns as it arched over the sky during the course of a cloudy day.

From 1997 to 2009, I visited the battlefield at least fifty times, spending at least two to three days there each time. I did test shoots in the summer months to help me prepare for what I would cover the following September, when the sunlight matched that of the 1862 photos. Driving,

walking, and sometimes running back and forth among various photo locations, I took images throughout the day to show how each scene was illuminated differently as the day progressed. This process took years to accomplish; living and working in Ohio, I could only visit the battlefield for sporadic, short visits. The weather also was a factor, refusing to cooperate on some visits. And—something I hadn't thought about—crops growing at several photo sites also made it impossible to take modern pictures. Because of these factors, sometimes I had to wait several years before I could take my photos at one of Gardner's sites.

There have been many changes to the battlefield over the years, either man-made or natural. Vegetation and crops are always changing. Trees presently growing at many of the sites have obscured or completely blocked some of these sites. Trees near the Middle Bridge have made it impossible to duplicate any of Gardner's pictures taken in that area, even when the trees are bare from late fall to early spring. Little more than a sapling in Gardner's image, the large sycamore tree that presently grows alongside Burnside's Bridge made it almost impossible to duplicate some views because of its massive shadow. Sections of the East, North, and West Woods were harvested over the years, and their present appearance has changed dramatically from that of 1862. Currently, there is an ongoing effort to restore the North and West Woods to their original condition. (It is important to note that all the photographic sites are not on National Park Service [NPS] property, and I secured permission first before entering private property. To visit any of these sites, even though many are on NPS property, check to see if the sites are accessible. Local farmers contract to farm the fields and have livestock fenced in on the battlefield, so please be respectful of the farmer's crops and livestock pens by staying out of them.)

Without "bodies," it would have been impossible for me to come up with an accurate camera location matching Gardner's. Volunteers also were necessary because many of the dead in Gardner's images cast shadows or were illuminated a certain way over a brief period of time during the day, positions that were crucial in establishing a time frame for a picture. I had to pose volunteers to put Gardner's camera locations into perspective. I duplicated Gardner's photographs involving soldiers, alive or dead, over several years using a group of volunteers to provide evidence of when the photo was taken and when it could not have been taken. In September 2002 I was fortunate to enlist the aid of a small group of loyal, friendly, and extremely helpful Confederate living historians who, over the next six years, helped me recreate Gardner's images. A special thank-you goes out to the volunteers who participated in spur-of-the-moment efforts as well. Sometimes taking pictures all day did not allow for my volunteers to change uniforms from Union to Confederate, or vice versa, so my volunteers might be wearing the wrong color of uniform in my modern pictures. While to some who saw me at work it may have been disconcerting to see men dressed in Civil War uniforms playing dead on a national battlefield site, I never had any intent to be disrespectful of the dead. I used these volunteers in my photos strictly for scientific and scholarly purposes. And if my study serves to heighten interest in this somber subject by calling greater attention to Gardner's photos and uncovering more information about them, I can think of no better way to honor the fallen so starkly depicted in them.

As my shadow studies began to reveal the times when Gardner took his photos, new questions arose as to the accuracy of some of the dates Gardner himself assigned to the images as well as some of the previously identified photo locations. I began to study other sources of information, including soldier diaries, original telegraphic messages sent by Gardner from the Antietam area, and the conditions recorded at the weather station in Frederick, Maryland. This documentary information sometimes conflicted with the information Gardner provided on labels pasted to the backs of some of the vintage prints—mostly stereo views—that he and Brady sold. My increasing skepticism prompted me to look at the images from a different perspective and to use lighting as my guide, noting patterns and recognize similarities and differences based on how the sun illuminated each image.

Ultimately, I became convinced that Gardner could not have been

photographing the battlefield on the dates in his captions. Was Gardner then intentionally lying about where he spent his time the week following the battle? Was Gardner simply careless in his own documentation of the photographs? Or was it a combination of both? Regardless, the dates in his captions are wrong, except for one. Some of my conclusions are based on hard evidence; others are rooted in circumstantial evidence and plausible theory. In this respect, my research will change or correct some of the history that has been written about Gardner and Gibson at Antietam.

Shadows of Antietam builds on Frassanito's work and takes the study of Alexander Gardner's photographs to a new level. For the first time it brings continuity to the photographs, enabling the reader to walk in the footsteps of Gardner and Gibson and see the aftermath of the bloodiest day in American history through their lens. Using black-and-white photography, and with the help of Civil War living historians and information amassed from a wide variety of sources, I have assembled a comprehensive study on the historic photographs of the Antietam battlefield unlike any before. This book also offers new insights into Gardner's groundbreaking photography at Antietam and answers (or suggests answers to) many of the questions that were a mystery to me and certainly many others for so long, includes the discovery of several of the unknown battlefield photographic sites, and, with the aid of magnification, presents some new, never-before-seen details in the images. The photographic research, conclusions, and theories presented on the following pages are expressly my own.

The Gardner and Gibson photographs presented in this book are from the Library of Congress and from private collections. The Library of Congress provides easy access to these images on their website.[1] Bibliographical information such as who took the picture or when it was taken accompany each photo. First to appear is the title of the image usually given by the artist. The second is the call number. Each call number assigned by the Library of Congress uses three different prefix numbers in the collection of Gardner negatives. A B817 is a seven-by-nine-inch plate with a large single image. A B815 is a four-by-ten-inch intact, uncut stereo view with two images on the same single glass plate. A B811 is a cut negative with only a half stereo view on each plate. Usually both halves of these cut plates still exist and are kept in the same sleeve. If only one half of a stereo plate survives, it is still classified as a B811. My headings for each Gardner or Gibson photo include the following: the kind of plate, the title given by the photographer, the source for each photo, and, if a stereo view, which half is used with my modern pictures.

Each daily heading includes sunrise, sunset, cloud conditions, temperature, and precipitation levels as reported by the Frederick weather station in 1862. This information all comes from historian Joseph L. Harsh's *Sounding the Shallows*.[2] I used the Weather Channel to provide the more current times for sunrise and sunset.

Because there was no Daylight Savings Time (DST) in 1862, the modern picture times are an hour later than Gardner's or Gibson's actual times. Each of Gardner's image headings includes two photographic times: the 1862 time, when I believe Gardner actually took his image, and the modern time when I snapped my pictures, which I tried to get as close to Gardner's time as possible. In some instances a modern picture may have a different time corresponding with my proposed Gardner time because the photo may have been used to establish camera angle only. All times mentioned throughout the book are modern DST unless noted as 1862 time.

Camera and shadow directions used on the maps with the corresponding photographs are from my own personal observations on the battlefield. To closely match the shadows in Gardner's images, I took practically all of the pictures each September within two weeks before or after the anniversary date of each photograph. The next best time to get an approximate correlation with shadows matching those in September falls in the last two weeks of March each spring.

At each photo location, I allocated fifteen minutes for Gardner and Gibson to take the image and to process it, though ten minutes might

have been sufficient. Also included in most of my photo presentations are a series of modern time-elapsed images that will show the progression of how objects are illuminated and the progression of shadows cast from them. I also have provided for each of Gardner's photographic sites, the camera direction from which he took the picture, and the direction of shadows. I mounted and centered a map compass onto one of the legs of my tripod for the camera direction and used another hand-held compass to take the direction of a ground shadow, usually my own.

The map I used to mark Gardner's and Gibson's photographic location sites is one of the more popular maps sold at the Antietam Battlefield Visitor Center and was produced in 1963 by cartographer James D. Bowlby. However, there are some discrepancies with this map and some of the others I have encountered with regard to fence lines—which I found only after viewing the images under magnification. Each of the following chapters has an enlarged section of the Bowlby map to designate Gardner's or Gibson's photo locations. These maps have an arrow that points to the top of the page to designate 0° as due north

and 180° as due south. With a flat map compass, one can face the same direction as Gardner did by aligning the map with a compass using the measurements I provide with each of Gardner's images.

Originally I did my modern-day field photography with 35mm black-and-white film. Eventually, I switched to digital photography because of its superior ability to review images on the field. And with a large memory card, it was easy to bring home a couple hundred images per visit. The ease of operating a little digital camera versus the cumbersome photography process of 1862 is quite significant. (Ironically, my digital camera is smaller than the lens housing of Gardner's camera!) However, in some instances, it took longer to pose my volunteers than it would have taken Gardner to record an image. In my presentation, each original Gardner image has an accompanying picture taken at each of Gardner's or Gibson's photo sites when possible; most of these photos were shot at approximately the same time location I believe Gardner or Gibson took their pictures.

Acknowledgments

I thank all the people that offered so much time and help in making this book possible, especially my parents, James and Eleanor Kalasky. They introduced me at an early age to the American Civil War on the many family trips to the famous battlefields.

A sincere thank-you to my "wingman," friend, author, and editor Bob Zeller. He is cofounder and currently president of the Center for Civil War Photography and was an invaluable and generous source of information regarding Civil War photography, especially the images taken at Antietam.

Thanks to William Frassanito, who truly pioneered the study of how Civil War battlefields were photographed. His books sparked a new interest in the photography of the war, including my own.

I also thank Rob Gibson, wet-plate photographer and historian, for his information on the cameras and the processes involved to develop the images Gardner and Gibson took in the field.

Three *huzzahs* to Archer's Brigade, a group of men who spent countless hours over six years volunteering their time for this project: Skip Koontz, Brad Wyand, Scott Schaffer, Clint Cardinale, Mark Beasley, Joshua Switzer, Sandy Andrews, Buddy Mellor, Drew Jordan, Brian Payne, Ryan McCormick, and Daniel Warrenfeltz. A very appreciative thanks goes out to Bob Stevenson (Aust.), Rob Gibson, Brian Merrick, Seth Nash, Justin Bowers, Philip and Steven Czajkowski, and Glen Diller, who also volunteered to pose in my photos.

I thank and acknowledge the following Antietam National Battlefield Park Service rangers for their help and information regarding the battle: Ted Alexander, Paul Chiles (ret.), Keven Walker, Brian Baracz, Keith Snyder, and Christie Stanczak. I also acknowledge and thank Dennis Frye from the Harpers Ferry National Historical Park.

A very personal thanks to my good friends and residents of Sharpsburg for their cooperation: Craig and Lil Wilson, Jonathon and Sarah Baker, Cathy Koontz, Glen Diller, John and Melissa Higdon, Howard and Ann Corcarin, Paul Bender, Ernie Schulli, Jim Van, Lynn Flook, Mike Kefauver, and Jason Weber.

Thanks to the following for their help with any computer graphic–related work: Nicole Fiddler, Bernard Gratz CPP, James Gratz, and Anthony Moreton. For their help and insight over the course of my writing, special thanks go out to Chuck Morrengelo, Eileen Bacha, Diane Mastro Nard, Margaret Popovich, and Professor Emeritus Hugh Earnhart.

I extend a gracious thanks to all of these people and the institutions they represent: the Library of Congress, for the superb work of the Prints and Photographs Division and for making its collection accessible to the public; Richard Sommers of the U.S. Army Military History Institute, for

providing me with the information on Sgt. David Nichol of Knap's Battery and the diaries of the 93rd New York Volunteer Infantry Regiment; Susan Garton and Lizanne Reger from the Smithsonian Institution's National Portrait Gallery; John Frye and Jill Craig from the Washington County Free Library; Jinhee Roper at Cornell University; Alan Jutzi from the Henry E. Huntington Library, San Marino, California.

Finally, a special thanks to Mr. and Mrs. Edward D. Sloan for their loan of the portrait of Col. Charles Tew photographed by Richard F. Barnes.

1 ✠ Wednesday, September 17
The Bloodiest Day

On September 3, 1862, four days after his victory at the Battle of Second Manassas, Gen. Robert E. Lee (fig. 1.1) began to move the 50,000-man Army of Northern Virginia toward Leesburg, Virginia. From September 4–7, Lee's army crossed into western Maryland across the Potomac River at White's Ford. Seeking to exploit an opportunity after his recent victory, Lee took the gamble of invading Maryland and bringing the war north for the first time.

Lee's invasion of Maryland sent shockwaves of fear among the populace in Maryland, Pennsylvania, and the District of Columbia. Lee knew that with the war going badly for the North, political and civilian support was beginning to wane. Another embarrassing loss or series of losses might be the final straw that would break the federal government's back and give the South its independence. Moreover, a successful southern campaign might induce England and France to recognize the Confederacy as a legitimate independent government.

Before the war, Maryland was a "border state," with many of its inhabitants split over which side they supported. In Baltimore on April 19, 1861, five days after Fort Sumter surrendered, Union troops on their way to Washington were transferring from one railway station to another across town when they were attacked by an angry mob of Confederate sympathizers. Four soldiers and twelve civilians were killed. A little over a year later, Lee hoped to tap into this anti-Union sentiment among the large number of Confederate sympathizers living in Maryland. Enough vocal and printed support might even persuade those who had remained neutral in the conflict up to this point to join in the southern cause.

Lee had intended to enter Maryland as a liberator, not a conqueror. He issued strict orders forbidding his army from any looting and pillaging of the area towns and farms. In western Maryland, where Union loyalty was strongest, Lee's army received a lukewarm reception at best. There were some jeers and patriotic displays of the Union flag, but for the most part the citizens of Maryland just stood and watched the passing troops. So within a week after crossing the Potomac, it became apparent to Lee that Maryland was not going to rally wholeheartedly to his support, and the number of men who enlisted fell far short of his expectations.

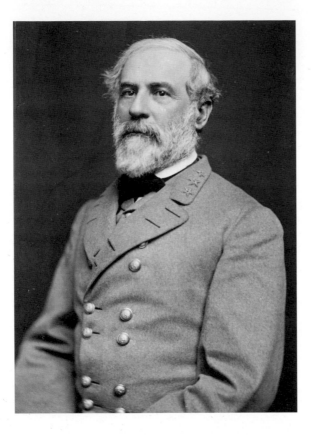

Fig. 1.1: Gen. Robert E. Lee. Courtesy of Library of Congress

As Confederate soldiers marched by farms and through the small towns, some farmers and townspeople, acting out of compassion at the sight of many barefoot and rag-tag looking soldiers, gave them fresh-baked bread, eggs, ham, or what extra food staples they could spare. In the Maryland countryside, Lee's army ate what it could until supply wagons arrived. Pvt. Alexander Hunter of the 17th Virginia Infantry wrote: "On the 8th we struck up the refrain of 'Maryland, My Maryland' and camped in an apple orchard. We were hungry, for six days not a morsel of bread or meat had gone in our stomachs, and our menu consisted of apple; and corn. We toasted, we burned, we stewed, we boiled, we tossed these two together, and singly, until there was not a man whose form had not caved in, and who had not a bad attack of diarrhea."[1]

Lee began to head north by northwest through Maryland. He knew that a direct attack on Washington would be a disaster. Even though the Union armies were in disarray, and morale was low in the ranks after the whipping at Second Manassas, Washington was heavily defended and fortified, and Lee knew that he would have to contend with the remnants of the Armies of Virginia and of the Potomac as well. But he knew that as long as his army was in Maryland, there was always the potential threat of a Confederate attack on Washington. Therefore, Lee hoped that an incursion into Maryland would draw the federal forces stationed in northern Virginia back into Washington, which would help the farmers in northern Virginia save what was left of their crops and livestock from being further decimated by the Union troops.

Lee continued to move his army north into Maryland until it reached Frederick on September 7. Two days later, Lee issued Special Orders 191, which divided his army into four parts to, among other tasks, clear out any Union troops in the Shenandoah Valley, to protect his rear, and to ensure safe passage for his supplies coming up from Winchester, Virginia. If this was successful, Lee then could reunite his forces at Hagerstown and continue north into Pennsylvania. On September 10 the divided army left Frederick, with Maj. Gen. James Longstreet and Brig. Gen. Daniel H. Hill directed to cross South Mountain and move on Boonsboro and Hagerstown. Three separate columns, each moving in different directions, were under the command of Maj. Gen. Thomas J. "Stonewall" Jackson. Not included in the original Special Orders 191 was Jackson's own mission to attack and capture the federal garrisons at Martinsburg and Harpers Ferry Virginia. This would remove any Union forces from Lee's strategic line of operations and prevent them from uniting with Gen. George B. McClellan, the commander of the Army of the Potomac (fig. 1.2).

The day before Lee invaded Maryland, Lincoln had reappointed McClellan to take command of the Army of the Potomac and the defense of Washington. In the spring and summer of 1862, McClellan had failed to take Richmond during the Peninsula campaign and lost command of

the army. But now, with the force in disarray, Lincoln had little choice but to turn to McClellan, who was an excellent organizer. McClellan immediately consolidated parts of Gen. John Pope's defeated Army of

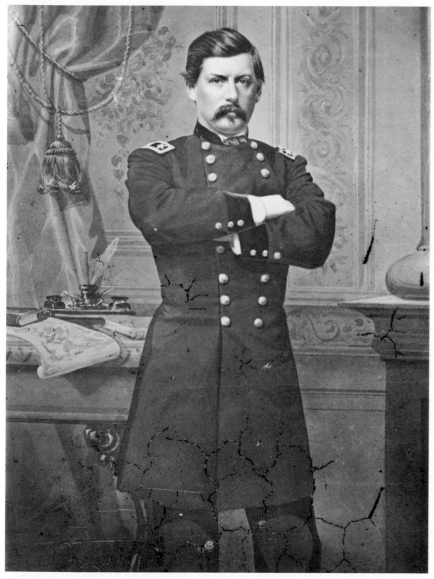

Fig. 1.2: Gen. George B. McClellan. Courtesy of Library of Congress

Virginia with the Army of the Potomac. As word spread quickly throughout Washington of Lee's invasion on September 4, Lincoln instructed McClellan to find and defeat Lee: "If he can't fight himself, he excels in making others ready to fight."[2] On Friday, September 5, McClellan leaves two corps behind for the defense of Washington and leads approximately 87,000 men in a total of six army corps out of the capital. Moving north and west into Maryland, McClellan split his army into three wings assigned to seek out Lee.

The center wing fell under the command of the Second Corps' Maj. Gen. Edwin Sumner and the Twelfth Corps' Maj. Gen. Joseph Mansfield, and it traveled up the National Road with McClellan and the headquarters of the Army of the Potomac. The left wing, led by Maj. Gen. William Franklin of the Sixth Corps, hugged the Potomac River; and the right wing, made up of Maj. Gen. Ambrose Burnside's Ninth Corps and Maj. Gen. Joseph Hooker's First Corps, cut due north. One of these wings would certainly find Lee.

The center wing traveled fifteen miles to Rockville, where it stayed idle for six days. During McClellan's stay at Rockville, we get our first indication that photographers Alexander Gardner and James Gibson were already traveling with the Union army from a military telegraph he sent from Rockville on September 9 to Timothy O'Sullivan at Brady's studio in Washington. In the telegram, Gardner instructs O'Sullivan to leave Washington at once and bring the commander of the Telegraph Corps a new horse.

On September 11, the Army of the Potomac was on the move again, with the lead elements of Burnside's wing arriving on the outskirts of Frederick (fig. 1.3). They arrived just one day after Lee left Frederick to execute Special Orders 191. McClellan was moving at a very cautious rate, for he had received estimates of Lee's strength at over 100,000 men. This was far from the truth, but these exaggerated figures of the size of Lee's army would haunt McClellan in Maryland and for the rest of his life. McClellan himself arrived at Frederick on September 13 and met with a hero's welcome—quite the opposite of the treatment Lee

received from the locals. With no documentation of their movements, I can only assume that Gardner and Gibson stayed with the center wing and probably arrived there at the same time as McClellan.

On the afternoon of September 13, McClellan was handed a spectacular opportunity. McClellan had Lee and the fate of the Confederacy in the palm of his hand. That morning, Cpl. Barton Mitchell of the 27th Indiana had secured a copy of Lee's Special Orders 191 wrapped around three cigars he found lying in a field on the outskirts of Frederick. With this, McClellan had the positions of Lee's divided army in Maryland and Virginia, but he still did not know the troop strength of the Army of Northern Virginia. McClellan telegraphed Lincoln: "I have the whole rebel force in front of me, but I am confident, and no time shall be lost. I think Lee has made a gross mistake, and that he will be severely punished for it. I have all the plans of the rebels, and will catch them in their own trap if my men are equal to the emergency. Will send you trophies."[3]

McClellan was no doubt charged with adrenalin at the prospect of destroying the Army of Northern Virginia piecemeal. That night he ordered the Sixth Corps to Harpers Ferry. General Burnside's wing was to advance toward Boonsboro while the center wing was held in reserve. He ordered Burnside to follow federal cavalry sent out in advance along the National Road. With Lee's plans laid out in front of him, it seemed as if there was nothing in McClellan's way to stop him. South Mountain would change all that.

On September 11, Lee split Longstreet's wing into two parts: Longstreet and Lee proceeded to Hagerstown that day while Gen. Daniel H. Hill remained at Boonsboro on the west side of South Mountain. That night, Hill, reacting to Confederate cavalry reports of the Union army on the move, moved his men to the top of South Mountain to hold the passes over the mountain, while Lee ordered Longstreet to backtrack and support Hill as soon as possible. Lee had to hold these passes over South Mountain in order to gain desperately needed time to pull his army together.

That night, Confederate soldiers at the crest of South Mountain watched the advance forces of the Army of the Potomac's campfires flickering down in the valley a few miles away. Lee would not have to wait long for McClellan to strike. The following sunrise revealed a division of Burnside's Ninth Corps in the valley below. Throughout the day of September 12, the rest of the Army of the Potomac came from the east side of Catoctin Mountain and filled the valley. Awestruck by this sight, General Hill wrote, "It was a grand and glorious spectacle, and it was impossible to look at it without admiration. I had never seen so tremendous an army before, and I did not see one like it afterward. For though we confronted greater forces at Yorktown, Sharpsburg, Fredericksburg, and about Richmond under Grant, these were only partly seen, at most a corps at a time. But here four corps were in full view, one of which was on the mountain and almost within rifle-range."[4]

On September 14, the two armies fought the Battle of South Mountain at the three strategic passes over the mountain near Frederick: Turner's Gap, Fox's Gap, and Crampton's Gap. Throughout the day, battles raged at these passes with Union forces eventually taking Crampton's Gap late in the evening. Out of 18,000 men, Lee's losses were significant, totaling around 3,500 men killed, wounded, or missing in action. Northern losses were significantly less, with 1,800 out of 28,000 men killed, wounded, or missing in action. That evening Lee still had not had any communication with Jackson, and he sent orders to Jackson and his forces to cancel the invasion.

There is no evidence that Gardner and Gibson took any photographs of the Maryland campaign from the time they left Washington until after the Battle of Antietam. It is a mystery to me why they took no photographs in the aftermath of the Battle of South Mountain, for there is no doubt in my mind that Gardner would not have hesitated in taking images of dead soldiers if he had been there before the corpses were interred. Most likely, they did not pass through Fox's Gap—where the heaviest fighting took place—but instead traveled the most direct route, the National Road through Turner's Gap, which had seen almost no casualties.

Before daylight on September 15, Lee began to withdraw his men from the western slope of South Mountain at Fox's and Turner's gaps

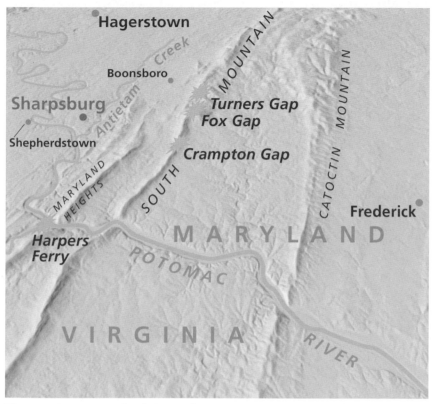

Fig. 1.3: Western Maryland, September 4–16, 1862. Courtesy Antietam National Battlefield

toward Sharpsburg. By that afternoon, Lee had only about 14,500 men on the western heights overlooking Antietam Creek. Just when things were looking dire for Lee, he received some reassuring news. Jackson sent a dispatch telling Lee that he had taken the federal garrisons at Martinsburg and Harpers Ferry. Immediately Lee sent another dispatch to Jackson ordering him to report to Sharpsburg. Realizing the severity of the situation, Jackson wasted no time and moved approximately 18,000 men toward Sharpsburg, excepting Gen. Ambrose P. Hill's division, which was left to guard the Union prisoners captured at Harpers Ferry. The decision to hold South Mountain had paid off. Lee reversed

his orders to retreat and decided to take McClellan head on. He made the decision to stand at Sharpsburg.

Even though he knew Lee was close by, McClellan was confused as to exactly where Lee was and how many of his supposed 100,000-man army was with him between South Mountain and Hagerstown. As the Army of the Potomac pursued this separate section of Lee's army during the morning of the 15th, McClellan received bad news: Harpers Ferry had fallen. As dismal as this news was, McClellan no doubt still held firm the prospect of defeating Lee's army piecemeal before it could escape across the Potomac or reunite with Jackson. As reports came in throughout the day, McClellan received the news he had been waiting for: the Rebel army stopped running and was making a stand. That afternoon, probing cavalry elements of the Army of the Potomac finally caught up with the Army of Northern Virginia at the Middle Bridge on Antietam Creek. As the cavalrymen approached the bridge, shots rang out from a large force of Confederate infantrymen guarding the bridge from the western heights. There was no attempt by the federal cavalrymen at a forced reconnaissance over the bridge or a crossing of the creek at some of the shallow fords to determine the number of Rebel forces hunkered in. By the end of the day, there would be three times as many Union troops facing Lee as the Confederate commander had at his disposal, but McClellan would not attack that day and would wait until the bulk of his separated army was amassed. This was the first of many missed opportunities for McClellan.

Dawn on September 16 was shrouded by a thick fog. Poor visibility along Antietam Creek and the surrounding heights obstructed McClellan's view of the enemy's positions. Late morning revealed that the Confederates still held the high ground on the west side of Antietam Creek. McClellan, with his generals, squandered the day as he personally arranged his corps for the battle that would come the next day.

By the end of the day, McClellan had amassed roughly 75,000 men on the east bank of the creek. The Sixth Corps was still in Pleasant Valley with 12,000 men, and two divisions of the Fifth Corps had not

yet arrived. As McClellan's army assembled, Jackson's men (except for those under A. P. Hill) began to arrive from Harpers Ferry and joined up with other scattered forces throughout the day. In the two weeks since Lee had left Leesburg, his forces were reduced by desertion, straggling, and battle casualties, from 50,000 to approximately 42,000 men, about half of the number McClellan had. Late in the afternoon, Lee left the heights just above Antietam Creek for another series of higher ridges closer to the town of Sharpsburg. Lee's battle line extended about three miles north to south, with Longstreet holding Sharpsburg and the land south of it and Jackson in control of the area north of Sharpsburg.

McClellan's plan for the next day's attack had the bulk of the Union army lead by Hooker's First Corps and Mansfield's Twelfth Corps attacking the Confederate left. They were to be supported by Sumner's Second Corps. These three massive corps were to smash through and roll up along the Confederate left flank. At the same time, a diversionary attack by Burnside's Ninth Corps was to assault the Confederate right. If either of these attacks on Lee's flanks were successful, McClellan, with Gen. Alfred Pleasonton's cavalry and Maj. Gen. Fitz John Porter's Fifth Corps, would then attack the center of the Rebel line. Also at McClellan's disposal would be Franklin's Sixth Corps, coming up from Pleasant Valley. If the plan had been executed with precision, McClellan should have been able smash Lee's army into submission or drive it into the Potomac River and back into Virginia.

At 4:00 P.M. on September 16, General Hooker's First Corps began to cross Antietam Creek over one of the three triple-arch stone bridges spanning the creek, the bridge known as the Upper or North Bridge. Hooker's men took their places behind the North Woods and East Woods and settled in. It was a cool night, but fires were not allowed so as not to give away their positions. Hooker's men had to eat their food cold and without warm coffee. To make matters worse, a light drizzle began to fall, soaking the troops trying to rest and stay warm. The corps was in position to initiate the battle the next morning.

But they had not passed unnoticed. Before dusk, Rebel skirmishers and infantry from the East Woods became involved in a fierce firefight with probing federal cavalry and infantry. Between the two sides, casualties amounted to a little over a hundred men killed, wounded, or missing. However, ninety-five of these men were from the 13th Pennsylvania Reserves, a staggering number compared to Confederate losses.[5] This action ended at dark, but Lee was fully convinced that this was where McClellan would strike from first. And he would be waiting.

At 5:30 A.M. on the morning of September 17, Hooker's corps launched its assault, heading due south from the Poffenberger farm behind the cover of the North Woods, hidden from Confederate artillery stationed on Nicodemus Heights and skirmishers on the Miller farm. As his men entered the protective northern side of the North Woods, it was still drizzling, and clouds obscured the rising sun. As Hooker's 9,000 men emerged from the southern end of the North Woods, they were greeted with sizzling shot and shell coming from Nicodemus Heights and from high ground across the southern end of the West Woods about a mile away. Hooker's artillery dealt with the Rebel artillery in the West Woods and Nicodemus Heights, while four federal batteries of 20-pound Parrott-rifled cannon across Antietam Creek blasted at the guns in front of the West Woods.

Leading the way south out of the North Woods on Hooker's left was Gen. James B. Rickett's division, bearing down the Smoketown Road toward the north end of the East Woods. Soon after Rickett's men stepped off, Gen. Abner Doubleday's division, on Hooker's right, entered a large clover field that extended from the North Woods to the Miller farmhouse, exposing them to the Rebel artillery. In the center and to the rear was Gen. George G. Meade's division, held in reserve. Shortly after Doubleday's division cleared the North Woods, the rain stopped. The clouds broke and the day promised to be hot and sunny.

Waiting for the federals was Jackson and 8,000 of his men in a defensive line that ran from the West Woods toward the East Woods. On Jackson's left was Brig. Gen. John R. Jones's division, concealed in the West Woods. Brig. Gen. Alexander Lawton's division was spread across the open pastures on the Miller farm just south of a large cornfield, known today as "the cornfield" (along what is the present-day Cornfield Avenue). To its right, Isaac R. Trimble's brigade was covering a section of

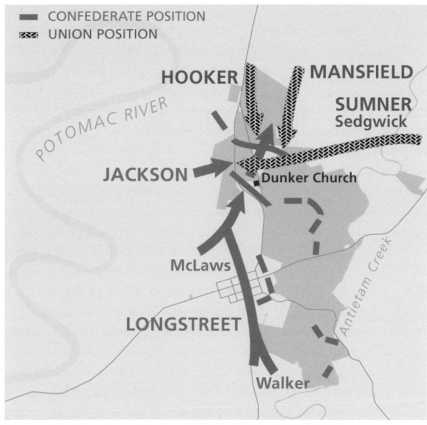

Fig. 1.4: Morning phase. Courtesy Antietam National Battlefield

the cornfield to the East Woods. There, Trimble's line angled southeast back toward the Mumma and Roulette farms. Held in reserve behind the West Woods was Gen. John Bell Hood's division from Longstreet's wing. And supporting the infantry were the artillery of Stuart's cavalry on Nicodemus Hill, Capt. William Pogue's battery in the West Woods, and Col. Stephen D. Lee's battery east of the Dunker church on the Mumma farm (where the park's Visitor Center is now located [fig. 1.4]).

Doubleday's division and a brigade from Rickett's division advanced into the large cornfield in their front, not aware that ahead Jones's and Lawton's Confederates were patiently waiting—lying prone in a clover field—for any federal troops attempting to pass through. As soon as the first lines of blue-clad infantry stepped out of the cornfield, Lawton's men stood up and fired at the unsuspecting federals, knocking them down by the scores. The Confederate rifle fire stymied the attack briefly, forcing some of the Union troops back into the cornfield. But it didn't take long for the federal line to regroup and surge back out into the clover field, engaging Lawton's men in a close firefight. The weight of the federal forces took a toll on the outnumbered Confederates. As casualties soared, the Rebel line weakened, while the federal lines rapidly regrouped for another thrust.

Gen. John Gibbon's Iron Brigade flanked both sides of the Hagerstown Pike and scattered the remnants of Jones's division. The brigade had a clear path to its objective: the high ground in front of the Dunker church where Rebel artillery was located. Two of the Iron Brigade's regiments south of the cornfield had barely walked a hundred yards when their right flank along the pike was hit by rifle fire. Confederate general William Starke, who had replaced a wounded John R. Jones, led this bold counterattack out of the West Woods. But Starke never made it to the Hagerstown Pike; while leading the charge, he was mortally wounded and carried off the field.

On reaching the Hagerstown Pike, Starke's men fired through the fence rails into the Iron Brigade at almost point-blank range. As the 6th Wisconsin right-wheeled to meet this new threat, the two remaining Iron Brigade regiments on the west side of the pike, hidden in the northern section of the West Woods, snuck up behind Starke's exposed left flank setting a murderous trap. Twenty minutes after Starke led his men out of the West Woods, they were hit from behind, flank and front, leaving the bodies of many Louisianans draped over the rails of the pike or heaped in piles alongside the fence. The remaining soldiers, realizing the perilous situation they were in, bolted back into the relative safety of the West Woods. The Iron Brigade redressed its line and continued through the Miller pasture toward the Dunker church. Maj. Rufus Dawes of the 6th Wisconsin recalled: "The men are loading and firing with demonical fury and shouting and laughing hysterically, and the whole field before

us is covered with rebels fleeing for life, into the woods. Great numbers of them are shot while climbing over the high post rail fences along the turnpike. We push on over the open fields half way to the little church."[6]

On Hooker's left, Rickett's division entered the eastern side of the cornfield and the East Woods, where it met stiff resistance from a brigade of Georgians. The fighting was fierce in the East Woods, but, again, the sheer weight of Union numbers began to quickly take its toll on the southern defenders. Rickett's division gained the upper hand, forcing the Confederates out of the cornfield and East Woods. But as the federals began to advance, they were slammed by the Louisiana Tigers Brigade. Rickett's line held against this sudden counterattack, and a short stalemate ensued in the East Woods. Again, it wasn't long before Rickett's men gained momentum and began to advance through the East Woods, slowly pushing the Rebels back.

While Doubleday's and Rickett's divisions were heavily engaged, General Meade's division was sent forward to a new position just north of the cornfield.

Watching from the West Woods, Jackson, forced to send in the last of his reserves to shore up his line, ordered General Hood's division forward. Hood's men had arrived earlier from Fox's Gap and were resting behind the Dunker church in the West Woods when they got the order to move. They filed into position immediately above the Smoketown Road in a clover field just as Doubleday's and Rickett's men finally pushed back Jackson's initial front line and then mounted one of the most gallant charges of the war. As the 6th Wisconsin major Dawes remembered, "A long and steady line of rebel gray, unbroken by the fugitives who fly before us, comes sweeping down through the woods around the church. They raise the yell and fire. It is like a scythe running through our line. 'Now, save, who can.' It is a race for life."[7]

But Hood's men did not fight alone. Weakening his own line on the Roulette farm, Gen. D. H. Hill sent three brigades forward to support Hood's right at the East Woods. Together they careened into the Union line. Hood's men drove Doubleday's division out of the pastures south of the cornfield and helped Hill clear any Yankees out of the East Woods. On the Confederate left, part of the overexcited Texas Brigade under Colonel Wofford waded into the Iron Brigade, pushing them back deeper into the cornfield. Their attack put them well in advance of any other supporting southern troops, and they ultimately paid the price for it. In just twenty minutes, the 1st Texas lost 186 of its 226 men, the highest casualty rate (82 percent) for any Confederate regiment during the war. The momentum of Hood's attack carried the Confederates through the cornfield, but they were repulsed by Union artillery and elements of Meade's division that had massed in the pastures below the North Woods. Hood's men hastily retreated, and by 7:30 A.M., both sides had returned to near their original starting positions, save for scattered Union forces in the East Woods.

Just as Jackson was regrouping his forces south of the Miller farm, Union major general Joseph Mansfield was leading his large Twelfth Corps down the Smoketown Road toward the sound of fighting. In a careless move, Mansfield rode into the East Woods at the head of his corps to personally place his men for the coming assault. He was mortally wounded and taken off the field. Hooker saw Mansfield's corps entering the field and attempted to rally his scattered forces to support a new thrust, with Mansfield, against Jackson. On horseback on his way to report the progress of the battle to Mansfield, Hooker was shot in the foot and carried off the field.

Meade assumed command of the First Corps, but it was too scattered and exhausted to help the Twelfth Corps. Brigadier general Alpheus Williams took command of the Twelfth and sent his former division, now under the leadership of Brig. Gen. Samuel Crawford, through a gap between the North and East woods toward the Hagerstown Pike and West Woods. A tenacious fight began again in the cornfield and in the pastures between the East and West woods. Out of fresh men and ammunition, Confederate forces retired to the West Woods. Crawford attempted several times to take the West Woods but was repulsed by artillery and desperate Rebel counterattacks. Worn out, Crawford's division took shelter in the cover of the north end of the East Woods.

On the southern end of the East Woods, things were going more smoothly for the federals. Brig. Gen. George S. Greene's division initially faced stiff resistance in the East Woods, but Greene pounded away at Confederate troops in the East Woods and in the pastures on the southern end of the Miller farm. Finally the Confederate right gave way; Hood's men raced from the pastures for the protection of the West Woods while D. H. Hill's men retreated south through the Roulette farm. A huge gap opened in the Confederate line, and two brigades of Greene's men cleared the East Woods and headed straight for the Dunker church. Just as the two federal brigades exited the East Woods, Stephen D. Lee's artillery was withdrawn from in front of the church. Greene's men advanced unopposed toward the Dunker church but stopped to regroup and wait for reinforcements and ammunition on the reverse slope of a hill a couple hundred yards away from the Dunker church and near the southern end of the West Woods. There they lay prone on the slope and waited.

Advancing north and along the right flank of Greene's division was the 125th Pennsylvania from Crawford's division. The regiment pushed past the Dunker church and moved deeper into the West Woods, eventually stopping past the church, about a hundred yards west. This, the most advanced Union position of the battle north of Sharpsburg, did not hold for long. Jackson's line was severely dented—what was once the front of his line was now the rear—and an immediate, fresh federal attack following Greene's clearing of the East Woods could have split Jackson's line in two. If the First and Twelfth federal corps had advanced in unison, the battle might have been over by noon.

At 9:00 A.M. the fighting north of Sharpsburg halted temporarily with the Union First and Twelfth corps scattered in the North and East woods. From the start of the battle, Union leadership on the field had steadily disintegrated as commanding officers were killed or wounded, and the attack plan quickly became mired into a series of separate dysfunctional attacks that doomed any chances of beating Lee. Quickly reacting to the unfolding events, Lee committed the last of his reserves to bolster Jackson in the north by weakening his defenses south of Sharpsburg.

Since Lee had interior lines, it was easier for him to move his men quickly from one section of the battlefield to another, while McClellan's corps, with exterior lines, had more distance to travel and so it took longer to move his men. Lee rushed Brig. Gen. John Walker's division and Col. George Anderson's brigade to the West Woods. He also dispatched Maj. Gen. Lafayette McLaw's division, marching up from Harpers Ferry, to the West Woods and sent Maj. Gen. Richard Anderson's division to aid D. H. Hill, who held a sunken farm lane at the southern end of the Roulette farm. Just as Walker's and Anderson's divisions arrived on the field, so did the lead elements of the massive 15,000-man Union Second Corps commanded by Maj. Gen. Edwin Sumner.

Early in the morning, as fighting began to rage, McClellan sent Sumner across Antietam Creek to reinforce the First and Twelfth corps but held back one division until Porter's Fifth Corps arrived to take its place on the field. Sumner personally led Brig. Gen. John Sedgwick's division through the Roulette farm, with Brig. Gen. William H. French's division trailing at a distance. The noise of battle had subsided as Sumner passed the southern end of the East Woods and moved onto the Miller farm. Assuming that both sides were fought out, Sumner ordered the 5,000 men of Sedgwick's division to the front in the open fields between the East and West woods. All three brigades, fifty yards apart, formed individual double-file lines extending north to south. Sumner himself led the first long line of Sedgwick's men as they marched through the pastures south of the cornfield.

Sumner's plan was to take the West Woods and possibly roll up the left of the Confederate line with the support of French's division. Sumner failed to communicate this plan to French, however, and sent orders to the brigadier general to advance to the sound of combat, assuming that French would be close behind. But it is estimated that French was fifteen minutes to a half hour behind Sumner, and by the time he reached the Roulette farm, Sumner had disappeared from sight. Sumner led his men in perfect formation through the open pastures without encountering any resistance whatsoever, but he failed to reconnoiter the Confederate

positions in and past the West Woods. Unopposed, Sumner's three long columns disappeared one at a time into the West Woods. It was not until attempting to leave the West Woods that they encountered stiff resistance.

By the time French arrived at the Roulette farmhouse, Sedgwick's division was completely out of sight in the West Woods. Instead of advancing toward the West Woods, French's division veered south to clear out Rebels on the Mumma and Roulette farms, thus protecting the left flank of Greene's division positioned in the Mumma swale.

Back in the West Woods, Sedgwick's lead brigade, drawing artillery and heavy rifle fire from Hauser's Ridge, could not execute its turn to the left on the western fringe of the woods. Similarly, the two brigades following in the woods were unable to return fire for fear of firing into the backs of their own men. Then, suddenly, the whole left flank of Sedgwick's division erupted in flame and smoke.

McLaw's division, just arriving on the field from the south, slammed into Sedgwick's flank and rear. Jackson now had approximately 7,000 men crushing in on the hapless federal division from three sides. Union soldiers, suddenly realizing the danger surrounding them, panicked and retreated north out of the West Woods. Sgt. William Andrews of the 1st Georgia Infantry recalled, "When we were within thirty feet of the Federal line, it wavered, then broke and dashed for the rear. The yell that went up from my throat started from the bottom of my heart. Where the line had stood the earth was covered in blue. I believe I could have walked on them without putting my feet on the ground."[8] Generals Sumner and Sedgwick both somehow manage to save themselves and rejoined the remainder of the division north of the cornfield. But less than twenty minutes after entering the West Woods, 2,500 Union soldiers—half of the division—had been killed or wounded.

Smelling blood, Confederates charged after the retreating federals through the pastures on the Miller farm to the edge of the East Woods, where several Union artillery batteries were lined up. After the last escaping federal troops passed through the cannons, the artillerists opened fire into the mass of pursuing Rebels. The Union artillery mowed down scores of men in the first wave, turning the Rebel attack into a full-fledged retreat back to the West Woods. By 9:30 A.M., more than 12,000 men, Union and Confederate, were dead, wounded, or missing in action in the area of the battlefield north of the sunken Roulette farm lane (today known as Bloody Lane). Casualties were almost evenly divided between the two adversaries, with northern casualties slightly higher. Capt. Albert Monroe of the 1st Rhode Island Infantry described the horrific aftermath:

> Over this space the two lines had been putting forth all their energies since early light, and the ground was strewn with dead and wounded horses and men, clothing, knapsacks, canteens, muskets and side arms broken and twisted in every imaginable manner. The blue and gray were indiscriminately mingled, either motionless and lifeless, or dragging their bleeding forms along in search of some less exposed situation. And there were those whose life-blood was fast or slowly ebbing away, with only strength sufficient to raise a supplicating arm for assistance or relief. The stretcher-bearers were straining every nerve to succor the helpless wounded, but it would have required a force in itself equal to a small army to have immediately removed them all.[9]

As Sedgwick's division was getting chewed up in the West Woods, French began to advance his division through the Roulette farm in pursuit of pesky skirmishers still firing on his men from the crest of a ridge several hundred yards away. Hidden on the opposite side of the crest were the remnants of D. H. Hill's division, 2,500 men. They were positioned along a sunken, worn-down farm lane that ran east to west separating the Roulette and Mumma farms from the Piper farm (fig. 1.5). Running roughly north and south were two other farm lanes, the Mumma and Roulette, which intersected with the lane where D. H. Hill's division was crouched, waiting. French's three brigades advanced up the slope to the crest of the ridge. As Union troops crested the ridge and were within fifty yards of the sunken lane, Hill's men suddenly rose up and poured a

murderous fire into the federal front ranks, knocking men down by the score. Col. John Gordon of the 6th Alabama Infantry recalled:

> Now the front rank was within a few rods of where I stood. It would not do to wait another second, and with all my lung power I shouted "Fire!" My rifles flamed and roared in the Federal's faces like a blinding blaze of lightning accompanied by the quick and deadly thunderbolt. The effect was appalling. The entire front line, with few exceptions, went down in the consuming blast. The gallant commander and his horse fell in a heap near where I stood- the horse dead, the rider unhurt. Before his rear lines could recover from the terrific shock, my exultant men were on their feet, devouring them with successive volleys.[10]

The entire federal line buckled and retreated back over the crest to take protection on the reverse slope. Sgt. Thomas Galwey of the 8th Ohio noted in his diary, "Jack Sheppard, my old mess-mate, jovial companion, and favorite with everyone, drops. He is shot in a dozen places. He never even groaned! Poor boy! This morning he boastingly said that the bullet was not struck that was to kill him!"[11] Over the next hour, French's brigades made repeated attempts to storm the lane but were beaten back over the crest each time. "Men were falling all around us. Our bugler was standing near me, when a cannon-ball struck him in the head and cut it from his shoulders. I think I got some of the blood and brains in my face," recalled Pvt. J. Polk Racine of the 5th Maryland Infantry.[12]

As French's exhausted men took shelter on the slope, D. H. Hill received 3,000 reinforcements from Richard Anderson's division. With these additional troops, Hill made plans to counterattack French's exposed left. But just before Hill prepared to advance, Sumner's third division, led by Maj. Gen. Israel Richardson, arrived with 4,000 fresh men, thereby squashing Hill's plan. Richardson came up on French's left with the Irish Brigade in the front and planned on turning Hill's right flank. The Irish Brigade reached the crest of the hill and was met with the same reception of Confederate rifle fire that French's men took

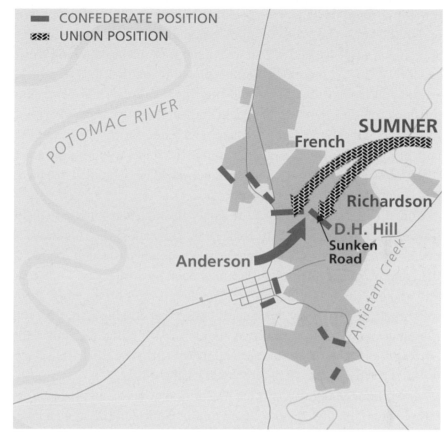

Fig. 1.5: Noon phase. Courtesy Antietam National Battlefield

earlier. Even though Union losses were extremely heavy, Confederate casualties in the lane began to escalate as well.

The stalemate at what is now known as Bloody Lane ended when two Union regiments led by Col. Francis Barlow punched a hole in the Confederate line; this took place between the Roulette farm lane and the present-day observation tower at the end of Bloody Lane. As Barlow's men reached the crest of the ridge, one Confederate regiment misconstrued an order to change direction, which eventually triggered a frenzied retreat. The regiment simply turned about-face and marched

into the cover of the Piper cornfield that bordered most of the southern end of the lane. The North Carolina regiments nearby in the lane presumed that a full-fledged retreat was under way and began to withdraw too. It was during these few minutes of confusion that Barlow struck, sending his troops into the gap and entering the sunken lane firing into the flanks of the Rebels, to their right and left. Seeing Barlow's success, the whole federal line rose in unison and made for the crest and the lane beyond. Panic spread quickly among the Rebel troops in the lane; with practically every seasoned Confederate officer wounded or killed, it was impossible to stop the rout.

Confederate soldiers raced for safety through the Piper cornfield toward the farmhouse, where Gen. D. H. Hill rallied the remnants of his men. Hot on their heels, federal troops pursued through the cornfield and orchards only to be slammed back by artillery on Cemetery Hill and on Hauser's Ridge. Several artillery pieces on the Piper farm were manned personally by General Longstreet and his staff, with the remnants of D. H. Hill's and George Anderson's infantry divisions supporting them. A spirited but weak counterattack led by Hill barely made it into the Piper cornfield before it was easily beaten back.

Two Confederate regiments led by Col. Cooke and Cobb's Brigade attempted to flank the Union soldiers now in control of the sunken lane. Sprinting out of a pasture below the West Woods, they rushed into the Mumma swale—where Greene's Division was once located—and cornfield. Their heroic charge was short lived; fresh Union forces arriving on the Roulette and Mumma farms repulsed the attack. Cooke was forced back to his original line near the West Woods with half of his original 600 attackers left behind, killed or wounded. There were approximately 6,000 casualties at Bloody Lane, including the counterattacks from the West Woods and Piper farm to retake the lane. Northern casualties were significantly higher, at about 3,500, than Confederate losses, about 2,500.

Shortly after 2:00 P.M., the heavy fighting north of Sharpsburg ended (aside from skirmishing) with both sides eyeing each other and waiting for the other to resume the fighting. Union forces held the North and East woods and Bloody Lane. But they lost their deepest penetration into the Rebel front line at the southern end of the West Woods as led by Greene's division. Throughout the morning, Lee had stripped his center and right to find reinforcements to match each federal thrust against Jackson. Lee had no more reserves to commit. Lee's lines in front of Sharpsburg and the land south of town were now paper thin.

By the middle of the afternoon, McClellan, however, had at his disposal almost all of Porter's Fifth Corps and his cavalry. Franklin's Sixth Corps was in front, bolstering the remnants of Hooker's, Mansfield's, and Sumner's corps at the East Woods. But afraid that his own line was now too thin, McClellan, under the advice of Porter, held back any notion of committing any of these troops. His last hope of turning one of Lee's flanks rested in the hands of the Ninth Corps.

At sunrise on the 17th, General Longstreet, in charge of Lee's right, anchored his defensive position on the eastern heights in front of Sharpsburg, with his line extending south approximately one mile on the Harpers Ferry Road. Maj. Gen. David R. Jones's division of 3,500 men held this line; 440 of these men were in an advanced position overlooking the Rohrbach Bridge and the high bluffs along the east side of Antietam Creek. By the time Lee finally finished siphoning off soldiers to support Jackson north of Sharpsburg, Jones had to hold his position with barely 2,000 men under his command. And across Antietam Creek was Major General Burnside, with more than 12,000 soldiers in his Ninth Corps.

The Ninth Corps' role during the battle was originally diversionary; McClellan planned to have Burnside's corps attack the Confederates' right flank to occupy it while McClellan attempted to turn Lee's left flank. This discretionary order, however, did not provide any specific timetable as to when McClellan wanted Burnside to attack. In the predawn hours, Burnside had his men on the march, approaching from the northeast and moving toward the Rohrbach Bridge, the only dry approach over Antietam Creek. Only a half mile from the bridge, Burnside stopped his men and waited until he got word from McClellan about when to

advance. At 8:00 A.M. Burnside's troops crossed the Rohrbach farm and arrived at the eastern heights overlooking the creek and the bridge.

Shortly after 9:00 A.M., Burnside finally received the order to attack, and the Ninth Corps made its first attempts to take the bridge. The small Confederate brigade of Brig. Gen. Robert Toombs faced Burnside's front across the bridge, holding a line approximately 600 yards wide. Covered with the protection of woods and stone quarries, the heights over the creek provided an excellent field of fire for the Confederates (fig. 1.6).

The first federal attack on the bridge was made by the 11th Connecti-

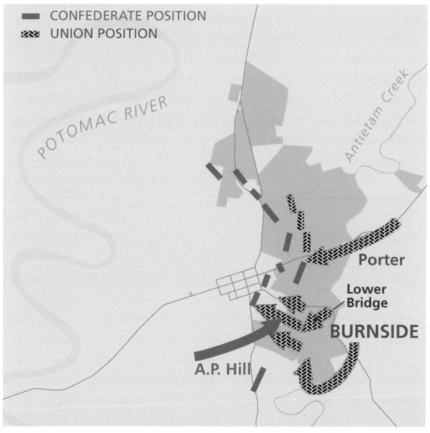

Fig. 1.6: Afternoon phase. Courtesy Antietam National Battlefield

cut, in Brig. Gen. Isaac Rodman's division. The direct assault from the knoll east of the bridge was met with murderous fire from the concealed Rebels on the heights, and the assault stopped as quickly as it began. A couple of hundred yards north of the bridge, Union soldiers found another shallow ford and started to cross the creek on the Rebel left. In the meantime, Burnside sent Rodman's division a mile downstream to find a ford to cross so that Rodman could attack the southern defenders in their flank. After 10:00 A.M., the 2nd Maryland and 6th New Hampshire in Brig. Gen. Samuel D. Sturgis's division made a second attempt along the Lower Bridge Road, and it was also repulsed. South of the bridge, Rodman's men crossed Antietam Creek and were pushing in on the Rebel right. A pincer movement slowly began to close in on the remote Confederate position. Toombs knew that it was only a matter of time before he would have to relinquish the bridge. There were no reinforcements, and ammunition was almost depleted, but Toombs held his ground until the last possible moment.

In the early morning hours, McClellan had been fixated on the events on the north side of the battlefield, taking for granted that Burnside had the situation in control on his left flank. As the morning progressed, McClellan became increasingly impatient and hostile toward Burnside about what exactly was happening on his end of the field. He had expected that Burnside would be across Antietam Creek putting pressure on the Confederate right by midmorning. It became apparent to Burnside that things were not going well for McClellan to the north and that his diversionary attack was now a full-fledged attack on the Rebel right, which he had not prepared for.

Around 1:00 P.M., with mounting casualties, no ammunition, and pressure building on both flanks, Toombs began to withdraw his men. As the Confederates abandoned their stronghold above the bridge, the 51st New York and 51st Pennsylvania crossed the bridge. Lt. John Hudson of the 35th Massachusetts Infantry recalled how "those of our troops not in the advance crossed some-what of those in front—and the whole column while on the bridge appeared like an irregular mob moving nervously,

but at a snails pace, towards the enemy."[13] Fanning out in all directions on the west bank, they encountered only slight Confederate resistance. Burnside, with the west bank now in his possession, had his divisions funneling across the bridge and fords to form a new offensive line on the Otto farm, but it took a couple of hours to get the men organized and resupplied before they were able to push on.

At 3:00 P.M. Burnside's divisions began to advance up the steep, undulating hills toward the Harpers Ferry Road and Sharpsburg. These hills provided some protection early in the attack, but as the federals cleared each of these small ridges, they became increasingly exposed to rifle and heavy artillery fire. Pvt. William Brearly of the 17th Michigan noted, "It was strange music to hear balls scream within an inch of my head. I had a bullet strike me on the top of the head just as I was going to fire and a piece of shell struck my foot-a ball hit my finger and another hit my thumb I concluded they ment me."[14] On Burnside's right Brig. Gen. Orlando Wilcox's division was moving through the Sherrick farm; in the center General Sturgis's division was moving through the Otto farm; and on Burnside's left was General Rodman's division. Confederates made a couple of futile small counterattacks to stem the Union advance but were all beaten back to the Harpers Ferry Road. With the town of Sharpsburg less than a half mile away, the federal lines gained momentum and surged forward. The last of Lee's artillery and D. R. Jones's men could not stop the waves of blue-clad soldiers marching up the last slope before Sharpsburg (some Union skirmishers had actually made their way to some of the houses on the outskirts of the town). In matter of a few minutes, Lee's right flank would certainly be broken.

But just as the Union troops were about to crash through Jones's line, the sound of heavy musketry erupted at the far left of the Union line. General A. P. Hill's division of some 2,500 men slammed into the unsuspecting flank of Rodman's line. After marching seventeen miles from Harpers Ferry, Hill committed his exhausted soldiers into a major assault and with great effect. Cpl. Berry Benson, 1st South Carolina, recalled, "We were ordered to the field, whither we went in rapid march, crossing the Potomac at Boteler's Ford, the water being hip dep. All wet and draggled we hurried on to the field of battle, and took position upon the Confed. right. Advancing through a cornfield, there suddenly rose before us a line of the enemy, whom we drove in disorder at the first fire."[15]

Panic ensued among the troops on the extreme federal left, triggering a slow retreat along the entire length of the Ninth Corps line. General Rodman attempted to rally his men, but he was mortally wounded. The scattered remnants of Burnside's divisions regrouped on the west side of Antietam Creek, back to where they initially launched their afternoon attack after taking the bridge. South of the Boonsboro Pike, Confederate casualties totaled about 1,500; the Ninth Corps sustained about 3,000. At 5:30 P.M. the last of the major fighting stopped on the battlefield.

During the battle on September17, both armies combined sustained approximately 23,000 casualties in dead, wounded, and missing in action—that's one fallen man about every two seconds. Even with all of the bloodletting in the Maryland fields that day, neither side had gained any advantage over the other. At day's end, Lee had lost his front-line positions on the Mumma and Miller farms, Bloody Lane, the Piper farm, and the Burnside Bridge. Lee's new front extended along Hauser's Ridge heading north of Sharpsburg, Cemetery Hill at the center, and the Harpers Ferry Road south of town. That night had to be unbearable to the front-line troops that had to listen to the moans and screams for help from the wounded and dying stranded out of reach between the armies. As darkness settled over the battlefield, both sides, within their respective lines, began the grim task of removing the wounded and burying the dead.

They took the wounded to field hospitals in the rear to await their turn with the field surgeons. Every available house or farm building was turned into hospitals and shelters for the wounded. Because of poor sanitary conditions, we will never know exactly how many died after the battle because of disease and infection. The eventual death toll from infections easily equaled and probably surpassed the number of those killed outright during the fight on the 17th.

2 ‡ Clearing the Fields

Dawn on September 18 revealed even more starkly the carnage. Between the front lines lay a no-man's land of wounded and dead soldiers splayed out in all kinds of wretched and contorted positions. Before being rescued, some of the wounded were in the fields for as long as thirty-six hours, without water and food and exposed to the elements. If the battle had resumed that Thursday morning, those who were still alive out in that no-man's land would have risked being wounded again, or killed by artillery shrapnel or bullets, or trampled to death. Scattered among the human bodies were the dead horses of the officers and artillery. The horrible stench of death permeated the Sharpsburg area for many days following the battle and produced a troubling plague of flies and pests.

Behind the cover of the West Woods, Confederate brigadier general Jubal A Early, commanding Ewells's division, logged:

> I deem it proper to state that all the killed and wounded of my own brigade were inside of my lines, as I established them after the fight, and that the killed and wounded of the enemy on this part of the field were also within the same lines. All of my killed were buried, and all of my wounded were carried to the hospital in the rear, though by some mismanagement on the part of the surgeons or quartermasters, of which I was not aware until too late, some 10 or 15 of my wounded were left in a hospital on the Maryland side of the river when we re-crossed.[1]

Quartered opposite the West Woods in the Union-held East Woods, Cpl. William Westervelt of the 27th New York wrote a graphic and detailed account of that morning.

> Just before daylight we were called into line, as that is considered the favorite time to surprise a camp, and we did not intend to be caught napping. Here we stood on our guns, while in the rear of us were the artillerymen with guns shotted and lanyards in hand ready to attach to the primer, and send death and destruction into the ranks of an advancing foe. All remained quiet, however, and soon after sunrise we were ordered to stack arms and break ranks. Soon a score of small fires

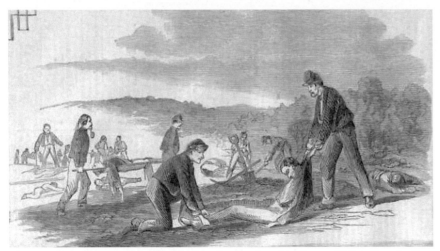

Fig. 2.1: "Burying the Rebel dead after the Battle of Antietam," Theodore R. Davis, *Harper's Weekly,* October 11, 1862. From the collection of Bob Zeller

were kindled with cornstalks and small twigs, and the coffee cup—was steaming, and meat frying, and we soon sat down to our morning meal right among the dead that, already in the hot September sun, began to give forth a very unpleasant odor. This only shows to what extent we could adapt ourselves to our surroundings. A few months before I could not have taken a mouthful of food and swallowed it in the presence of a corpse. Now, although they showed unmistakable signs of decomposition, we did not mind it, even though they lay so thick we were obliged to lift some of them out of our way to make room for our lines of battle. Stretcher bearers now came up, and while they carried off scores of wounded, we turned in with pick and shovel, in the capacity of grave diggers, and the like most everything else done by the army, our grave digging was on a wholesale scale. We first dug a grave six feet wide and about sixty foot long. In this grave, or rather trench, were placed side by side, forty of a South Carolina regiment. A few rods from this was another that contained thirty more. This disposed of all that lay close to our lines, and as we had but few tools for digging, it took most of the day to complete our wholesale internments (fig. 2.1).[2]

With both armies poised to renew the fight, removal of the wounded or dead between the front lines was extremely hazardous work. Issues between the opposing armies were settled more on a personal level between the skirmishers and sharpshooters, and anyone who was caught in the middle, between the lines, became fair game. Informal truces here and there to remove wounded no doubt happened, even though they violated orders of both high commands. Fortunately, for some of the wounded on the northern part of the battlefield near the Dunker church, the humanitarian side prevailed, and sometime during the day a brief spontaneous truce was made by both sides to evacuate some of the wounded. Civil War artist Alfred Waud sketched one such encounter at the Dunker church, depicting the removal of wounded by both Union and Confederate soldiers under white flags of truce (fig. 2.2).

In the early evening of the 17th, Lee believed that McClellan would not attack in the dark but would renew hostilities the following day. So early on the morning of the 18th, Lee held a council of war with his generals to discuss whether to attack the federal right or to cut their losses

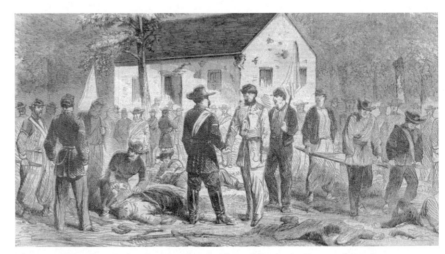

Fig. 2.2: "The Campaign in Maryland, Flag of Truce in Front of Dunker Church," Alfred R. Waud, *Harpers Weekly,* October 25, 1862. From the collection of Bob Zeller

and cross back into Virginia. After initial reports came in, Lee realized that he could not attack and decided to wait and watch the Army of the Potomac. McClellan anticipated that it would be Lee who would attack, and he waited throughout the day of the 18th for the Confederates to start the battle again. Both armies warily eyed each other, neither side interested in continuing the slaughter.

At dusk on the 18th, the armies were again resting on their arms, waiting to resume the killing the next day. Lee saw the opportunity to save his beaten army and issued orders to get the Army of Northern Virginia across the Potomac River at Boteler's Ford. Throughout the night of September 18 and into the early morning hours of the 19th, Lee, uncontested, moved the entire Army of Northern Virginia back onto Virginia soil. The exact time when the Confederate army crossed back into Virginia has not been accurately established, but it is safe to estimate that the majority, if not all, of the army crossed before 9:00 A.M. According to A. P. Hill, "We lay upon the field of battle that night and until the next night at 1:00 o'clock, when my division was silently withdrawn, and, as directed by General Lee, covered the retirement of our army. My division crossed the Potomac into Virginia about 10:00 A.M. the next morning, every wagon and piece of artillery having been safely put on the Virginia shore."[3] Years later, on a visit to Antietam, General Longstreet was asked if he and other officers felt that it was a forced fight. Longstreet replied, "My young man, we had more time to get away before the battle than we did after it."[4]

On the evening of the 18th, Union soldiers closest to the front heard the movement of artillery and infantry coming from the direction of the Confederate lines. Many of the front-line troops believed that Lee was retreating, and this information was passed up through the chain of command to McClellan. Cautious and hesitant, McClellan was not going to take any chances that evening; he did not know if Lee was retreating or reorganizing his forces to renew the offensive the next day. Initial reports along the front began to come in shortly after sunrise on the 19th. "I have been in my 'barn window' for half an hour and cannot see a Rebel," a federal signalman reported at 6:30 A.M. "I have scanned the whole ground from right to left & at this moment there is not a Rebel in sight."[5] Union pickets were soon ordered forward along the entire front. The advance revealed that the Confederates had retreated from their front-line positions during the night, leaving their severely wounded behind.

It is evident that even after the first reports came in, McClellan was still in the dark as to Lee's intentions. Did Lee regroup closer to the Potomac? Was Lee setting a trap? At 8:30 A.M., McClellan telegraphed Maj. Gen. Henry W. Halleck, general in chief: "But little occurred yesterday except skirmishing, being fully occupied in replenishing ammunition, taking care of wounded, &c. Last night the enemy abandoned his position, leaving his dead and wounded on the field. We are again in pursuit. I do not yet know whether he is falling back to an interior position or crossing the river. We may safely claim a complete victory."[6]

General Pleasonton, commander of the Union cavalry, located Lee's army safe on the Virginia side of the Potomac River at Boteler's Ford. Union artillery was brought up and engaged Rebel artillery on the other side of the river. In accordance with the Confederate accounts, it appears that Pleasonton opened his artillery assault between 9:00 and 10:00 A.M. Porter's Fifth Corps, stationed near the Middle Bridge, was the healthiest corps in the Army of the Potomac, and sometime after 9:00 A.M. its leading elements were moving to Boteler's Ford. Meanwhile, the rest of the Union army sat at their positions waiting to move.

At 10:30 A.M., McClellan wired Halleck: "Pleasonton is driving the enemy across the river. Our victory was complete. The enemy is driven back into Virginia. Maryland and Pennsylvania are now safe."[7] While Union and Confederate artillery dueled with each other across the Potomac, Porter's Fifth Corps arrived at noon with sharpshooters and infantry, opening fire on the Confederate artillerist. After giving Lee the valuable time to move his army further away from the Potomac River toward Martinsburg, the Confederate artillery was ordered to move back late in the afternoon. Seeing the Confederate withdrawal, a Union force of about 500 men was sent across the river in pursuit,

and they managed to capture six cannons. Sometime in the evening, this reconnaissance party retired back across the Potomac, but it was unable to haul the newly acquired cannons across the river, thus ending the fighting at Shepherdstown.

All through the early hours on the morning of the 19th, Union troops were at arms waiting to renew the fight. Shortly after federal pickets reported that the Confederates had abandoned their positions, Union troops at the front broke ranks and began to cook breakfast and make coffee and just sat or lay down from sheer exhaustion. Details were sent out to fill canteens for desperately needed water while supplies and munitions were brought to the front to replenish the ranks. Stragglers were numerous on both sides during the battle, and in the early hours of the 19th, some Union soldiers who were lost or had run from the field of battle began to trickle back to their regiments, though many soldiers were still missing from their units.

While the Fifth Corps was put in motion toward Shepherdstown in pursuit of Lee, orders were issued to the various corps to advance to the former positions held by their Confederate counterparts. And so began the clearing of the dead and wounded from the fields. Federal soldiers first cleared the remaining wounded who were stranded between the lines—Union first, then Confederate. Other soldiers looked for the dead of their own regiments in order to give their fallen comrades a decent burial before other burial details got to them. Cpl. William B. Westervelt of the 27th New York described when the area around the Dunker church and West Woods were secured.

At daylight we were again under arms, when our picket line reported no signs of the enemy in our front. At sunrise they were ordered to advance, when it was discovered they had made good use of their time during the cessation of hostilities, and were safe with their supply trains, and artillery south of the river, leaving most of their wounded, however, in our care. About noon we got orders to move, and as we crossed the battle-field the stench from the unburied dead almost took our breath away. We soon crossed the Sharpsburg Pike, where the dead lay in every conceivable position; one with his rammer half drawn from his gun, as he had finished loading his piece, having his gun in one hand and the rammer in the other, with a small, round hole through his forehead, his countenance being but slightly disfigured, but more expressive of surprise than pain.[8]

In the late morning and early afternoon, after passing through the vacated Confederate front lines, Union troops cleared any remaining wounded and the burial details were assigned. Federal forces used even the Dunker church as a triage center, with the field surgeons amputating limbs on the pews. One soldier wrote, "Mr. Snavely said that arms and legs were piled up several feet high at the Dunker Church window where the amputating tables sat. A visiting veteran since the war said that he was passing by the church and an officer hailed him to assist a man in loading them on a cart to haul them away and bury them."[9]

Those units that had shirked from combat or did not participate in the fighting were given the horrific job of collecting the remaining dead—Union first, then Confederate. Corporal Westervelt's 27th New York Infantry, Sixth Corps, was one of those units. It did not suffer a single casualty, with no one either wounded or killed during the battle.[10] The 27th, known as Bartlett's Brigade, had arrived at the battlefield on the afternoon of the 17th and took their position in the East Woods, where they remained until the late morning of the 19th. Because this regiment did not fight on the 17th, it was assigned to the burial details.

The regiments assigned to the burial details were ordered up in battle formation and walked in lines across the fields with picks and shovels gathering the dead and dragging them to prearranged burial locations. Once they collected enough Union soldiers for mass burial, they dug trenches and placed the bodies in and covered them. In some of these graves, soldiers' bodies were stacked one on top of another, sometimes three deep. It was not until late in the afternoon and early evening that Union soldiers began to gather and bury Confederate dead.

Horse carcasses were hauled off the battlefield by local farmers contracted for the removals and then burned in large pyres, adding another distinct smell that the inhabitants of Sharpsburg and the Union soldiers would never forget. Reports indicate that after the battle, Mr. Samuel Mumma dragged fifty-five dead horses from his farm to the East Woods, where he burned them. One battery alone had twenty-six horses killed near the Dunker church.[11]

During the war, some soldiers would not touch the corpses for fear of contracting disease, so they rolled bodies onto blankets or onto fence rails to haul them to the burial sites. If blankets or rails were unavailable, some enterprising soldiers used picks to impale the dead and drag them. This practice was documented during the Battle of South Mountain a few days before Antietam and may also have been employed at Antietam as well.[12] In one of the Gardner pictures at Antietam, a soldier appears to be lying on an axe with the handle protruding out from under him. Another practice involved heating discarded bayonets and then bending them to a ninety-degree angle, allowing soldiers to fashion a hook of sorts to drag bodies.

In the summer of 1862, the area around Sharpsburg experienced a drought, making the soil dry and hard; that and the fact that much of the Sharpsburg area subsurface is made up of limestone rock made grave digging difficult. Many graves were very shallow as a result, covered only with a thin layer of dirt, so that many months later rains and erosion exposed the rotting corpses.

Most of the dead from both armies were buried by September 20, though days, weeks, and even years later bodies and body parts could still be found on the battlefield. Over the years, farmers plowing these fields have turned up unmarked graves, and residents of Sharpsburg had found human bones scattered around houses and farms that had been dug up by animals. Local resident O. T. Reilly, who witnessed the aftermath of the battle, wrote of putting large flat stones over some shallow graves to prevent chickens from digging up the remains. He also wrote of his father-in-law, who in 1866, was a member of the burial corps assigned to dig up Union remains for reinterment, unearthed one body that felt too heavy for its size. After rolling the body over, it revealed that there was a twelve-pound cannon ball inside the remains. It had had just enough force to enter but not enough to exit.[13]

Gardner's photography of the dead at both Antietam and Gettysburg shows that the burial crews first cleaned up the fields and buried the dead closest to the towns and then worked their way outward toward the sparsely populated surrounding farms. When Gardner and Gibson arrived at these battlefields, they took any images of dead away from the towns and on the farmlands. At Antietam, most of the pictures of the dead, if not all of them, were taken on the northern part of the battlefield on the Mumma and Miller farms. More than 25,000 Union soldiers from three different corps and over half of the Confederate army at one time or another participated in combat on those farms.

3 ✛ Pandora's Box

It has widely been accepted that Gardner began taking pictures of the dead Confederate soldiers on September 19 simply because that is the date on three of his captions. While I believe that Gardner and Gibson started on the 19th, I am convinced that only the Bloody Lane photos were taken on the 19th and that Gardner resumed his work the following morning in the area of the Dunker church.

The notion that Gardner entered the battlefield on the heels of the Army of the Potomac that Friday morning, September 19, is highly questionable. The earliest time that the two could have safely walked onto the battlefield that day would have been after it was determined that Lee was across the Potomac River and that he no longer posed a threat at Sharpsburg. Gardner or any of the other curious civilians who went to see the battlefield almost certainly would not have done so until after the Union lines advanced and occupied the vacated Confederate battle positions.

Without knowing the Confederate army's intentions, it is doubtful that Gardner and Gibson would be bold enough, much less gain permis-

sion, to follow the front line on the night of the 18th. For the second straight night, the Union army was at arms, ready to fight. All of McClellan's army (except the Fifth Corps) had its back against Antietam Creek, with only three bridges to cross in the event of disaster. I do not think that Gardner would have allowed himself, his darkroom wagon, and his equipment to be swallowed up in a chaotic retreat over one of the narrow bridges, as had happened to their employer Mathew Brady at First Bull Run. Gardner would have waited until he was certain that the Confederates no longer posed a threat on the battlefield itself.

Frassanito's research suggests that the photographers began taking photos in the vicinity of McClellan's headquarters at the Pry House on the afternoon of the 18th. I also believe they were at the Pry house on the 18th and camped for the night near McClellan's headquarters in Keedysville. Early in the morning the two photographers returned to the Pry house and learned that Lee had abandoned his front-line positions and ultimately retreated back into Virginia, but they had to wait until at least noon before getting word that it was okay to move forward onto the battlefield.

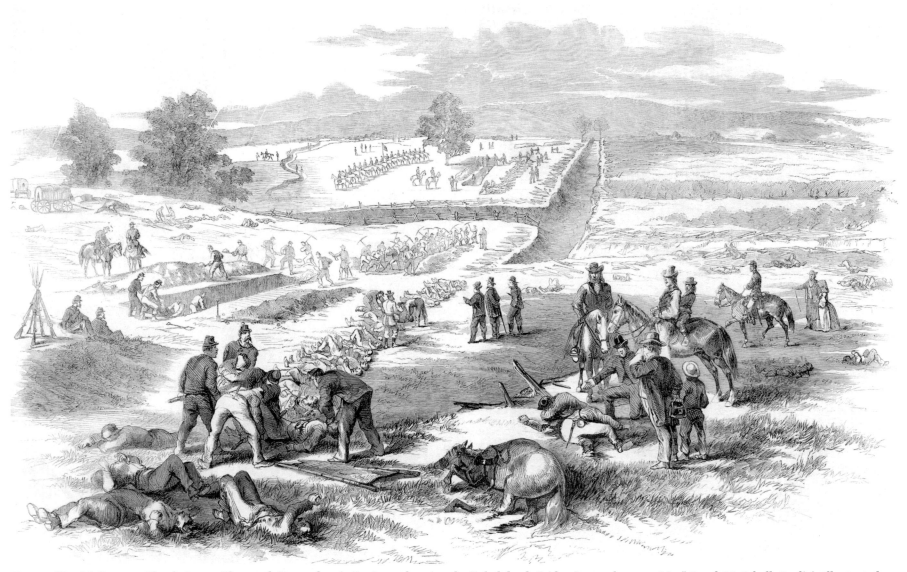

Fig. 3.1: "Burial Crews at Bloody Lane—The 130th Pennsylvania Regiment burying the Rebel dead, Friday September 19, 1862." Frank H. Schell, *Leslie's Illustrated*, October 19, 1862. From the collection of Bob Zeller

To get from the east side of Antietam Creek to the battlefield, Gardner and Gibson would have had to make their way through the postbattle cleanup. Initially, the Boonsboro Pike would have been clogged with infantry, artillery, supply, and ambulance wagons of the Fifth Corp heading west in pursuit of Lee. Adding to this congestion were civilians who came to help transport and care for the wounded, or simply to sightsee or look for souvenirs. Gardner and Gibson primarily stayed on the roads or farm lanes when possible, but they did travel cross-country through open pastures and mowed fields, since all of the images on the northern part of the field were taken in such off-road locations.

Even though none of the Bloody Lane images are dated, we can place Gardner and Gibson on the battlefield at Bloody Lane on the 19th. On the 18th the sunken road was held by Union forces but was under constant sniper fire, negating the removal of Confederate dead in the lane. After the Rebel army escaped into Virginia early on the 19th, artist Frank Schell from *Leslie's Illustrated Weekly* was sketching at Bloody Lane the 130th Pennsylvania burying the Confederate dead (fig. 3.1). At about the same time, Gardner took his image (see fig. 6.3) of a Union burial detail approximately 100 feet from where Schell made his sketch. Although Gardner does not appear in Schell's sketch, his camera location was overlooking the lane at the extreme right edge of the print. The shadows in Gardner's image and Schell's sketch also establish that they were both done late in the afternoon, and Schell's sketch is explicitly dated September 19. I have ruled out any possibility that Gardner's image could have been taken on the 20th, or any date after that, because this would mean that Gardner would have had to encounter the burial details still gathering the dead at Bloody Lane a full twenty-four hours after Schell made his sketch. Because both views show burial parties at work, and both views show a Bloody Lane that is already partly cleared of bodies, if Schell was there on the 19th, then Gardner must have been there too. The location of Schell's sketch is approximately 100 feet north of the present-day 130th Pennsylvania Infantry monument at Bloody Lane.

Of the seventy-six documented photos Alexander Gardner and James Gibson took at Antietam in the week following the battle, sixty-seven are four-by-ten-inch stereo views and nine are seven-by-nine-inch single-image plates. Gibson took eight of the images and Gardner the rest. Of all these seventy-six photographs, only seven are dated, and then only on stereo views: three are dated for the 19th, two for the 21st, and two again for the 22nd. There is not one image dated as having been taken on Saturday, September 20, making it a mystery as to where and what images Gardner may have recorded that day, if any. So how do we account for the dates of all those images that do not have dates? A traditional method has been to assume dates and locations by association. When several views of one subject are recorded from different camera positions, and only one of those views is dated, we might assume that all the views of that subject were taken on the same date—for example, the sixteen Burnside Bridge images. My research suggests that they were. After all, for convenience's sake, Civil War photographers also had a tendency to shoot several different images in one area before moving on to another location, as exemplified in the Dunker church series of images.

Two days after the battle, on Friday, September 19, Gardner began taking photographs on the battlefield. This was well before the burial details could finish their gruesome task. In his original captions, Gardner explicitly dated three views as having been taken on the 19th. The first one shows dead soldiers said to be members of the Union army's Irish Brigade somewhere on the battlefield. The second is of Col. Turner G. Morehead, commander of the 106th Pennsylvania Reserves, again taken somewhere on the battlefield. The third image, stereo view 564, is labeled "Demolished Confederate Battery, near Sharpsburg September 19, 1862." Of these three images, only the location of the third was identified by William Frassanito in his research on the photographs of Antietam.[1] Frassanito identifies this and six other different views recorded near the Dunker church, and since all were taken within a short distance of each other, it has been assumed that the other six pictures taken near the Dunker church were also photographed on the same day. One of the photographs in this group shows the Union battery of Capt. Joseph M.

Knap. After researching the best available evidence of the time, Frassanito concluded that the battery left the battlefield "sometime in the late morning or afternoon of September 19," and therefore the photo was taken on the 19th as well.[2]

This conclusion proved wrong, however, when a diary entry by Sgt. David Nichol, a member of Knap's battery, surfaced in the vast collections of the Army Heritage Center. Frassanito learned of it and shared this discovery with friends and colleagues and, indirectly, with me. Nichol wrote on September 20: "We were about going off Battle-field when we were halted by an artist to take our picture."[3] As mentioned earlier, Gardner did not date any images as being taken that day, so this diary entry gives a crucial on-the-field accounting of where Gardner and Gibson were that morning. By association, then, we can assume that the other images near the Dunker church were taken around the same time of day on September 20.

The lack of credibility in Gardner's dates initially became apparent to me with the caption for plate 564 taken in front of the Dunker church, titled "Demolished Confederate Battery, near Sharpsburg, September 19, 1862" (see fig. 7.5). As previously noted, Gardner's explicit inclusion of the date in his caption and Frassanito's original research seemed to solidly establish this as being an accurate date.

But when the question of *what time* and *where* Gardner could have actually accessed the battlefield on the 19th is reconsidered and weighed against Nichol's diary entry and the evidence provided by my shadow studies, I can only conclude that Gardner did not take photos on the battlefield on the morning of the 19th. My photographs demonstrate that Gardner's series of seven images near the Dunker church were taken before 10:30 A.M. (1862 time), and my examination of the *Official Records of the War of the Rebellion* and study of personal accounts indicate that it is highly improbable that the two photographers could have been anywhere near the Dunker church that morning.

According to the *Official Records,* McClellan wired Halleck at 8:30 A.M. (1862 time) on the 19th stating that he was still unaware of what Lee was doing. The only Union forces on the move early in the morning were Pleasonton's Cavalry and eventually Porter's Fifth Corps. It is extremely doubtful that Gardner and Gibson could have been entering the battlefield before McClellan knew Lee's new position and put the rest of his army on the move. Union general Alpheus Williams wrote, "It was understood that we were to attack again at daylight on the 19th, but as our troops moved up, it was found the Rebels had departed. Some of the troops followed, but we lay under arms all day, waiting for orders."[4] Cpl. William B. Westervelt of the 27th New York Infantry wrote in his diary that it was not until around noon on the 19th that his regiment received the order to advance to the West Woods, which would have been a couple hours *after* the photographs were taken had they been shot on the 19th.

Therefore, I believe it was impossible for Gardner and Gibson to have been in front of the Dunker church on the morning of the 19th when, at the same time, Union soldiers were advancing into the West Woods looking for the Rebel army.

Furthermore, if Gardner had indeed arrived on the morning of the 19th, it is my contention that he would have found it looking significantly different than what he photographed on the 20th. The battlefield around the Dunker church on the morning of the 19th would have still been littered with dead from *both* sides. The absence of Union dead in all but one of Gardner's images indicates that a large-scale cleanup of the fields had already occurred. What Gardner actually records on the northern part of the battlefield on the 20th is the gathering up of scattered Confederate dead not buried the previous day.

Illustrations from some of the artists covering the battle support written accounts as to the number of wounded and dead in the fields of the 19th. As seen in Capt. James Hope's painting of the Antietam battlefield, the dead and wounded of both sides covered the hills and fields (fig. 3.2). Another survivor of the battle who fought with Hope, a colonel of the 2nd Vermont, remarked on viewing Hope's paintings years later: "If I were to criticize, I should say there were not enough dead men in the hills."[5]

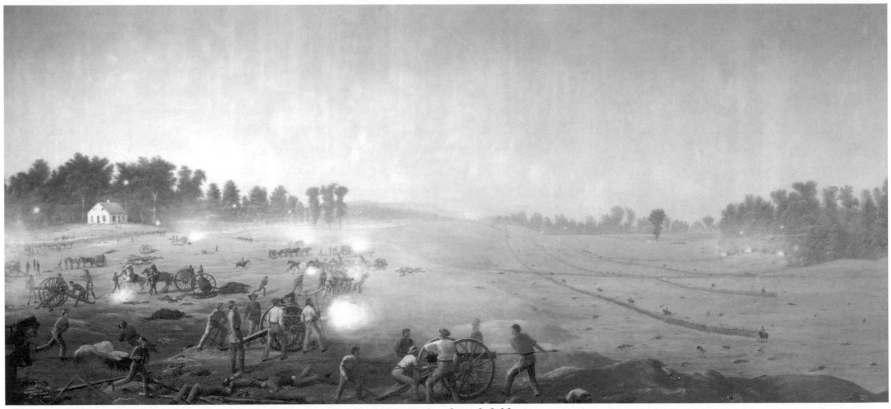

Fig. 3.2: "Artillery Hell." Painting by Capt. James Hope. Courtesy Antietam National Battlefield

In Frank Schell's sketch of civilians entering the battlefield, bodies fill the view in a variety of twisted and mangled configurations (fig. 3.3). My modern photo presents for the first time the location where Schell made this sketch, on the Miller farm between the West and East woods near the edge of the clover field along what is now Cornfield Avenue (fig. 3.4). The trees in the background are the East Woods, and Red Hill is off in the distance at far right. The section of East Woods depicted in Schell's sketch was eventually chopped down and the land cleared for farming. Markers along Smoketown Road and Cornfield Avenue presently denote where the original edge of the East Woods stood.

A comparison of the shadows in Schell's sketch with the photo I took at 3:40 P.M. on September 18, 2010, indicates that Schell's made his sketch late in the afternoon. Evidently, Schell was on the northern part of the battlefield prior to 3:00 P.M. before heading to Bloody Lane because it does show wounded still being cleared from the field when Schell and civilians arrive.

I also find it interesting that in most of Gardner's images taken around the Dunker church and other shots on the northern part of the battlefield there is a relative lack of debris on the landscape, which adds to the theory that a significant cleanup of the battlefield had taken place. Most

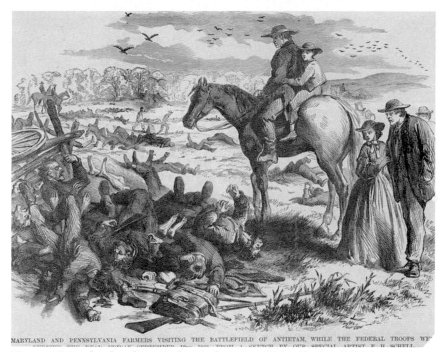

Fig. 3.3: "Maryland and Pennsylvania farmers visiting the battlefield of Antietam, while the Federal Troops were burying the dead, Friday, September 19th, 1862." Frank H. Schell, *Leslie's Illustrated,* October 19, 1862. Courtesy Western Maryland Room, Washington County Free Library

William B. Starke's brigade, along with the debris of battle, remain almost untouched with all their accouterments, with the exception of missing firearms. So I maintain that if Gardner and Gibson had been on the battlefield proper before the afternoon of the 19th, the majority of the images would have looked like the pictures of Starke's dead. It is important to note that nearly all the dead were photographed on their sides or backs, indicating they had been rolled over and searched for personal possessions before being photographed.

Gardner's other dates must also be called into question. Stereo view No. 585 "Graves of Federal Soldiers at Burnside Bridge, Antietam, September 21, 1862" provides a date for the taking of the Burnside Bridge series. But on that same day, sometime before 10:00 A.M. (1862 time) at McClellan's headquarters more than two miles west of the bridge, Gardner sent a telegram on the military wires back to Washington requesting more glass plates so he could take more photos. But his

obvious is the absence of weapons, especially rifles, on the ground. The only photograph that has any rifles on the ground is the "Irish Brigade" image, where they can be seen above the soldier at far left (see fig. 7.8). In most of the pictures, the bodies of Confederate soldiers are lined up for burial, with their uniform pockets turned inside out, the contents emptied by skirmishers, burial details, or looters. Missing in most of the images of the dead soldiers are their accouterments, their bedrolls, canteens, knapsacks, hats, and cartridge boxes. Even the horses that are in the images have been picked clean of saddles, saddle bags, blankets, stirrups, and bridles. The exception to this are the five images Gardner recorded along the Hagerstown Pike (see figs. 7.17–21). The dead of

Fig. 3.4: Author.

caption suggests that on that day Gardner was at the Burnside Bridge taking all the time he needed to expose sixteen different negatives as if he had an endless supply of plates. Furthermore, the shadows in these images reveal that they were taken at various times of the day starting at 8:00 A.M. (1862 time), indicating that Gardner could not have been at two different places at the same time.

One of the most compelling pieces of evidence to determining when the photographs at Antietam were taken is based on the weather conditions at that time. The closest official reports of weather for the Sharpsburg area came from the Frederick weather station some fifteen miles away, and accounts in diaries and from the *Official Records* correlate with those provided by the weather station. However, the quality of Gardner's photos dated the 19th do not match up with the weather reported from any of the above mentioned resources. Four days—the 19th, 21st, 22nd, and the 24th—had little or no cloud cover reported at Frederick. Gardner's pictures taken on those days show clear and crisp images due to the cloudless, sunny skies, and they show distinct shadows. Images that were recorded on the 18th and 20th have a darker and hazy appearance due to inconsistencies with fluctuating cloud conditions producing less distinctive shadows or none at all. However, weather conditions can change from sunshine to rain in the short distance of a few miles, and since Frederick is fifteen miles from Sharpsburg, the weather and cloud conditions could have been completely different. The images at Sharpsburg, however, indicate only some slight differences from what was reported at Frederick.

Based on the information that I have accumulated to support my findings, one must then question the credibility of Gardner. Gardner knew how to manipulate photographs and information to his advantage, even if it meant stretching or twisting the truth. In his biography of Gardner, D. Mark Katz tells the story of how he would experiment with different ways of photographing documents for copying purposes.[6] Eventually, he developed the idea of duplicating a check, and in time he created an almost perfect copy of one. To test his work, Gardner took both an original and fake check to a bank, where an unsuspecting clerk cashed the bogus check. Before leaving, Gardner called for the president of the bank to inform him that the clerk had just cashed a phony check. Gardner then presented the original to the astonished president and clerk. This unprecedented act of counterfeiting by Gardner ultimately forced the banks of New York to design and create a check that could not be photocopied.

Gardner is also known to have staged one of the most famous Civil War photographs, that of a dead Confederate sharpshooter in his lair at Devil's Den on the Gettysburg battlefield. In 1961 Frederic Ray revealed that the same body was seen in two different locations of the Devil's Den, and William Frassanito elaborated on how Gardner and Gibson dragged the rebel corpse some seventy-four yards and lay the body alongside one of the two boulders in the image.[7] Between the boulders was the improvised stone wall built by Confederates when they occupied Devil's Den on July 2. Placed for effect, leaning against the stone wall, is one of Gardner's props, a musket—not the weapon of a sharpshooter. However, no evidence suggests that either Gardner or Gibson physically manipulated any bodies or used props to glamorize or dramatize a scene at Antietam.

After disregarding all but one of Gardner's dated captions, I conclude that Gardner and Gibson began their Antietam series of photographs on September 18 at the Pry house and not on the battlefield proper. Gardner took his first battlefield views late in the day on the 19th at Bloody Lane. Although Gardner provided dates for seven of the Antietam images, none of those dates is September 20. But we now know that many of his most important images were taken that day. On the 21st, after almost depleting his inventory of glass plates the previous day, Gardner telegraphed for more plates and stayed in the vicinity of McClellan's headquarters photographing Sharpsburg. He then spent the entire next day at the Burnside Bridge and the 23rd at the Middle Bridge.

The sequence of photographs taken between September 24 and early November when McClellan finally moved his headquarters to Warrenton, Virginia, is unknown. This includes approximately forty-five addi-

tional photographs taken prior to and following Lincoln's surprise visit to the battlefield October 1–4. During Lincoln's two-day stay and tour of the battlefield, Gardner photographed the president and McClellan as well as assorted members of McClellan's staff.

Of Gardner's seven dated images, I believe only the picture of Gen. John C. Caldwell and staff bears the correct date, September 21. Gardner was not particularly efficient at keeping a log or diary, and I think that he added the dates and captions to the images later, when he returned to Washington. The question about the accuracy of Gardner's three captions dated the 19th in turn raises a question about the credibility and accuracy of the remaining dated captions and, indeed, all of his captions, thus opening a Pandora's box.

4 ✠ Alexander Gardner and Battlefield Photography

Alexander Gardner was born on October 17, 1821, in Paisley, Scotland, the first of four children of James Gardner and Jean Glenn.[1] Little is known of his twin sisters Agnes and Catherine, but younger brother James followed in the footsteps of his big brother and became a photographer. As a young child, Gardner was an excellent student who excelled in the sciences, especially chemistry. As a teenager, he worked as a silversmith apprentice to a jeweler in Glasgow. (He applied his knowledge of the jewelry trade when he opened his first photography studio, enticing prospective clients with gold watches as a courtesy gift for patronizing his studio.) In 1842, Gardner switched professions and entered the world of banking and finance, and by 1847 he was a manager at a loan institution.

As a young man, Gardner became a Freemason and embraced the Calvinist philosophy of the time. He began writing on the problems facing the working class and explored forming a cooperative settlement in the United States of America. To do this, Gardner formed the Clydesdale Joint Stock Agricultural and Commercial Company in 1848 and purchased land in the state of Iowa with the help of investors—friends and family who shared his ideas and beliefs. Gardner's brother, James, and eight others sailed across the Atlantic and established the colony in Monona, Iowa, in 1850. Gardner stayed in Scotland to manage the financial assets of the company and to raise more capital from prospective investors. In 1851 Gardner entered the newspaper business with his purchase of the *Glasgow Sentinel*.

At the Crystal Palace Exhibition in London in 1851, the great nations of the world introduced new industrial and scientific innovations, including advances in photography. Photography was still in its infancy, but it was attracting people of all walks of life into the studios for portraits, making it a lucrative business. It was at the exhibition that Gardner, attending as a newspaperman, likely met the internationally known American photographer Mathew Brady. Gardner returned home and set about learning the trade from some of the local photographers in Glasgow.

In 1852, Gardner sold the newspaper after the failure of his Clydesdale investment venture; the investors and members of the colony had

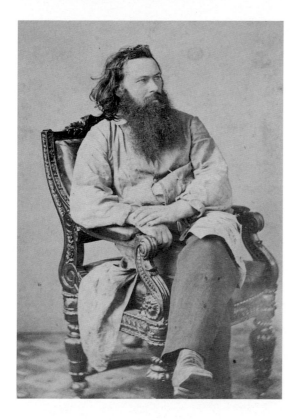

Fig. 4.1: Alexander Gardner. Courtesy Smithsonian Institutions National Portrait Gallery

learned that a tuberculosis epidemic had killed almost all of the colonists. More than halfway across the Atlantic, he decided to continue on and make a different, new life for himself in America (fig. 4.1).

Shortly after arriving in New York, Gardner landed on the doorstep of Mathew Brady's studio. By the end of the year, Gardner, with his business experience and his love of science, had become Brady's assistant and manager of the New York studio. Before the start of the Civil War, he moved to Washington, D.C., and managed Brady's new studio there, where Brady also employed Gardner's brother James as well as photographers George Bernard, Timothy O'Sullivan, and James F. Gibson, another Scotsman.

Biographical information about James Gibson, who accompanied Gardner to Antietam, is extremely limited, making him one of the least known photographers of the war. There are no known photographs of Gibson, very unusual considering his trade. Gibson was born in Scotland in 1828. He left Scotland to come to America in July 1856 and lived in Washington with his wife, Elizabeth, and worked at Brady's Washington studio.

After Fort Sumter surrendered, Brady envisioned the historical significance and potential profits of photographing the aftermath of the first major land battle and possibly the last battle of the war. In early July 1861, the armies of the Union and Confederacy gathered a short distance from Washington at Manassas Junction in Virginia. Brady wanted to accompany the army and presented his idea on photographing the battle to President Lincoln and Allan Pinkerton. At one time a deputy sheriff in Chicago, Pinkerton before the war would create one of the most reputable detective agencies and who would eventually establish the Secret Service.[2] Lincoln employed Pinkerton's agency throughout the war for gathering intelligence on the Confederacy and served as the eyes and ears of McClellan's army. The plan was accepted, and on July 21 Brady, along with hundreds of spectators, positioned himself on the outskirts of Manassas Junction to watch the day's events unfold. As the battle progressed, however, it turned disastrous for the Union army. The federals were routed and fled the field in a panic. Soldiers and civilians

voted to disband and dissolve the company. Gardner left Scotland in early 1853 to join his brother in Iowa and to settle any business matters concerning the termination of the colony. The two brothers returned to Scotland that summer, and Gardner resumed his newfound passion for photography. It was also on his return that he married Margaret Sinclair, whose brother Robertson had been one of Gardner's friends who settled in Iowa.

Gardner opened up his own studio in Dumbarton, Scotland, early in 1856 but closed it after only a few months. He had decided it was time to leave Scotland with his wife, brother James, and more relatives and friends. Their plan was to unite with the members of the original colony in Iowa and settle there. On the trip to America, however, Gardner

alike were caught in the stampede back to Washington—including Brady, who failed to bring back any photographs. But Brady did not give up the idea of covering the war. And if he did not go himself (Brady's presence in the field can be documented throughout the war), he sent his cameramen. A long misconception is that Brady did not give his cameramen the credit for taking the images he sold at his studios.[3] In some cases he did. Far more common, though, was the Brady studio name alone or more prominently displayed. So the images from his gallery came to be known as Brady photos, no matter who took them.

In the spring of 1862, Brady's portrait studios were doing well enough that he was able to outfit his photographers with new cameras and darkroom wagons. That March, James Gibson and George Barnard went back to the First Bull Run battlefield after the Confederates withdrew from the area and Union troops secured the old fighting ground and produced some spectacular images of the battlefield and the former Rebel defenses. That April, Brady sent Gibson to accompany the Army of the Potomac during the Peninsula campaign in Virginia, and, again, Gibson took some of the finest images of the war. But during the first year of the war, fresh battlefield views were unobtainable because of the lack of Union victories and, as a result, access to the postbattle scenes.

While Gibson was following McClellan in Virginia, Gardner stayed in Washington at the studio and worked for the U.S. Topographical Engineers duplicating and enlarging maps for the army.[4] Gardner was also assigned to the Army of the Potomac and became the personal staff photographer for McClellan, making him well-known among the officers and soldiers. In the summer of 1862, Alexander Gardner and James Gibson briefly became business partners even though they still worked for Brady as subcontractors.[5] Their partnership soon folded, but they must have remained on friendly terms while still working for Brady. By September 1862, Gardner had built a long-lasting friendship with Allan Pinkerton, which kept him close to McClellan's headquarters and put him in a position to make the photographs he did at Antietam.

In early September 1862, just a few days after McClellan merged the Army of the Potomac and Pope's Army of Virginia, Lee invaded the north, and Union forces left Washington in pursuit of Lee. Tagging along at a safe distance from the army were Gardner and Gibson.

The Battle of Antietam was the North's first victory in the East, which meant photographers had access to a "fresh" battlefield before all of the bodies were cleared away. The photographs at Antietam brought to the home front a whole new perspective of the war.

Alexander Gardner and James Gibson arrived on the Antietam battlefield in a small rickety delivery wagon that had been converted into a mobile darkroom. This wagon carried their cameras, chemicals, and darkroom equipment as well as their personal effects, such as bedding, food, cooking gear, clothes, and an extra saddle. A large drum for water was probably also stored on board for long excursions; not only was water a major everyday necessity for drinking and cooking, but it was also used in developing the photographic plates. Quite possibly, the two photographers were accompanied by a hired guide or teamster

Fig. 4.2

with another wagon. The teamster would take care of the wagons and horses but may also have acted as cook, looked for water, or even ran plates between Gardner and Gibson.

Once on location, the photographers had to unload and set up cameras and the darkroom, with its chemicals and developing trays. When they developed an image, they probably had the brake on and the horse tied up. Gardner obviously did not unhitch the horse from the wagon at every photo site. Two images at Antietam show the horse still hitched to the darkroom wagon while the pictures were being taken. When taking several images in one certain area for a prolonged time, they probably unhitched the horse and tied him so as not to jolt the wagon while sensitizing and developing the plates; one of the Burnside Bridge pictures depicts this.

At Antietam, Gardner used two cameras: a seven-by-nine-inch field camera and a four-by-ten-inch stereographic camera (fig. 4.2). The major difference between the two is that the stereographic camera had two lenses instead of one, situated an eye-width apart, which resulted in two smaller images on the glass to provide the two slightly different images needed for 3-D viewing. Prints were made from the stereo glass negatives and then mounted on cards. When placed in a stereoscopic viewer, the image provided the optical illusion of depth, just as the View-Master and 3-D movies do today.

The process involved in taking a picture was complex. The height of the camera was adjusted with a collapsible tripod constructed of wooden legs resembling crutches. Gardner probably carried only one tripod, since the camera housings were interchangeable. The photographer focused the camera using an expandable bellows between the lens and plate housing. But to take distant or close-up shots, he had to manually move the camera forward or backward, for there were no telescopic or zoom lenses. The lens on the five-by-seven-inch large-format camera was composed of three pieces of hand-polished glass, a single piece at front and two pieces cemented together in the back, that would flip the image at a certain distance. Once the photographer had the camera in position, he would look through the back of the camera at a frosted piece

Fig. 4.3: Back of camera showing frosted glass light meter.

of glass that functioned as the light meter. Here the image was projected upside-down onto the frosted glass (fig. 4.3). If the image was too dark or light, he could change the aperture determining the amount of sunlight entering the camera by using manual F-stops, which were small metal diaphragms with different-sized holes inserted behind the lens. As long as weather permitted and the photographer was satisfied with the image on the frosted glass light meter, it was time to take a picture.

While Gardner was setting up the camera and lining up the image, Gibson prepared the glass plates. These plates were made of expensive glass and were custom cut to size and kept cleaned and polished. The single-image camera plates were seven-by-nine inches and the stereoscopic cameras plates four-by-ten inches. Both were carried in slotted dustproof boxes until needed. The plates were prepared by applying, or pouring, collodion onto one surface area of the glass until it was thinly covered. Collodion, which is the consistency of cough syrup, had to be handled and applied with great care since it was a highly combustible compound. Two of its ingredients were grain alcohol and ether. Daytime temperature played an important role in how fast the image had to be taken. The hotter the day, the faster the image had to be taken, or the collodion would dry up or harden.

After the plate was prepared, the assistant—wearing a large tarp over his back and tied around his legs—took it back into the wagon where

it was immersed in a tank of silver nitrate for a few minutes, making it light, or photo, sensitive. This was done in either complete darkness or with "safe light" filtered through a red piece of glass inserted into the roof or side of the wagon to allow the assistant to see in the darkroom. The glass plate was then placed inside a plate holder, which was another smaller light-proof box with a removable cover, which was also used to transport the plates to and from the camera in the fields. The assistant took the wet plate to the photographer, who pulled the frosted-glass plate out of the way and attached the plate holder onto the back of the camera, which was usually covered with a black cloth to keep out light. The photographer would then reach underneath the cloth and pull the cover off the plate box through a hinged trapdoor on the side.

To take a picture, the photographer removed the lens cap and counted the number of seconds he wished to expose the plate before putting the lens cap back on. Then he slid the cover of the plate box back through the trap door to return the exposed plate to darkness. The assistant removed the box and took it back to the darkroom wagon. Under the red safe light, he opened the plate box and removed the plate and put it in a white developing tray. He then poured developer onto the plate. One of the ingredients of the developer was iron sulfate, which reacted with the silver to create a microscopically thin metallic image on the glass. The final step was to remove the plate from the tray and pour water over it, stopping the developing process. After gently blotting the plate dry, the assistant placed it in a slotted carrying case. From start to finish, the process took approximately ten minutes for each image.

Lighting was critical. While the ideal outdoor conditions were clear, blue, sunny skies, that was not always the reality. Photography was still possible under cloudy conditions as long as there was ample lighting. The photographer had several choices on how to adjust the amount of light to let into the lens of the camera. This was done by adjusting the number of seconds the lens cap was off while taking the image, by changing the F-stops, or through a combination of the two. If facing strong sunlight, the photographer might have his assistant hold a board or cloth above the lens to block the sunlight or glare from the lens. A mixture of sun and clouds, with the sun popping in and out, gave even the most experienced photographers a really difficult time. As evident in the quality of the photos at Antietam, four of the six days Gardner and Gibson took photos were mostly clear and sunny conditions.

Lighting also impacted how colors were photographed differently in black and white, making it hard, or sometimes impossible, to determine who the dead in the pictures were by their uniforms alone. Reds and dark yellows photograph black, while light blues and grays may appear white. Union uniforms are somewhat easier to distinguish in a picture: light-blue trousers may look white and the dark-blue coats black. The dark-green uniforms of Berdan's Sharpshooters photographed as black. A sergeant's infantry shoulder chevron was light blue and appeared white against a dark coat. But on the artillery uniforms, the red chevron showed as black and blended into the coat. At Antietam, Confederate uniforms were a hodge-podge, ranging from the traditional light gray to uniforms imported from England and France that had enough blue in the material that, when photographed, appeared black. This can make it difficult, if not impossible, to distinguish Union from Confederate dead in some photographs. Added to that, because of the increasing scarcity of Confederate uniforms, many Rebel soldiers discarded all or part of their own worn-out uniforms and substituted them with uniforms from the Union dead. In A. P. Hill's flank attack on the Ninth Corps, some Rebel soldiers were in Union uniforms confiscated from the captured garrison at Harpers Ferry. This confused some Union soldiers and kept them from firing for fear of hitting their own men.

5 Thursday, September 18
The Pry Farm

Jonathan Gruber's *Farmers' Almanac* for Hagerstown and area, 1862
 Sunrise: 5:54 A.M. Sunset: 6:06 P.M.
Weather Channel.com, September 18, 2007, for Sharpsburg, Maryland
 Sunrise: 6:55 A.M. Sunset: 7:15 P.M.
Cloud conditions from the Frederick, Maryland, weather station, September 18, 1862, with 1 representing clear skies and no clouds and 10 as heavy cloud cover and overcast skies

 7:00 A.M. Degree: 10 Type: cumulo-stratus
 2:00 P.M. Degree: 8 Type: cirro-cumulus
 Precipitation: 0.156 inches Time: 5:15–6:00 P.M.
Temperature 7:00 A.M.: 71° 2:00 P.M.: 79°
 9:00 P.M.: 72.5°

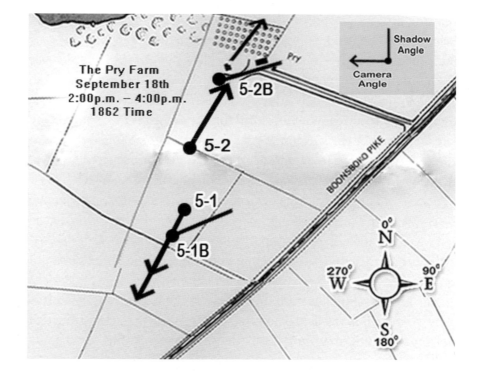

Original camera location: Currently on private property

Gardner's 1862 photographic time: 2:40 P.M.

Modern time: 3:40 P.M., September 18, 2010

Camera angle: 203°

Shadow angle: 65°

Although no documentation has ever surfaced about how photographers Alexander Gardner and James Gibson made their way to the Antietam battlefield, I posit that the two photographers arrived on the morning of the 18th in the town of Keedysville, behind Union lines and a good, safe distance from the front. Since fighting had not resumed by the afternoon, I think that Gardner and Gibson moved closer to the battlefield, reaching McClellan's headquarters at the home of Philip Pry off the Boonsboro Pike. With his camera set up on a hill near the Pry farmhouse, Gardner took two views, approximately 150 yards from each other and looking off in different directions. The first image was of a reserve artillery unit relaxing around campfires in a large field; the second was of the Pry farmhouse. The two men may have contemplated taking more images but probably decided to conserve their glass plates for the battlefield. With ominous rain clouds forming on the horizon that afternoon, the two likely decided to call it a day before the rain hit. Accounts from different Confederate commands record the day as warm and clear until the late afternoon or early evening, when a thunderstorm rolled through.[1] In Frederick, the weather station reported that it rained from 5:15 P.M. to 6:00 P.M. with almost .2 inch of rainfall measured.

Frassanito provides strong evidence that the first photo, showing the reserve artillery unit, probably was not taken on the day of the battle but was more than likely shot on the 18th. There are no records that the artillery battery in the photo was stationed there on the 17th. Frassanito explains that the reserve artillery was positioned on a ridge to the right of this photographic location on the day of the battle, not where it is shown, which is in the field below the soldier sitting in the foreground of the image looking off toward the battlefield. Frassanito further suggests

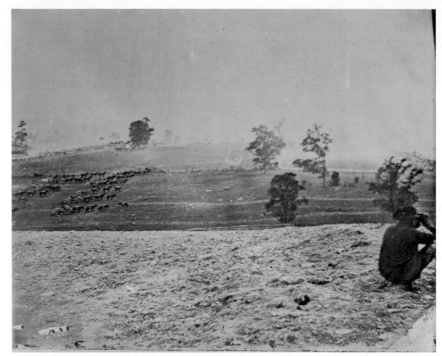

Fig. 5.1: Stereo plate 671: "View of Battle-field of Antietam, on day of battle, Sept. 17, 1862." Courtesy Library of Congress (B811-671 right half)

that this artillery was part of Humphrey's division stationed there on the 18th. There is a slim possibility that these two images were recorded sometime between September 19 and 22, but no artillery was stationed in this area on these dates, which further strengthens the evidence that these images were taken on the 18th.

With the camera position facing southwest, it is obvious that the soldier looking through the binoculars has his back in silhouette, making this an afternoon or early evening image. I established a time frame for this image based on the shadow from one of the large trees in the middle of the field. Unfortunately, there are no large trees in the field today, and the original camera position on top of the hill is now blocked by trees.

Fig. 5.1a

Fig. 5.1b

Fig. 5.1c

I took my first picture (fig. 5.1a) on top of the hill on an afternoon in May 2001. And I took the following pictures at the base of the hill a short distance from the original camera position and facing the same direction as Gardner's picture. Without any trees in the field in the background, I used myself as a sundial to record the angle of the shadow of the tree in the distant field. I originally stood where the tree was located in the original image that I based my shadow study on, but the grass and weeds were too high and completely distorted my shadow. Therefore, I had to move closer to the camera position at a spot where I could record a visible shadow; standing near the middle of the picture, I almost blend in with the terrain.

The two modern images presented here I took on September 18, 2010, at 3:40 P.M. I took figure 5.1b with the shadow angle at 65°. An enlarged section of figure 5.1c shows my shadow matching the direction as the one the tree casts in Gardner's image.

Original camera location: Currently on private property
Gardner's 1862 photographic time: 3:30 P.M.
Modern time: 4:30 P.M., September 16, 2005
Camera angle: 20°
Shadow angle: 74°

On the afternoon of September 16, the family of Philip and Elizabeth Pry was evacuated to safety in Keedysville by the Army of the Potomac. The house was then occupied by McClellan from the 16th through the 20th, serving as his headquarters. (In Gardner's catalog, the picture of the Pry farmhouse was incorrectly identified as Hooker's battle headquarters.) Wounded in the ankle during the battle, Gen. Joseph Hooker was taken back to the Pry house to recover. Gen. Israel "Fighting Dick" Richardson, wounded in the action at Bloody Lane, was also taken to

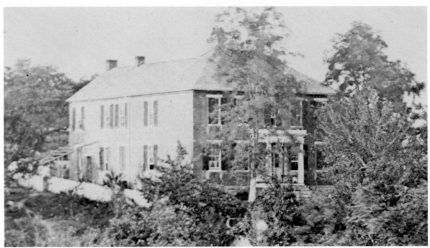

Fig. 5.2a

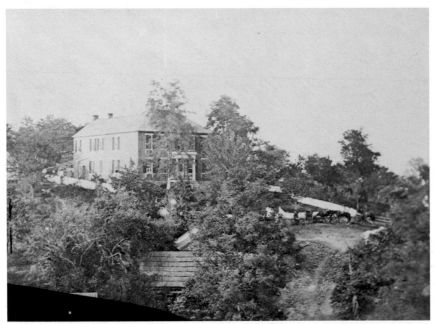

Fig. 5.2: Stereo plate 576: "General Hooker's Headquarters during the Battle of Antietam." Courtesy Library of Congress (B811-576 left half)

the Pry house for treatment; his wound proved to be fatal. On his visit to the battlefield in October, Lincoln visited the Pry farmhouse to pay his respects to the dying general.

It was simple to determine the time frame for the Pry house photo. I took a modern series of pictures about every hour, then studied the shading and sunlight on the house in my modern images and compared them to Gardner's photo, pinpointing the closest match. Today, Gardner's camera location site is blocked by woods, which makes taking a picture from his original site impossible. The only way to take a picture today of the Pry house today from the same angle as Gardner used is from the roof of the smokehouse in front of the Pry house. The farm buildings between Gardner and the Pry house in Gardner's picture are long gone. The area occupied by these barns is now thick woods, but still discernible are the foundation stones for a barn (from the battle period or later). I enlarged the shot of the Pry farmhouse for ease of comparison.

I use four pictures I took on September 16, 2005, to place the time Gardner took his picture. I shot the first picture at 10:40 A.M. (fig. 5.2b). The left side of the chimneys, the left side of the house, and the front of the picket fence are all in silhouette, or dark. At 1:25 P.M., the chim-

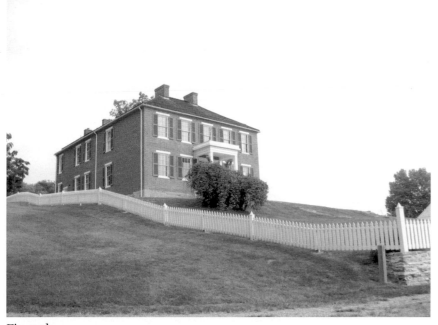

Fig. 5.2b

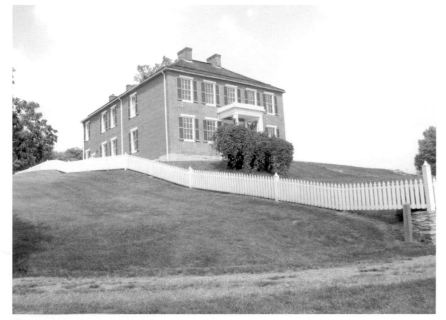

Fig. 5.2c

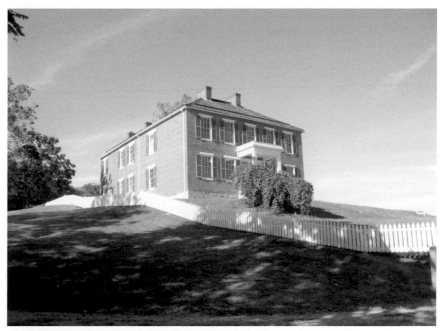

Fig. 5.2d

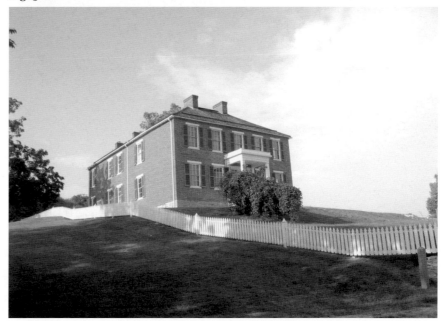

Fig. 5.2e

neys, house, and fence are all fully illuminated with direct sunlight (fig. 5.2c). The next picture, which I took at 4:24 P.M., shows the left side of the chimneys illuminated, with their shadows falling to the right onto the roof. The side of the house also is illuminated, with the front of the house in silhouette but not yet completely dark (fig. 5.2d). By 5:10 P.M., the front of the house is completely dark and the shadows of the trees on the ground are much longer (fig. 5.2e). Also notable is the progression of the tree shadow on the side of the house in the later two pictures. I cannot give an exact time as to when Gardner took his image, but, based on my field investigation, I place it at approximately 4:30 P.M.

6 ✠ Friday, September 19
Bloody Lane

Jonathan Gruber's *Farmers' Almanac* for Hagerstown and area, 1862

 Sunrise: 5:56 A.M. Sunset: 6:04 P.M.

Weather Channel.com, September 19, 2007, for Sharpsburg, Maryland

 Sunrise: 6:55 A.M. Sunset: 7:13 P.M.

Cloud conditions from the Frederick, Maryland, weather station, September 19, 1862, with 1 representing clear skies and no clouds and with 10 as heavy cloud cover and overcast skies:

 7:00 A.M. Degree: 1 Type: cirrus

 2:00 P.M. Degree: 4 Type: cirrocumulus

 Precipitation: 0

Temperature 7:00 A.M.: 66° 2:00 P.M.: 75.5°

 9:00 P.M.: 65.5°

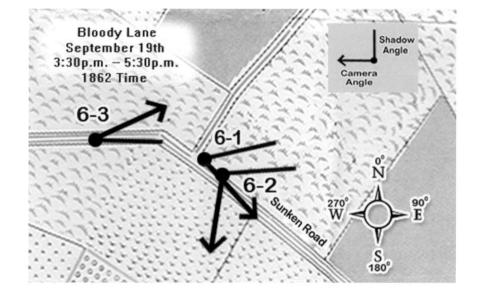

Between 8:30 and 10:30 on the morning of September 19, McClellan learned that Lee had withdrawn from his positions at Sharpsburg, according to the telegraphs that he sent to Halleck in Washington. Originally planning to renew the fight at Sharpsburg, McClellan had to switch operations from battle preparation to pursuit. He issued new orders to the corps of the Army of the Potomac, which in turn were passed down the chain of command. It took Lee approximately ten hours to get his Confederate army out of Sharpsburg and across the Potomac River at Boteler's Ford. Porter's Fifth Corps, stationed in the area of the Middle Bridge, was the first to move in pursuit, while the remaining Union corps on the west side of Antietam Creek were ordered forward to the positions abandoned by the Confederates.

Because Gardner and Gibson more than likely took the images of the Pry farmhouse and the silent artillery on the 18th, it is likely that the two stayed near the Pry house that evening, together with the other reporters and newspaper artists. For Gardner, McClellan's headquarters was the most logical place to find firsthand information about the previous two days, and it was also the safest. In the morning hours of the 19th, the two photographers must have became aware that Lee had abandoned his positions at Sharpsburg and that they would have access to the battlefield. A mile from the Pry house, the Middle Bridge was the closest place for the two photographers to cross Antietam Creek.

It is unlikely that Gardner would have been able to cross the Middle Bridge with his photo wagon and gain access to the town of Sharpsburg in the early-morning hours of September 19. The bridge was no doubt choked with Union troops and supply wagons on the move in pursuit of Lee. Reporters and newspaper artists, however, didn't need to wait for the bridge to reopen; they could have easily crossed Antietam Creek on horseback at the many shallow fords. Somewhere between the Pry house and the Middle Bridge, Gardner and Gibson probably began hearing firsthand accounts and stories of the magnitude of the casualties still littering the battlefield.

I assert that Gardner and Gibson crossed Antietam Creek at the Middle Bridge in the early afternoon of the 19th, after the remainder of Porter's Fifth Corps and supply wagons had crossed the bridge and headed west on the Boonsboro Pike. From this spot, the closest concentration of battle casualties was in a sunken farm lane about one mile northwest of the bridge, Bloody Lane. Gardner may have had a guide, or he might have simply been told to take the first road on the right and then head up the hill to the sunken lane. By midafternoon, I place Gardner and Gibson at Bloody Lane, which may have been one of the first areas of the battlefield almost completely cleared of Union dead, for by the time Gardner arrived on the afternoon of the 19th, all that was left were the dead Confederates. With all the movement and commotion from the burial crews, Gardner and Gibson probably had to wait patiently. Finally, the opportunity to record history presented itself when members of the 130th Pennsylvania stepped out of the lane to pose—or at least pause—for the camera after gathering dead Confederates fallen on the lane.

Original camera location: Park property—no restrictions on access to site
Gardner's 1862 photographic time: 4:10 P.M.
Modern time: 5:10 P.M., September 3, 2006
Camera angle: 135°
Shadow angle: 80°

I am convinced that the first American soldiers to be photographed dead on a battlefield were those of the 2nd or 14th North Carolina in George B. Anderson's brigade. The 2nd North Carolina's left flank was just west of the Roulette farm lane; its right flank extended east into the lane, where the dead are located in these two images. The 14th North Carolina's left flank was also anchored in this same area, with its left touching the 2nd North Carolina's right. When the Confederate center was breached by the 61st and 64th New York regiments under Col. Frances Barlow, Confederate troops from North Carolina retreated east and west in the lane, or through the Piper cornfield bordering the south

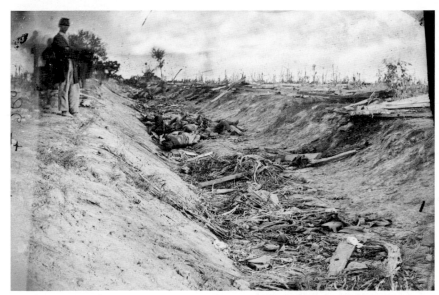

Fig. 6.1: Stereo plate 563: "View in Ditch on right wing, after the Battle of Antietam." Courtesy Library of Congress (B815-563 right half)

Fig. 6.1a

Fig. 6.1b

side of the lane. Barlow's troops pierced the Rebel line about halfway between the Roulette farm lane and the present-day observation tower at Bloody Lane. In Gardner's image, the small tree on the south bank across from the soldier marks the spot where the center of Barlow's line attacked the lane. The large tree on the south bank in my photograph is possibly the same tree seen in Gardner's picture—a witness tree.

I think Gardner's first photograph was plate 563, which was taken near where the Roulette farm lane intersects with Bloody Lane. In the three pictures I took imitating plate 563, I focused on duplicating the shadow cast from the legs of the soldier standing on the north bank of the lane in Gardner's image.

Notice in my pictures the progression of the shadows of the volunteers' legs as they stand on the north bank of the lane, as compared to the shadow cast by the single soldier in Gardner's image. I took the first picture (fig. 6.1a) at 5:14 P.M. Fig. 6.1b is an enlarged view of the soldier on the north bank in Gardner's photo. I took Fig. 6.1c at 5:51 P.M. I think

Fig. 6.1c

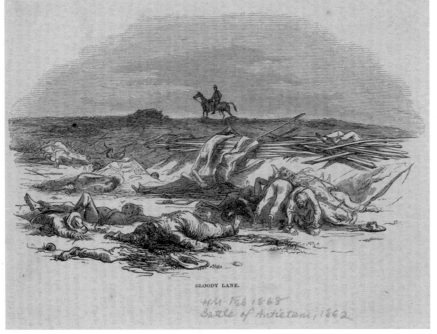

Fig. 6.1d

that it was sometime in this half-hour time period between figure 6.1a and the figure 6.1c when Gardner took his image.

Notice in the modern pictures the progression of the shadows of the present-day worm fence rails—cast by the support rails in the corners of the worm fence, which stick up in the air at forty-five-degree angles—on the south embankment. These are missing in Gardner's picture. Whether the fence in Gardner's image had them or not is anyone's guess, because much of the original fence was taken down during the battle and used for cover, or knocked over in the Confederate retreat from Bloody Lane. The only shadows cast by the worm fence in Gardner's pictures show up where the angles in the fence touch or slightly extend over the lane. The horizontal rails on the south bank in both Gardner's and my pictures do not cast any shadows into the lane at any time.

While researching sketches of the battle, I came across one of a pile of dead Confederates at Bloody Lane (fig. 6.1d). On the top of the pile was the body of a soldier with his rear end sticking up in the air. This sketch illustrated the same pile of dead Confederates in Gardner's image that is barely visible in the lane to the right of the knees of the soldier standing on the bank at the left of figure 6.1b. I wondered why these dead soldiers were piled into a heap and found the answer in O. T. Reilly's book:

A member of the 53rd Pennsylvania Regiment, who had fought at Bloody Lane September 17th and was doing picket duty on the 18th near the Observation tower in Bloody Lane, said they were so much exposed to the Confederate sharp-shooters that they gathered together the dead soldiers and piled them four and five high and used them as breastworks. This misled many persons who visited the battlefield before they were buried and said they were shot where they lay, to that depth, but there were a few places where they lay a couple deep."[1]

Original camera location: Park property—no restrictions on access to site

Gardner's 1862 photographic time: 4:20 P.M.

Modern: 5:20 P.M. September 3, 2006

Camera angle: 190°

Shadow angle: 83°

Gardner picked up his camera and moved eastward in the lane to take plate 553, a close-up of the dead Confederates heaped in the middle of

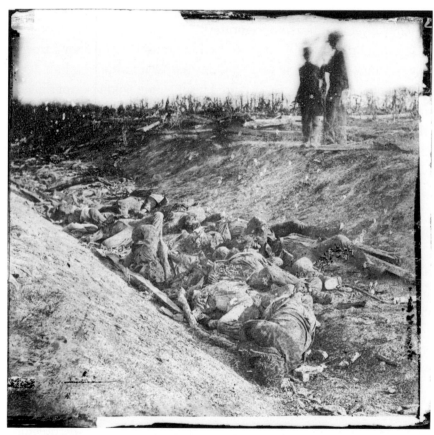

Fig. 6.2: Stereo plate 553: "Ditch on the right wing, where Kimball's Brigade fought so desperately, at the Battle of Antietam." Courtesy Library of Congress (B811-553 right half)

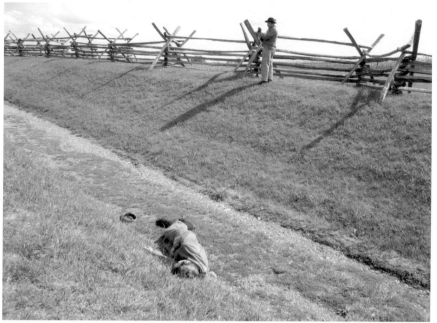

Fig. 6.2a

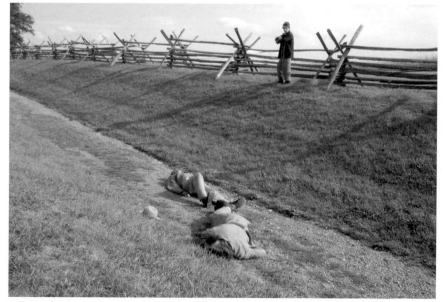

Fig. 6.2b

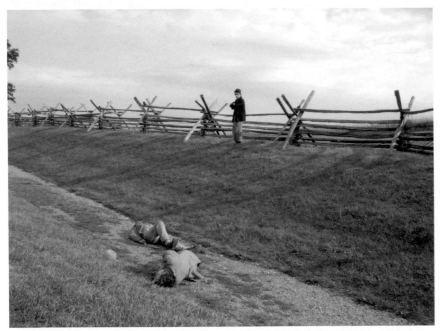

Fig. 6.2c

Original camera location: Park property—no restrictions on access to site
Gardner's 1862 photographic time: 5:00 P.M.
Modern: 6:00 P.M., September 17, 2006
Camera angle: 70°
Shadow angle: 88°

After taking the two images of the 2nd or 14th North Carolina, Gardner and Gibson moved west and uphill approximately 150 feet past the bend in the lane. Here, Gardner took the last image at Bloody Lane about an hour before sundown. It was at this time that Gardner and artist Frank Schell likely encountered one another.

It is important to note that in the foreground of Gardner's image, this section of the lane is very shallow, maybe a foot and a half deep. As the lane extends east toward the line of Union soldiers standing on the north bank, the lane gets deeper as it nears the bend. This section of Bloody Lane has not changed that much in appearance from how it was in 1862, unlike the setting of the two previous images. In the background of the picture, to the right and bordered by trees, is the Roulette farm lane. Notice the trees' shadows across the open field, extending uphill to the right of the lane. This is the field that the Irish Brigade marched across to attack Bloody Lane, which is off the image to the right. Notice the absence of bodies and debris on the hillside in the background above the lane and in the distant field at the right, indicating that the wounded from both sides had been removed and that Union troops had been buried by the time Gardner and Gibson arrived on the field.

One shadow of special interest is in the left half of stereo plate 565—that of Alexander Gardner himself. As he stood behind his tripod and removed the lens caps on the stereo camera, the sun cast Gardner's own bulky shadow and those of two of the tripod legs on the lip of the south bank of the lane, just above the head of the soldier lying at bottom right. Because it was late in the day, Gardner had to take the previous two images and this picture facing east, with the setting sun to his back, so it his own shadow was unavoidable. Because the image was cropped

the road. He positioned his camera where the soldier stood on the north bank in figure 6.1d I attempted to duplicate Gardner's image to study the shadow of the dead soldier lying in the lane in the foreground, closest to the camera. This shadow falls on the soldier lying to his immediate left and against the north bank of the lane. The progression of my volunteer's shadow can be seen in the three shots I took at different times. I took the first (fig. 6.2a) at 3:44 P.M. Notice the slight shadow cast from the dead soldier on the floor and bank of the lane. I took the second (fig. 6.2b) at 5:18 P.M., and it best represents the time when Gardner took his picture. The third view (fig. 6.2c) I took at 5:52 P.M., and it shows a more pronounced and longer shadow than the one in Gardner's picture.

During my work at Bloody Lane, one thing that surprised me was how of the roadbed has eroded. My pictures show that the depth of the lane presently is almost twice as deep as what it was in 1862.

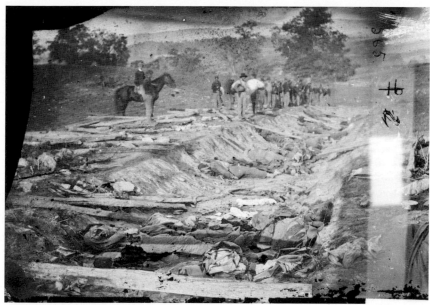

Fig. 6.3: Stereo plate 565: "View on ditch on right wing, which had been used as a rifle-pit by the Confederates, at the Battle of Antietam." Courtesy Library of Congress (B815-565 left half)

down before being sold as a stereo view, Gardner was easily able to remove his shadow. This is the first and only known image of Gardner or any other Civil War photographer caught casting his own shadow in an image taken on a fresh battlefield.

I discovered Gardner's shadow because I cast a similar shadow in my own photographs. In one, taken at approximately the same time Gardner took his photo, my own shadow takes on almost precisely the same appearance as Gardner's. Only after comparing my shots to the left side of Gardner's stereo plate did I realize that the dark area on the extreme right side of the left image was, in fact, the famous photographer's shadow.

Also of interest in the background of stereo view of plate 565 is Red Hill, the small, 1,000-foot mountain in the background. Oddly, Red Hill, which Gardner called Elk Ridge, is clearly visible in the left half

of the stereo view but is almost invisible in the right half of the stereo view (fig. 6.3a). It was at the peak of this mountain where a makeshift Union signal station was located during the battle.

It has been written that the dead soldier in the foreground at bottom right with the shadow of the fence rail running across his body is that of Col. Charles C. Tew (fig. 6.3b). This identification has been called into question by Civil War historians, and my own research leads me to conclude that it is not Tew. Colonel Tew commanded the 2nd North Carolina at Bloody Lane, his regiment's line extending east from the bend in the lane down to the intersection of the Roulette farm lane. After Brig. Gen. George B. Anderson was mortally wounded, brigade command fell to Tew. To the 2nd North Carolina's left at the bend was the 6th Alabama under the command of John B. Gordon.

After examining a crisp enlarged image of plate 565 from the Library of Congress, I am convinced this is not Tew's body. Tew went uphill in the lane behind the 6th Alabama to talk to Gordon shortly after taking command of Anderson's Brigade. According to Gordon, while he was talking to Colonel Tew behind the firing line inside the lane, both of them were hit almost simultaneously by bullets. Gordon said that the volley came from in *front* of the 6th Alabama. Tew fell with a bullet to the brain; Gordon caught a bullet in the right leg (this was first of five wounds Gordon received at the fight for Bloody Lane). While Gordon rose and continued to walk the firing line encouraging his men, Colonel Tew lay where he fell.

After examining a crisp enlarged image of stereo plate 565 from the Library of Congress, I am convinced that Col. Tew's body can be found in the middle of the lane at the feet of the soldier leaning against the north bank in the center of the image. The top of Tew's partially bald head with his very distinctive dark hairline is facing Gardner (fig. 6.3c). Unfortunately the body is covered with a blanket, hiding any distinguishable markings on the uniform that could identify this man as an officer. I believe this is Col. Tew because this is the same section of Bloody Lane, just past the bend, where Tew and Gordon were struck. There are also

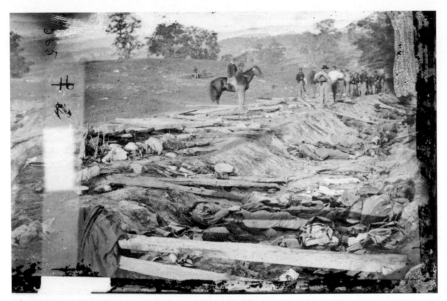

Fig. 6.3a

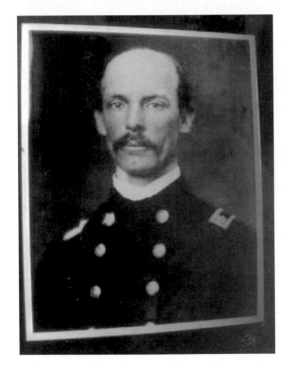

Fig. 6.3b

no other bald men in the photograph. Even though it could be argued that there may have been some other partially bald Confederates fighting in this area of the lane, however, it is the very distinct shape of the dark hairline on the side of the face and head that acts like a fingerprint. The soldier in the foreground at right leaning on the south bank has been identified as possibly being Tew, but under magnification this soldier has a full head of hair and what looks like a mustache is actually dried blood under the nose, which was almost ripped off his face from the impact of a bullet or shell fragment. One account tells of a Union soldier from the 8th Ohio who wanted a souvenir from the fight at the lane finding Colonel Tew sitting along the north bank of the lane holding a sword across his lap. The federal soldier attempted to pull the sword from the dead colonel's hands when, to his astonishment, the colonel pulled back. Either Tew was dead and this was simply a reflex, or it was Tew's last act before dying. Significant to this story, the soldier at bottom right in the image is lying on the south bank, not the north bank, of the lane where the Ohio soldier found Colonel Tew.[2]

Fig. 6.3c

Fig. 6.3d

Fig. 6.3e

Fig. 6.3f

Fig. 6.3g

I recorded my series of pictures over a two-hour time frame late in the afternoon of Sunday, September 17, 2006. From the same camera position Gardner used, at 4:40 P.M. my shadow barely touches the fence rail across the lane (fig. 6.3d). And the next three pictures I took—at 5:00 (fig. 6.3e), 5:25 (fig. 6.3f), and 5:45 P.M. (fig. 6.3g), respectively—demonstrate how the shadows from the rail and my body got longer and changed direction over time.

I took the next image at the site of plate 563 at 6:00 P.M., and it shows the south embankment completely immersed in shadow at the sites of plates 563 and 553 (fig. 6.3h). This occurred between 5:30 and 6:00 P.M. The next two pictures I took at 6:05 P.M. back at the location of plate 565 (figs. 6.3i and 6.3j). Only after 6:00 P.M. do the length of the shadow cast from the rail and my shadow begin to match those in Gardner's image. This goes toward proving that Gardner had to take the two images of the dead North Carolinians first before moving west and uphill to take the image of the dead Alabamans.

Fig. 6.3i

Fig. 6.3h

Fig. 6.3j

Fig. 6.3k

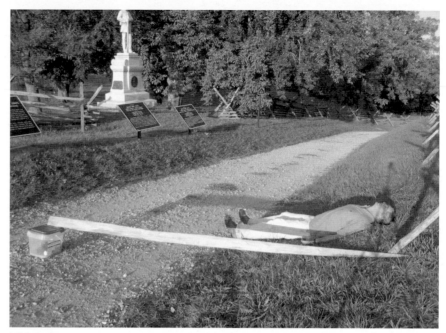

Fig. 6.3l

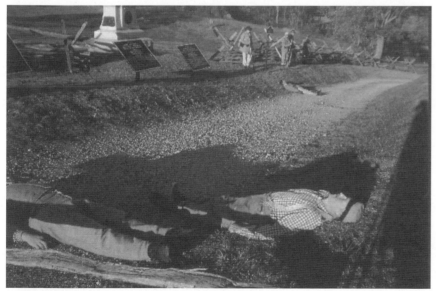

Fig. 6.3m

At 6:30 P.M. two more photos were taken at the location of plate 565 of me lying in the lane (figs. 6.3k and 6.3l). The shadow cast from my head is quite obvious, just as, under magnification, the alleged body of Colonel Tew casts a shadow from the head as well (see fig. 6.3c). As I determined, Gardner takes plate 565 between 6:00 and 6:10 P.M.

The last image of Bloody Lane shows how the Park Service has removed the trees on the north bank to return the landscaping to that of 1862. I took this photo on September 18, 2010, at 6:15 P.M., too late in the day to match Gardner's photo (fig. 6.3m). One set of shadows in Gardner's picture that helped me determine a time frame is cast by the two soldiers standing in the distance above the horse's rear, seen in figure 6.3a. In the photo, the soldier looking back at Gardner at left is easily visible because of his light-blue pants and dark coat. To the right of him is another soldier clad in dark blue who moved slightly while the image was being taken, so his figure is a little blurred.

7 ✠ Saturday, September 20
The Mumma and Miller Farms

Jonathan Gruber's *Farmers' Almanac* for Hagerstown and area, 1862

 Sunrise: 5:57 A.M. Sunset: 6:05 P.M.

Weather Channel.com, September 20, 2007, for Sharpsburg, Maryland

 Sunrise: 6:56 A.M. Sunset: 7:12 P.M.

Cloud conditions from the Frederick, Maryland, weather station, September 20, 1862,

with 1 representing clear skies and no clouds and 10 as heavy cloud cover and overcast skies

 7:00 A.M. Degree: 10 Type: cirrostratus

 2:00 P.M. Degree: 10 Type: nimbus

 Precipitation: 0

Temperature 7:00 A.M.: 62.5° 2:00 P.M.: 74°

 9:00 P.M.: 66°

The morning of September 20 dawned with Union forces on the east bank of the Potomac River across from Shepherdstown. McClellan, now aware that Lee was at Martinsburg, sent a much larger force of three brigades across the Potomac River. Lee must have been annoyed with the thought that McClellan, infamously known for being overcautious and slow, might actually pursue Lee into Virginia. Lee dispatched A. P. Hill with a larger force back toward Shepherdstown to check the federal incursion. Around noon, the two forces met. Federal forces held their ground for a while, but the number and experience of Hill's men took their toll. As the Union forces were driven back toward the Potomac, the order was issued for the withdrawal of these federal troops. What started as an orderly withdrawal, however, turned into an ugly, panicked retreat across the Potomac River. A. P. Hill drove the remaining Union forces over the cliffs along the river. Trying to swim across the Potomac, Union troops were picked off by Confederate snipers, with the bodies floating down-river. The last of the Union forces was finally safe on the east bank after 2:00 P.M., and the Battle of Shepherdstown was over.

On the morning of the 20th, Gardner had his wagon on the move at first light, arriving on top of the knoll or plateau opposite the Dunker church and the West Woods shortly after 6:00 A.M. (1862 time). Even

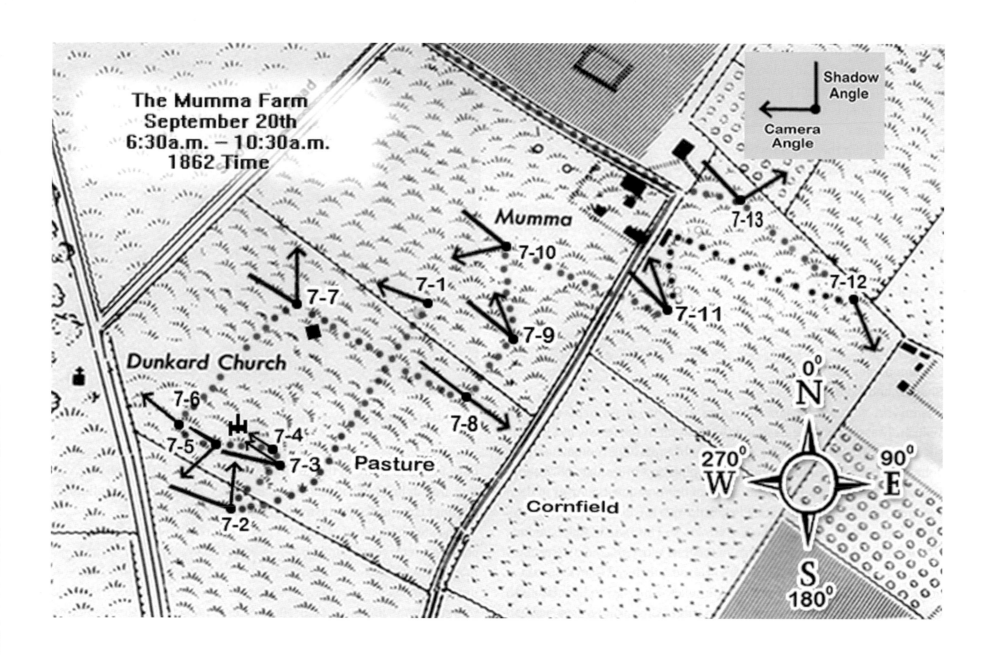

The Mumma Farm
September 20th
6:30a.m. – 10:30a.m.
1862 Time

Shadow Angle

Camera Angle

Mumma

7-13

7-10

7-1

7-12

7-7

7-9

7-11

Dunkard Church

7-6

0° N

7-5

7-4

7-8

7-3

Pasture

270° W

90° E

7-2

Cornfield

S 180°

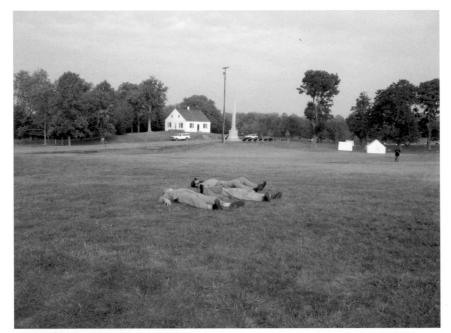

Fig. 7.3b

Fig. 7.3c

Fig. 7.3d

Original camera location: Park property; no restrictions on access to site
Gardner's 1862 photographic time: 7:25 A.M.
Modern time: 8:45 A.M., September 18, 2005
Camera angle: 300°
Shadow angle: 295°

This Gardner photograph is one of the most famous images of the Civil War. I took my first modern view (fig. 7.4a) on September 18, 2005, with the volunteers grouped as the bodies were in the original image. I undertook a more in-depth study of the illumination of the dead soldiers in a series of pictures shot on September 3, 2006. This time I had a volunteer pose every hour on the hour in front of the Dunker church so that my shots could follow the progression of his shadows. In the first view (fig. 7.4b), taken at 8:00 A.M., the volunteer lay on the ground, his head casting a long shadow on the ground and his right foot casting a shadow against his right leg. This level of detail is not evident with any of the soldiers in Gardner's image. In the background, both sides of the Dunker church and West Woods are fully bathed in sunlight in this early-morning photo. By 9:00 A.M. both the shadows cast from my volunteer's head and feet have receded (fig. 7.4c), and while the church appears the same, the trees in the West Woods have a little silhouette forming on left side of their trunks. At this moment, the illumination of the Dunker church and the trees of the West Woods closely match Gardner's, so I believe that plates 562 and 552 were taken sometime between 8:30 and 9:00 A.M., with plate 562 shot first.

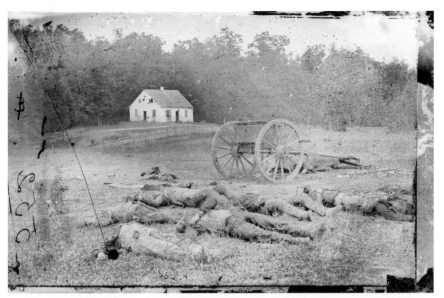

Fig. 7.4: Stereo plate 552: "Completely Silenced: Dead Confederate artillerymen, as they lay around their battery, after the Battle of Antietam." Courtesy Library of Congress (B815-552 right half)

Fig. 7.4a

Fig. 7.4b

Fig. 7.4c

Original camera location: Park property; no restrictions on access to site
Gardner's 1862 photographic time: 7:35 A.M.
Modern time: 9:00 A.M., September 18, 2005
Camera angle: 218°
Shadow angle: 296°

After Gardner exposed plate 552, he walked approximately thirty feet southwest and set up his camera facing a southwest direction to take the next image of dead artillery horses and a caisson. I took a version of this image on September 18, 2005 (fig. 7.5a). In Gardner's image, the dead horses and caisson are easily visible in plate 568, showing the close connection of this group of images. Of particular note in this view is that not only were the horses picked clean of harnesses, but the caisson has been stripped to the ground. This image was the model for a woodcut that appeared in *Harper's Weekly,* October 18, 1862. (Note that the woodcutter included the shadows of the trees on distant Hauser's Ridge across the Hagerstown Pike at the end of the West Woods [fig. 7.5b].) Again, I assign an early morning time for these pictures because of how the horses and caisson are illuminated. After developing this plate, Gardner moved down the slope and took another image of the Dunker church.

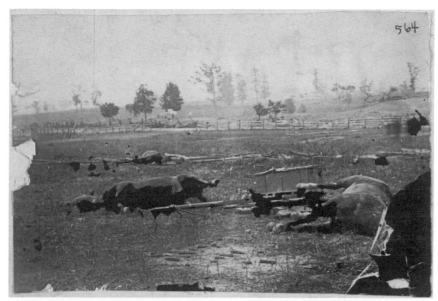

Fig. 7.5: Stereo plate 564: "Demolished Confederate Battery, near Sharpsburg, September 19, 1862." Courtesy Huntington Library, San Marino, California

Fig. 7.5a

Fig. 7.5b

Original camera location: Park property; no restrictions on access to site
Gardner's 1862 photographic time: 7:50 A.M.
Modern time: 9:10 A.M., September 18, 2005
Camera angle: 302°
Shadow angle: 297°

A photograph I took on September 18, 2005 (fig. 7.6a), best represents the time when Gardner took image 573. But the following views, taken on September 2, 2006, prove that Gardner had to have taken the Dunker church series before 11:00 A.M. DST (or 10:00 A.M. 1862 time), for beginning at about 11:00 A.M., the Dunker church, West Woods, and the dead soldiers are illuminated differently than they were in Gardner's images. A shadow cast from the roof begins to descend down the front of the church, something not visible in any of Gardner's three photos of the church (fig. 7.6b). The leaves on the trees of the West Woods adjacent to the Dunker church are still in the light, but the trunks are dark. Shadow direction is 312°. At 12:00 P.M. the trunks of the trees are in complete shadow, and the shadow cast from the roof falls about halfway through the windows across the entire front of the church (fig. 7.6c). The shadow direction is 340°. By 1:00 P.M. the entire front of the church is dark, deep in shadow, and the chimney casts a very pronounced shadow on the roof to its right. Shadow direction is now 05° (fig. 7.6d).

Under magnification, it is clear that the soldier standing next to the doorway of the church is talking to another soldier sitting in the doorway. What appears to be a shadow cast from the chimney on the left side of the roof is actually a small section of roof ripped open by a federal artillery round that cut a hole in the peak of the roof, shaving and exposing the brick on the inside of the church (fig. 7.6e).

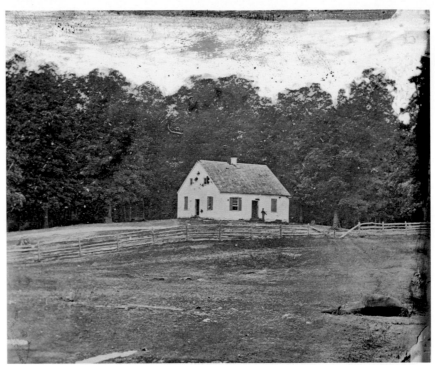

Fig. 7.6: Stereo plate 573: "Dunker Church on Battle-field of Antietam." Courtesy Library of Congress (B811-573 right half)

Fig. 7.6a

Fig. 7.6b

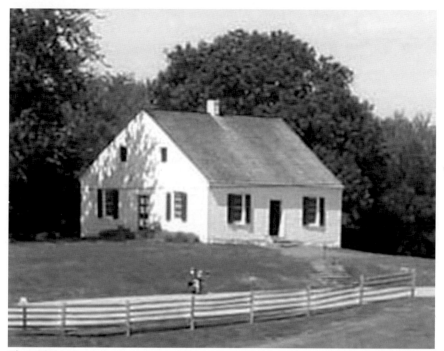

Fig. 7.6c

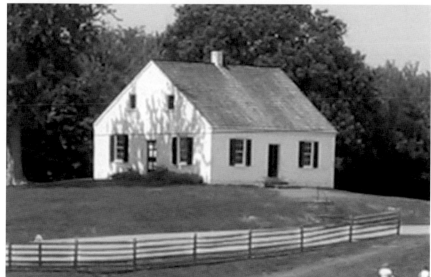

Fig. 7.6d

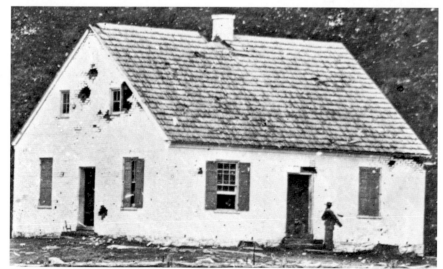

Fig. 7.6e

Original camera location: Park property; a farmed area—check with National Park Service

Gardner's 1862 photographic time: 8:05 A.M.

Modern time: 9:20 A.M., September 18, 2005

Camera angle: 0°

Shadow angle: 300°

Gardner took this stereo view just north and slightly east of where the New York Monument stands today, facing due north. The illumination on the right side of the cannon barrels and the artillerist indicates early-morning sun. Several shadows extending in a northwest direction are barely detectable underneath Capt. Joseph M. Knap's horse and the rider lying next to him and near the rump of the dead horse in the foreground. In the distant center is a tall tree next to the site of another notable Gardner photo of a dead Confederate next to the grave of Union lieutenant John Clark.

Again, I aligned my camera with the clump of trees at that site today. In posing my volunteers, I had to gauge the distance of the foreground between the camera location and the line of artillerists while at the same time making sure that my volunteers' heads lined up with the contour of the terrain behind them in the middle distance. This picture, which I took on September 17, 2005, at 9:18 A.M., represents the left half of the original stereo view. The volunteer at the far left in my picture (fig. 7.7a) is standing approximately where the left wheel of the third cannon from the right is located (gun 4).

The date of this photograph, September 20, 1862, is established in the diary of Sgt. David Nichol, a member of Knap's Battery. Sergeant Nichol served in Independent Battery E, Pennsylvania Light Artillery, under the command of Joseph M. Knap (fig. 7.7b). I have no doubt of the diary's authenticity, even though Nichol used a blank diary volume printed for 1863 to record his entries for 1862. I surmise that the original diary must have been damaged, and to save his memoirs, Nichol simply copied the text from his original 1862 diary to an 1863 one. I

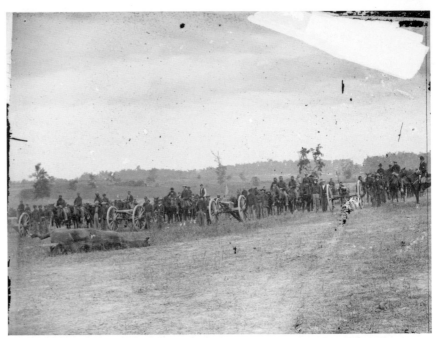

Fig. 7.7: Stereo plate 577: "Captain Knapp's Battery, Pennsylvania Artillery (Bank's Corp) on Battle-field of Antietam." Courtesy Library of Congress (B811-577 left half)

Fig. 7.7a

have transcribed the following entries from the five days that Sergeant Nichol spent in the vicinity of Sharpsburg.

Tuesday Sept. 16th: Marched in mourn—firing could be heard very near. The Rebs were some eight miles from us. Our advance were still driving them. Prisoners still kept coming in. I saw about 30,000 thousand of our men in a large field ready to move ahead. We marched over to the right and were ordered to be ready at any time during the night.

Wednesday Sept. 17th: This was a memorable day that will be recorded in the annals of history, the Battle of Antietam. Moved in mourn at 2 A.M. The enemy opened on our men, the firing was very heavy, the musketry was awful. We went in action about 8 A.M. amidst a heavy storm of bullets by the enemy sharpshooters. Our section was ordered to another position more to the right. After firing a few rounds, were ordered to another position in the woods out of which our infantry had driven the enemy. We had merely got in place and were about unlimbering for action when a Rebel brigade opened on us, the bullets came around us like hail. We lost one gun here and six horses, we also had four men wounded and one killed. We went off the field, shortly after joined the rest of Battery with remaining gun and after firing a few more rounds here, the battery was ordered off the field to rear to fill our empty chests with ammunition, here we camped for night.

Thursday September 18th: Left camp in mourn [*sic*] and took a position near front ready to move at short notice. Nothing transpired during day, both parties seemed satisfied to suspend hostilities. It was reported the enemy had crossed the river into Dixie, camped for the night.

Friday September 19th: The Rebs had left for sure, our advance closely pursuing them. We moved about three miles, this brought us on one part of field contested by our corps, the sight was awful, men strewn the ground, mutilated in every manor and form, there must have been 2 dead Rebs to every 1 of our men. We camped here for the night.

Saturday September 20th: Moved in mourn, we were about going off Battle-field when we were halted by an artist to take our picture, we

Fig. 7.7b

unlimbered and came to action front. We came through Sharpsburg, a great many of the houses were pierced with cannon ball. We took off the pike and struck on the road for Harpers Ferry. Camped for night, made some 12 miles.

Knap's Battery served with great gallantry and distinction during the battle. Emerging from the southern end of the East Woods, the full battery of six rifled guns went into position in the clover field between the East and West woods around 8 A.M. Their original position was on the north side of the Smoketown Road on Miller farm property. To Knap's

right in the clover field was Cothran's New York battery. To Knap's left, across the Smoketown Road on Mumma property, was Hampton's Pittsburgh battery. Confederates who made several attempts to capture the battery were met with canister, and the attacks were beaten back. Shortly before noon, one such attack was in turn repulsed by a bayonet charge by the 3rd Maryland Volunteers, driving the Confederates back past the Dunker church and through the West Woods. At 12:00 P.M., two guns (1 and 2) from Knap's Battery under the command of Lieutenant McGill were ordered forward by General Greene to assist Colonel Tyndale in the West Woods. The two guns were deployed near the intersection of the Smoketown Road and the Hagerstown Pike, just across the Smoketown Road near where the Maryland Monument stands today. Gun 2 was ordered into the woods; after unlimbering, it was hit by a destructive fire from the Confederates. One crew member and four horses were killed, and four men were wounded, forcing the artillerist to abandon the gun. The other gun returned to its original position, rejoining the battery in front of the East Woods. Whether Sergeant Nichol was with gun 1 or 2 is unclear. Captain Knap eventually withdrew from the field around 3:00 P.M. after depleting his ammunition. On the 19th, Captain Knap replaced the gun the battery lost in the West Woods with an iron twelve-pound howitzer and caisson abandoned by the Rebels on the battlefield.

Shortly after Gardner took his final image of the Dunker church, he and Gibson approached a Union artillery battery parked on the Mumma farm adjacent to the Smoketown Road. As Sergeant Nichol wrote, it was in the morning, when the battery was ready to leave the field, when the two artists asked the battery to pose. After getting the commander's consent, the photographers sensitized the next stereoscopic plate while the battery lined up with the gun crews next to their three-inch ordinance-rifled Parrot cannons. They took this image on the field of battle within a few hundred yards of where the battery served so bravely just three days earlier. The battery was stationed at one time in the field just above the cannon at far right of the stereo view, between the Smoketown Road and the Miller cornfield.

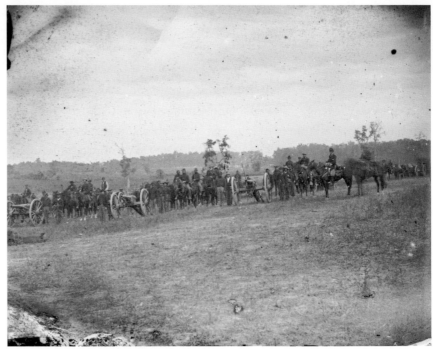

Fig. 7.7c

It is unfortunate that Sgt. Nichol is not present in Gardner's image. Facing the battery, guns 1 and 2 are completely out of the viewer's sight at far left. In Gardner's stereo view, only four of Knap's original six artillery pieces are in view (guns 3–6, from left to right). In the right side of the stereo view (fig. 7.7c), Captain Knap is mounted on horseback to the right and facing west. To his right is another mounted officer who is slightly blurred because the horse and rider moved. To their right is a caisson with the East Woods looming behind.

Gardner took this picture while burial details were cleaning up the last remnants of the Rebel dead on the Mumma and Miller farms. Gardner not only recorded a remarkable portrait of Knap's battery and the men who served in it, but both halves of the stereo negative, which still exist, reveal fascinating information that is not easily visible to the naked

eye but is evident when the highest resolution digital scans of the twin images at the Library of Congress are downloaded and examined in the extreme zoom mode, as if under a magnifying glass. The photographs reveal nothing less than a vast panorama of the northern section of the Antietam battlefields, particularly the open fields between the East and West woods that were so hotly contested and traded back and forth during the action on the morning of September 17.

In zoom mode, Union soldiers can be seen in the distant Miller clover field above and between the heads of the artillerists of Knap's Battery. Of particular note is a Union burial detail at work in the field above the second cannon from the right (gun 5) immediately to the right of the flag pennant. High magnification of the burial detail shows several soldiers looking at two Union soldiers, one kneeling on the ground and the other bent over, as if placing a dead Confederate into a grave (fig. 7.7d).

Though not shown, high magnification also revealed that to the right of the burial detail are Confederate bodies scattered in the field. Two other Union soldiers are standing far off in the Miller pasture, to the left of the hat of the artillerist standing directly behind the right wheel of the first cannon to the right (gun 6). These two soldiers are also standing next to another Gardner camera site, stereo negative 569, which is the picture of the rock outcropping located next to what is today called Cornfield Avenue (see fig. 7.15).

Gardner took three other images later in the Miller field shown behind Knap's Battery. The photo location of stereo negative 558, the image of a dead white horse that Frassanito identified as possibly being the mount of Confederate colonel Henry B. Strong, is blocked from view by the artillerists to the right of the first cannon (gun 6; see fig. 7.23). What I believe to be the location of the two Confederate bodies in plate 555 is blocked from view by the blurred horse and rider to the right of Captain Knap (see fig. 7.14).

Just above the second cannon from the right (gun 5) stands a tall tree in the middle distance. This is the site of Gardner's photograph of a dead

Fig. 7.7d

Confederate lying next John Clark's grave (plate 551; fig. 7.16). The tree that stood in 1862 next to Clark's grave no longer exists, but presently a large clump of trees stand within fifty feet of the tree in Gardner's image. The tree next to Clark's grave and the cluster that grows there today are part of an east-to-west brush line that existed in 1862 and is still there today. The thick tree line that runs north and south and intersects with the brush line at left in my photo was not there at the time of the battle. In Gardner's image, this tree line consists of four trees along the same line as the present-day trees; perhaps some of these small trees from 1862 might still be growing there today. One of these trees, the one above the fourth cannon from the right, is close to the Smoketown Road and is the one protruding above the caisson in plate 568.

Original camera location: Park property; no restrictions on access to site
Gardner's 1862 photographic time: 8:25 A.M.
Modern time: 9:45 A.M., September 2, 2006
Camera angle: 110°
Shadow angle: 303°

As Knap's Battery had limbered up preparing to leave the field, the burial details on top of the plateau resumed interring the dead, and Gardner looked for another photographic opportunity. He may have already spotted it as he took the photos of the Dunker church and Knap's Battery. Down the hill to the east, about two hundred yards away in the Mumma swale near the farm lane, was a cluster of bodies gathered together for burial. He moved down the slope, faced his camera east, and centered the focusing frame on this group of bodies. This photograph, stereo negative 550, became the first image in his catalog of the Antietam series.

Although the caption misdates the photo as September 19 instead of September 20, I believe Gardner's identification of this group as Union soldiers is accurate, making this the first photograph of Union soldiers ever made on a battlefield. The color of the uniforms and the eagle plate on the soldier at far right are evidence that these are Union soldiers gathered for burial. Some of the bloated bodies must have been badly torn up, as indicated by how they were moved: These soldiers were dragged to this spot on blankets that are visible underneath some of the dead. One object on the ground that caught my eye lies underneath the soldier on a blanket in the middle of the cluster. Lying on his back with his knees bent, he appears to have the handle of an ax protruding from underneath his back. An ax may have been used in moving the bodies, which was done at the Wise farm after the Battle of South Mountain.

The location of this image remained unknown even after Frassanito's exhaustive study. But I have firmly established the site of this photograph as a spot about seventy-five feet west of the Mumma farm lane alongside a natural wash. I base this on my visual comparisons of the geographic

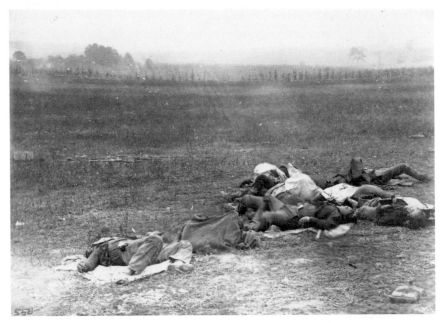

Fig. 7.8: Stereo plate 550: "Group of Irish Brigade as they lay on Battle-field of Antietam, Sept.19, 1862." Courtesy Library of Congress (B811-1290 left half)

details and examinations of the cornfields on the battlefield at the time of the battle, since the image shows a cornfield. Over a thirteen-year period, I visited every cornfield location on the battlefield proper and explored each one thoroughly. Of the six cornfields north of Sharpsburg, and including the Piper Farm at Bloody Lane, only three large cornfields had any Federal incursions in or near them that resulted in substantial casualties on the battlefield. I determined that only one cornfield on the entire battlefield matches the one in Gardner's image—the Mumma cornfield (behind the park's visitor center).

With the Irish Brigade mentioned in Gardner's caption, the most obvious cornfield would have been on the Piper property that bordered Bloody Lane. But after exploring the whole perimeter of the Piper cornfield, nothing matched the contour of the land shown from Gardner's

camera position. I quickly ruled out the Miller cornfield, because any vista facing east, north, or west would have included in the background one of the three large wooded areas in the vicinity—the East Woods, West Woods, or North Woods. And a southern view from the northern edge of the Miller cornfield provided no match either.

Since Gardner photographed most, if not all, of the dead on September 19 and 20 north of Sharpsburg, these cornfields would have been the prime candidates for such a camera location. Three other cornfields on the northern part of the battlefield—the Nicodemus cornfield behind the northern portion of the West Woods, the Roulette farm's cornfield, and another at the northeast corner of the East Woods—I immediately ruled out as well, since none comes close to matching the contour of land or shape of the cornfield in Gardner's image.

That left three cornfields south of Sharpsburg and the Boonsboro Pike that had combat in or near them: one on the Sherrick farm and two on the Otto farm. Again, I ruled out these three because they do not match the shape of the cornfield and contour of land in the Irish Brigade picture. Because Gardner did not begin work on the southern part of the battlefield until a few days after the battle, finding a large group of Union troops near one of these cornfields south of the Boonsboro Pike would be highly unlikely, since Union troops were buried first, and quickly.

From the illumination of the bodies in plate 550, and my own shadow studies at the site I identified, I was able to determine that the image was taken at about 9:25 in the morning. The soldiers' faces, arms, and legs are in silhouette, just as they are in Gardner's image. Unfortunately, the rising morning sun blows out the background of the image, almost eliminating any details that would help reveal its location. The time when Gardner takes this shot fits precisely into the crucial sequence of the photos Gardner took on September 20, starting with the photos taken on top of the hill near the Dunker church and continuing as he made his way through the Mumma swale to the Mumma farmhouse.

When I first began to photo document my suspected site with volun-teers, I realized that I was too far away from Gardner's spot, as is evident in the picture I took on September 18, 2005, at 9:30 A.M. (fig. 7.8a). The next photo, which I took at 10:45 A.M. on September 3, 2006 (fig. 7.8b), is a little closer to the Mumma farm lane but is still not in proportion with regard to terrain. My version, taken on September 2, 2006, at 9:45 A.M. (fig. 7.8c), best portrays the actual camera location with the planes of field in proportion to each other. Unfortunately, the weather did not cooperate that morning, and lighting conditions were less than perfect.

Gardner's Irish Brigade photo shows three planes of fields in the image. The first is a bowl-shaped grass pasture in the foreground with the cluster of soldiers. The second is a large cornfield with a distinct shape. The leading edge of the corn in front of the photographer follows the contour of the grass field in the foreground, with a low spot in the center of the image where the corn appears sparse and gaps appear in

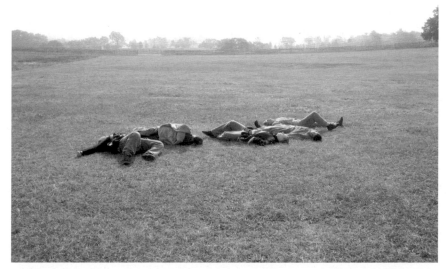

Fig. 7.8a

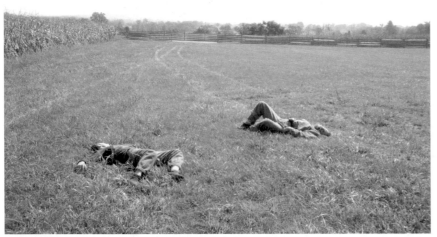

Fig. 7.8b

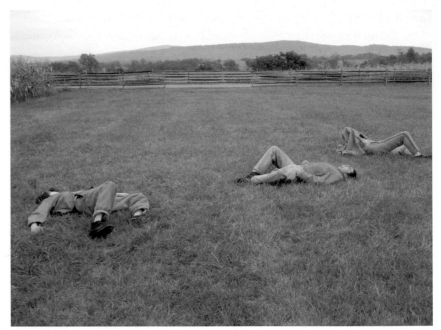

Fig. 7.8c

the otherwise uniform rows of corn. Also, the stalks of corn abruptly descend from both sides toward the center of the dip, suggesting that there is a drop-off at this spot. Under magnification, looking into the rows of corn, I can see that the cornstalks run steadily downhill, away from the viewer, until halfway into the field, where they abruptly change direction and run sharply uphill to the back edge.

Barely visible and almost blending into the cornstalks are fence rails running horizontally in front of the bottom half of the cornstalks. I do not believe these horizontal lines in front of the cornstalks are anomalies or defects in the image, because they follow the shape of the land in front of the corn too closely and are too symmetrically aligned. Also, these rails can be seen in both half of the stereo image, ruling out the possibility that these were lines created in the developing process. The rear of the cornfield also has a very distinct shape. The back edge runs

horizontal in the image from the trees at left until it suddenly slopes down toward the right side. The tall cluster of trees at left at the back of the field could be part of a woods or part of a tree line bordering fields or a farm lane. Very faint in the background, just above the cornfield, is the third plane, a distant ridge crowned with a tree line gradually running upward to the right side of the image.

The first plane, the grass field in the foreground of my image, follows the same bowl-shaped contour seen in Gardner's image. Unfortunately, corn growing on the left side of my picture obscures the slope of the land extending left along the Mumma farm lane. Out of view and behind my camera position is a significant change to the original lay of the land: The National Park Service has cut a section of land out of the hillside for water drainage and erosion control. Gardner's camera position was about seventy-five feet from the cornfield looking east. Separating the

first and second plane is the now-paved Mumma farm lane located between the post-rail fences in front of the corn. In 1862, this was a recessed dirt farm lane and so was not distinguishable at the base of the corn in Gardner's image. Depending on camera height and angle and the height of the grass, the park's raised black-top road even today can be completely obscured.

The second plane in my photograph is the Mumma cornfield, which has the same contour features found in Gardner's image, from the bowl-shaped leading edge of corn to the distinct shape of the back edge of the field to its slope to the right. Looking into the cornfield, the corn runs downhill halfway into the field, where it then rises sharply to the back edge.

In 2006, for the first time since I undertook my studies in earnest, the field in the background of my photographs became a cornfield again—just as it was in 1862. And in September 2006, when the corn was full-grown, I observed and documented that the corn in the background of my images was growing precisely as it did in the background of Gardner's 1862 image. While most battlefield image locations are precisely determined by identifying a boulder or some other permanent object that exists in both the vintage and modern photos, this is the first time that a then-and-now agricultural element—in this case corn—has been used to help establish a photo location.

In Gardner's photo, the cornfield dips from both the left and right sides of the image toward a low spot in the center of the photograph. On both sides of that low spot, the corn grows uniformly (although the section on the left may show some battle wear and tear). But at the center of that low spot there are gaps in the corn. Only a few stalks are evident, and the rows are not uniform here. This was also the case in 2006, when corn grew in that same field: The corn grew in uniform rows in that field except for the low spot in the center of the image, where only a few stalks grew, creating the appearance of gaps.

The reason the corn won't grow here now, just as it didn't in 1862, became apparent when I walked up and looked at the spot. There is a natural wash that runs through this part of field and stretches downhill away from the camera and through the cornfield. At this low spot in the Mumma farm lane, there is a three-foot vertical drop on the east side of the lane. From this drop, the wash forms a shallow V and runs downhill into the middle of the field. Today, a drain pipe runs underneath the paved Mumma lane, which is part of the drainage system that the park installed to check erosion. The frequent presence of water running through this wash still inhibits the growth of corn here (or any other crops, for that matter), just as it did in 1862. Even with normal precipitation, this wash area—about twenty feet wide and extending down into the middle of the field—stays waterlogged or marshy most of the year, preventing crops from growing in this area. This explains the sparseness of the corn at this spot in my picture as well as in Gardner's. In 2007 this area was planted with beans, and just as with the corn the

Fig. 7.8d

year before, beans did not grow in this marshy area, as is even more evident in my 2007 bean field picture (fig. 7.8d).

In my picture, just above the volunteer soldier and behind the cornfield at far left, is a large tree that marks the back corner of what I believe to be the location of the cluster of trees seen in Gardner's 1862 image. More than likely this tree was one of those in Gardner's picture. To the left of these trees, and just out of view, are the Roulette house and farm buildings. In the middle background on the right side, behind the cornfield, are trees lining the west side of the Roulette farm lane until they intersect with Bloody Lane. Trees are also visible at this spot in Gardner's photo, and they could be some of same trees along the Roulette farm lane in the background of stereo negative 565.

A scanned eight-by-ten-inch glossy print from the Library of Congress of the right half of stereo negative 550 reveals a ridge or mountain in the background. The background was enhanced by darkening the image, which revealed the distinct shape of a tree-lined ridge with its discernable humps rising to the right above the cornfield. At the far right side of the image on the ridge line is a small knoll or hump with a cluster of tall trees. There is today a cluster of trees growing in this same area that is visible just to the left of the observation tower at the end of Bloody Lane in the modern picture. This third plane in the background is the hillside from which the Irish Brigade advanced onto Bloody Lane.

However, when I stand at my photographic site for plate 550, just west of the Mumma farm lane, and look east, as Gardner's camera did, a fourth linear plane is visible. Red Hill, a 1,000-foot mountain about two miles east of my location, looms ominously in the background. But there are only three planes visible in Gardner's image. As those who have questioned my plate 550 location are quick to point out, Red Hill is not visible in the background of the image but seemingly should be. The grass field and cornfield are easily distinguishable and account for two of the planes. The hillside from which the Irish Brigade attacked matches the contour and slope as the third plane in Gardner's enhanced image. So what happened to Red Hill in Gardner's background? In a

few other of Gardner's Antietam pictures, Red Hill is obvious in the background, so why not in this image?

What I discovered is that atmospheric conditions at certain times can

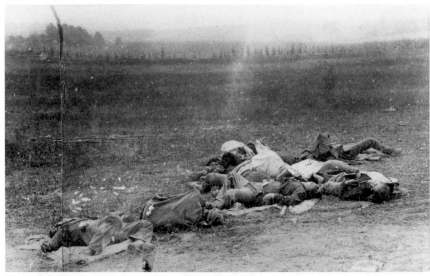

Fig. 7.8e

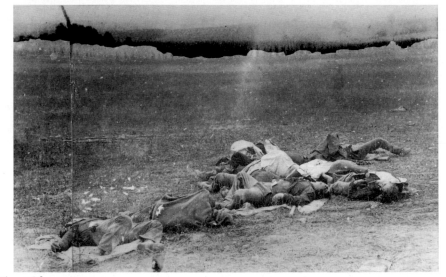

Fig. 7.8f

simply make Red Hill disappear. Several factors and combinations can contribute to this, such as early morning fog rising from Antietam Creek, glare from the rising sun on the camera lens, and something as technical as the reflective properties of chlorophyll in the composition of leaves that can deflect or reflect sunlight. In my ten years spent photographing this site, out of the more than 200 hundred photos, Red Hill is visible in only about half of them. For example, when I was photographing this site on the mornings and early afternoons of September 2 and 17, 2006, I took thirty-seven images at the Mumma cornfield in both black and white and color. Of those thirty-seven pictures, Red Hill was completely invisible in eighteen of them. This is what happened when Gardner took

his picture of Union dead on the 20th. Red Hill is not visible in two of my modern pictures I present here. As I mentioned earlier in discussing plate 565, in the right side of the stereo view, Red Hill is missing above the ridge, though it is visible on the left side of the stereo view (see fig. 6.3a). This anomaly occurs in another view, too. In the left half of stereo plate 588, taken at the O. J. Smith farm, part of South Mountain should be visible to the left of the trees on the ridge in the background but is missing (see fig. 11.1).

One other aspect of this photograph needs to be examined in detail—the absence of a post-rail fence along the Mumma farm lane in Gardner's image. Maps of the battlefield show the entire Mumma lane as lined on

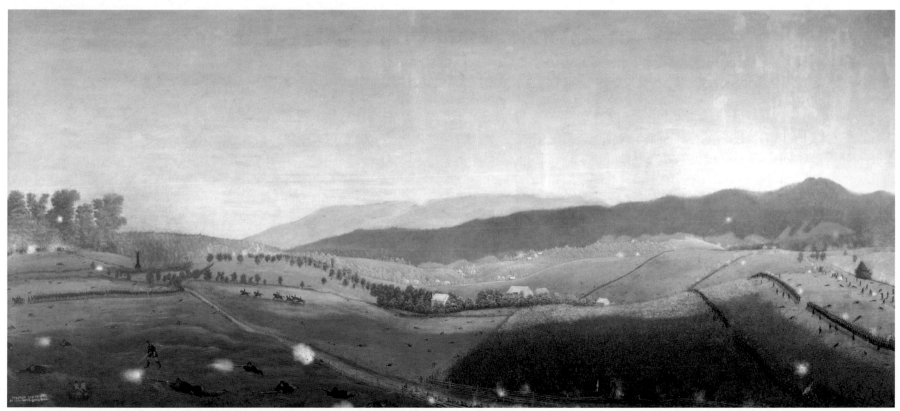

Fig. 7.8g: "A Fateful Turn." Painting by Capt. James Hope. Courtesy Antietam National Battlefield

both sides with post-rail fencing. In Gardner's image of the remains of the Mumma house, however, a post-rail fence bordering the farm lane enters the image from the left side (see fig. 7.11). The only sketch or illustration of this section of the Mumma farm lane that I have found appears in veteran Capt. James Hope's painting depicting the fighting in the Mumma swale (fig. 7.8g). In Hope's painting, a post-rail fence borders the Mumma farm lane on both sides. Although it does not continue along the entire lane, the National Park Service has erected a section of post-rail fencing on both sides of the lane, which is clearly seen in front of the cornfield in my pictures. This post-rail fencing should also be visible in Gardner's image but is not. This initially caused me to question whether I had found Gardner's camera site for plate 550. However, an in-depth study of Gardner's image of the Mumma house eventually led me to question the accuracy of Hope's painting as well as the cartographers' mapping of only the Mumma farm but other areas of the battlefield as well.

Since Hope and the cartographers documented the battlefield after the war, we must ask how much of the Mumma farm lane actually was bordered by post-rail fencing on both sides during the battle. In Hope's painting, which shows the action in the Mumma swale, fencing borders both sides of the lane in front of the cornfield extending all the way back to the burning Mumma house. But Hope mistakenly has the lane going to the left of the house, where the present paved park road runs. The main farm lane at the time of the battle actually ran to the right of the Mumma house (today a private access road for park vehicles).

Almost all of the topographic maps I have seen of the Mumma farm lane show a post-rail fence bordering both sides of the lane from Smoketown Road to Bloody Lane. But in Gardner's picture of the Mumma farmhouse and buildings taken only three days after the battle, there is a discrepancy in how much of the lane actually had post-rail fencing on both sides. Gardner's picture has fencing bordering both sides of the lane from the left side of the image to the missing section of fence where the soldier is standing. Because it is out of view, how far south along the Mumma farm lane did this double post-rail fence line extend? In

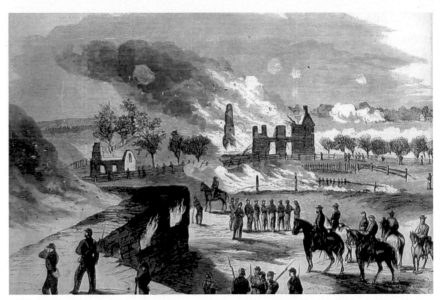

Fig. 7.8h: "The Battle of Antietam—Burning of the Mumma's house and Barn," Alfred R. Waud, *Harper's Weekly*, October 11, 1862. From the collection of Bob Zeller

the Mumma house view, from the gap in the fence heading toward the burned-out springhouse at right, the lane is now bordered on only *one* side by post-rail fence. Just past the springhouse, the lane and fence bend abruptly at a ninety-degree angle and continue to the Smoketown Road. Under high magnification, this section of the fencing can be recognized behind the ruins of the Mumma house. This rail fencing running along only on one side of the lane also appears in an illustration made during the battle by artist Alfred Waud. Waud drew his sketch from a point near the burning Mumma barn, almost face to face with Gardner's camera position from the opposite side of the Mumma house (fig. 7.8h).

Another discrepancy in Gardner's image when compared to sketches of some of the cartographers is the picket fencing that bordered the Mumma orchard behind the springhouse. Some cartographers have converted the picket fencing to post-rail fencing. Another misconception

is that the fencing bordering the Smoketown Road was a post-rail fence of the same stout construction as the fence that bordered the Hagerstown Pike. In the enlargement of the Knap's Battery image, the fence above the artillerist is not the same type of post-rail fencing seen along the Hagerstown Pike and is the type commonly referred to as Virginia worm fence. Examining Schell's sketch under magnification, this same type of fencing can be seen along the Roulette farm lane where it intersects and forms the T with Bloody Lane (see fig. 3.1).

I also cannot find any concrete proof in the *Official Records* or in any of the diaries from the soldiers that the *entire* Mumma lane was bordered by post-rail fencing at all. The cartographers were not exceptionally accurate by any means, as I have found out. There are many accounts of a fence along the Mumma lane but none specifically identifying what kind of fence it was and whether it bordered both sides of the lane. In Gardner's image, along the entire edge of the cornfield, the bottom half of the stalks are not visible, being blocked out by a low fence. Illuminated more than the bottom rails, the top rails of this fence line, clearly visible halfway up the stalks, run horizontally. Gardner's picture shows fencing at the left side of the image in front of the corn, with several rails scattered on the ground and some that were knocked off or dislodged and are leaning along the fence. This fencing resembles the same type

of low worm fence that appears in the images at Bloody Lane. At the time of the battle, sections of the Mumma farm lane were undoubtedly bordered by post-rail fence. But exactly how much of the lane during the battle was post-rail is not known. The Mumma family rebuilt the house and farm buildings in 1863. More than likely the post-rail fence along the entire lane was rebuilt at this time as well.

In establishing the Mumma cornfield as the location of Gardner's image 550, the question remains: Who are the dead Union soldiers? They obviously cannot be from the Irish Brigade, for the Irish Brigade attacked Bloody Lane more than 400 yards away from this camera position. It is possible that when Gardner was in the Mumma swale, he might have been informed that the Irish Brigade advanced on Bloody Lane through the fields from the Roulette house at left to Bloody Lane at right. This is correct, but they marched on the slope behind the cornfield, not the area in the foreground or through the cornfield. Union general Max Weber of French's division attacked Bloody Lane through the cornfield and was engaged with John Gordon's Alabamans at the lane. Most of Weber's casualties, including Weber himself, fell in front of Bloody Lane, not in the cornfield. I believe that the dead here were from Greene's division or from other federal units, who were struck down as they crossed through this area in their frontal assault on Bloody Lane.

Original camera location: Park property; farmed area—check with National Park Service
Gardner's 1862 photographic time: 8:40 A.M.
Modern time: 10:00 A.M., September 18, 2005
Camera angle: 340°
Shadow angle: 312°

After taking a single image of the Union dead, Gardner and Gibson made their way in the direction of the Mumma farmhouse, knowing that they would soon need to replenish their water supply. For up on the hill across from the Dunker church, they would not have a source of water other than what they carried in the wagon. They could go back to Antietam Creek, but that would waste valuable time, and a cleaner and better source of water would be from a farmhouse well. Along the way to the Mumma house, Gardner took two more pictures of dead Confederates on the hillside, just north of my location for plate 550. The first is stereo plate 554, showing a lone dead Rebel soldier; the second, stereo plate 557, shows a long line of bodies ready to be buried.

Frassanito recognized that the two images are related, which in turn led me to discover the previously unknown precise camera position of plate 554 and to figure out the order in which these two images were recorded. At the extreme top of image 554 is a line of bodies that runs uphill to the left in the background. Frassanito points out the various shadings of light and dark patterns of the uniforms in this line and how they match the shading pattern of the uniforms in plate 557.[1] The position and shadings of one body in particular, the last soldier at the extreme far right in plate 554, matches the shadings of the soldier closest to the cameraman in plate 557. His legs and feet go to the right, while the upper torso and head touch the next soldier to his left. The soldier closest to Gardner in plate 557 is placed almost perpendicular to the row of bodies behind him. One may conclude, then, that this is the same dead soldier in both photographs and that this soldier was instrumental in establishing Gardner's camera position for plate 554.

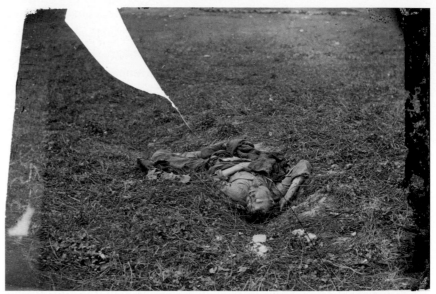

Fig. 7.9: Stereo plate 554: "He Sleeps his Last Sleep: A Confederate Soldier, who after being wounded, had evidently dragged himself to a little ravine on the hillside, where he died." Courtesy Library of Congress (B811-554 left half)

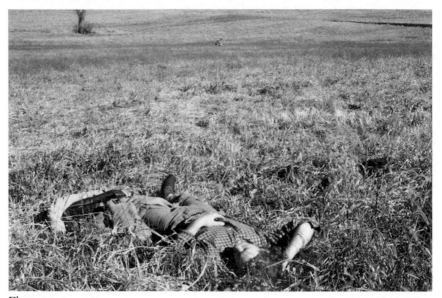

Fig. 7.9a

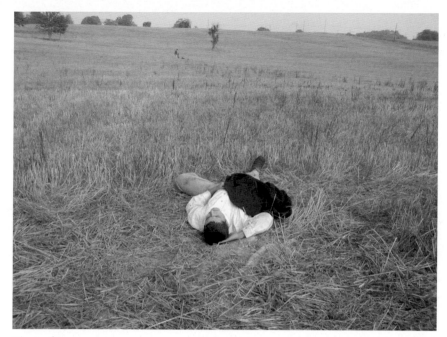

Fig. 7.9b

for this picture, I relied on the movements of Gardner and Gibson en route to the Mumma farmhouse. Knowing that the camera was placed between the Irish Brigade photo (plate 550) and the line of soldiers (plate 557), I figured that the lone soldier picture was probably taken fifteen minutes before plate 557. In the black-and-white glossy I took on September 19, 2004, I posed the volunteer in a slight depression on the hillside in the background directly above his right hand; I had another volunteer kneeling in the grass where the line of bodies was located (fig. 7.9a). I duplicated this scene with a digital image I took on September 18, 2005, to include more of the landscape of the image site. The Smoketown Road is at the top of the ridge in the background (fig. 7.9b).

I found the photographic site of plate 554 only after posing volunteers at the site of image 557. In September 2004, using Frassanito's location of Gardner's view of image 557, I posed one volunteer to represent the last soldier in line, just as in Gardner's picture. Once I did this, it became obvious that Gardner had to take the picture of the lone Confederate soldier from a point somewhere to the left of the soldiers in plate 557. I walked away and uphill from my volunteer until I came to a spot below the gravesite of John Marshall (see fig. 7.1). With the volunteer lying on the ground off in the distance to the right as a marker, I narrowed possible camera positions. At one spot, I found a small depression in the ground and had another volunteer lie in it.

Gardner's image of this lone soldier shows plenty of sunlight, but no telltale shadow is cast from the soldier, or any other object, that would indicate a time when the shot was taken. In coming up with a time frame

Original camera location: Park property; farmed area—check with National Park Service

Gardner's 1862 photographic time: 8:55 A.M.

Modern time: 10:05 A.M., September 18, 2005

Camera angle: 254°

Shadow angle: 315°

Gardner and Gibson then moved downhill to take their next image, one of a long row of dead Confederates. This photographic position is about halfway between where today are the New York Monument near the Visitor's Center and the Mumma farmhouse. These Rebel dead had been placed shoulder to shoulder in a neat V-shaped line, with their heads pointing to the left and their feet to the right, with the exception

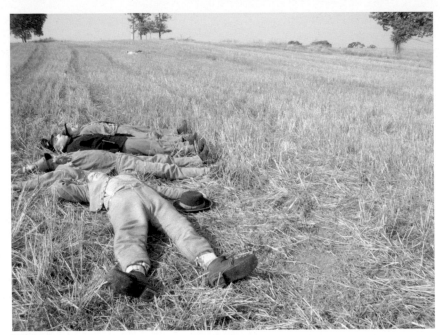

Fig. 7.10a

of the soldier closest to Gardner. On September 18, 2005, I attempted to duplicate this scene with a volunteer, in particular trying to recapture the shadow falling on the left thigh and the shadow cast by the feet. Unfortunately, my camera location and the line of bodies are slightly off (fig. 7.10a). I attempted to correctly duplicate this picture multiple times over the last five years but was foiled by crops growing in this field.

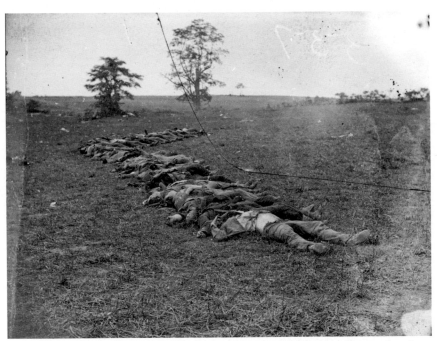

Fig. 7.10: Stereo plate 557: "Gathered Together for burial: After the Battle of Antietam." Courtesy Library of Congress (B811-557 left half)

Original camera location: Park property; farmed area—check with National Park Service
Gardner's 1862 photographic time: 9:15 A.M.
Modern time: 10:30 A.M., September 17, 2003
Camera angle: 340°
Shadow angle: 317°

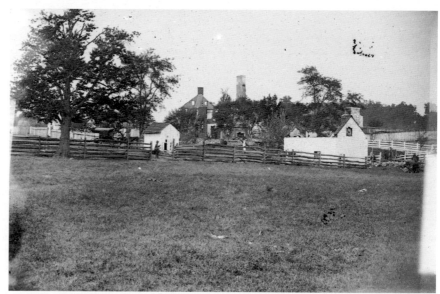

Fig. 7.11: Stereo plate 574: "Ruins of Mumma's House on Battle-field of Antietam." Courtesy Library of Congress (B815-574 left half)

Samuel Mumma's house, barn, and springhouse were all torched as Confederate forces abandoned their positions around the farm buildings. They did this to deny Union sharpshooters any high vantage point from which to pick off Confederate officers and soldiers. Six soldiers from the 3rd North Carolina carried out the orders issued by Brig. Gen. Roswell Ripley. The house was gutted, only its brick walls and chimneys left standing. The appearance of the present-day house has changed from the original, though the brick walls and two chimneys have been incorporated into the newer structure. The old barn burned down to its stone foundation; the new barn sits on the original site. Out of view in Gardner's picture, the barn would have been to the right of the springhouse chimney. Appearing the same as it did during the battle, the springhouse is one of the only original Mumma farm buildings standing today. Above the roofless springhouse, facing Gardner's camera position, is the spot where Waud sketched the burning Mumma house and barn. Frassanito analysis of this image noted that Gardner's darkroom wagon is parked near the ruins of the house.

I have established the time Gardner took this photo at about 10:30 A.M. I determined this by matching the direction of the shadow cast from the soldier standing near the gap in the fence in Gardner's image with the shadow cast from a tree in a picture I took on September 17, 2003 (fig. 7.11a). In my photo, the illumination of the fence rails, the springhouse chimney, and the tree at left match the illumination and shadows in Gardner's picture. By 12:30 P.M., the rails on this side of the post-rail fence are in silhouette. It is important to remember that in Gardner's picture that there was no longer a roof on the springhouse to cast a shadow against the side of springhouse, as there is in the modern photo.

It seems that the battle might have caught the Mumma family in the act of sprucing up their property that September—with the possibility that they may have been building the post-rail fence just prior to the battle. From the tree at left to the springhouse, the fence is natural wood. But from the springhouse and beyond the sharp bend, the fence is painted white on both sides, as were all the picket fences. The Mummas lost everything during the battle when Confederates destroyed their house and other farm buildings; they were never reimbursed by the U.S. government for their losses.

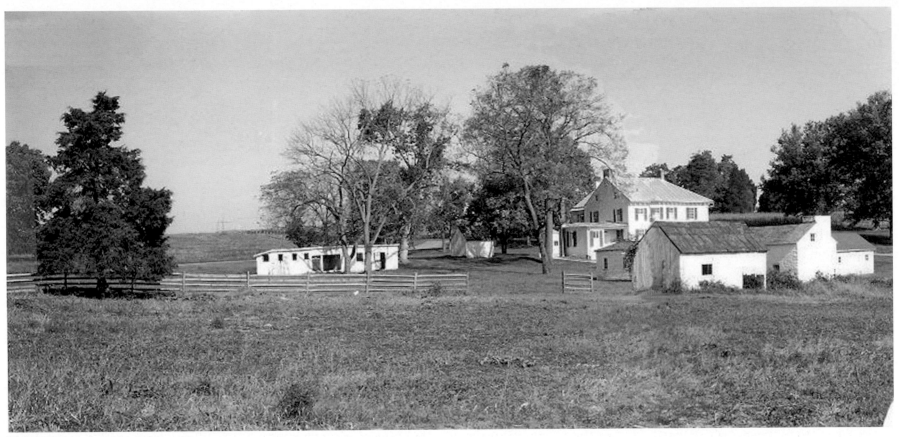

Fig. 7.11a

Original camera location: Park property; farmed area—check with National Park Service

Gardner's 1862 photographic time: 9:30 A.M.

Modern time: 11:40 A.M., September 25, 2010

Camera angle: 160°

Shadow angle: 335°

Before or after taking the picture of the Mumma farmhouse, Gardner and Gibson no doubt refilled their tanks and buckets at the springhouse. From there, Gardner may have turned right and followed the small stream that emerged from the brick structure and flowed into the field southeast of the farmhouse. In this field, about 150 yards east of the Mumma farm lane, Gardner took the image of the Roulette house (misspelled in Gardner's caption). The contour of the land has not changed since Gardner took his picture; but from this vantage point, the Roulette house is now completely obstructed by poplar and other trees.

Gardner's original camera position was in line with a barbed-wire fence that today borders the stream running toward the Roulette farm buildings. Much to my surprise, the ditch in the foreground of Gardner's picture still exists. Park Ranger Keven Walker showed me the small ditch when he accompanied me on a photo shoot in the spring of 2004 (fig. 7.12a). The field from which Gardner took his picture gradually slopes down toward the Roulette farm until it reaches a spot where the ground suddenly rises, forming a little hillock near the end of the Mumma property. With the grass and weeds cut low, the ditch can easily be found at the base of the hillock. Hidden by tall grass and weeds, the trench is invisible from a distance. The easiest way to find the location of the ditch is by following the barbed-wire fence along the stream until the whole fence line suddenly dips before rising again. The reason for this sudden drop is that one of the upright posts for the fence sits in the bottom of the trench, so the fence forms a V, as seen in my 2004 picture.

In Gardner's image, two trees growing in front of the Roulette House have their branches protruding above the roof of the house; one tree

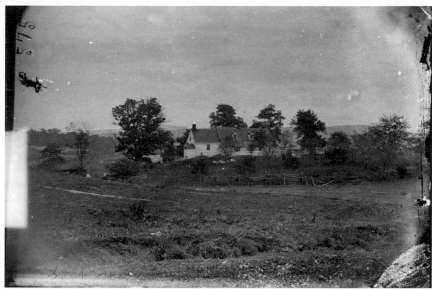

Fig. 7.12: Stereo plate 575: "Rullet's House, on Battle-Field of Antietam." Courtesy Library of Congress (B815-575 right half)

Fig. 7.12a

Fig. 7.12b

cover at the time, as captured in this photo. The Mumma farm photo, however, shows more sunlight. But weather records indicate that Gardner had fluctuating lighting conditions on the 20th. The weather station at Frederick reported high cirrostratus clouds in the morning followed by nimbus clouds in the afternoon. This appears to be the same weather pattern fifteen miles away at Sharpsburg on the 20th.

is above the middle of the house, while the other tree stands to the far right at the end of the roof. The modern photo of the Roulette house in Frassanito's book shows the same witness trees. Nearly thirty years after Frassanito's book was published, my photo shows that the trunks and branches of the two large trees sticking up above the roof of the Roulette house have not changed much.[2] These trees are visible in a picture I took at 1:45 P.M. on March 20, 2011 (fig. 7.12b). Just a few feet away from Gardner's camera position, I took this photo from a new walking trail that runs alongside the barbed wire fence from the Mumma springhouse to the Roulette house.

My estimation of the timing of this photo is based on the time of the Mumma farm photo, not on shadows. I believe Gardner took his picture of the Roulette house about twenty minutes after he took the Mumma house picture. When Gardner shot this image, the lack of definitive shadows on the house from trees or any other objects was due to cloud

Original camera location: Park property; farmed area—check with National Park Service
Gardner's 1862 photographic time: 9:45 A.M.
Modern time: 11:30 A.M., September 25, 2010
Camera angle: 50°
Shadow angle: 335°

The photographic location of this picture of dead Confederates—is still unknown, though I can narrow it down to a possible location that fits in with Gardner's movements that day. No building, rock formation, or distinct expanse of terrain in the background exists to allow us to determine a site with any certainty.

The image shows a group of dead Confederates on a small incline with a white picket fence at the top. Behind the fence is a section of woods, what I believe to be an apple orchard. Slats have been removed from the picket fence and placed under some of the bodies to make it easier to carry or move them without touching them. Gardner specifically mentions Hooker's men in the caption, implying that this picture was taken on the northern section of the battlefield. Since I am suspicious of some of Gardner's captions, I researched all of the farms on the battlefield proper. I documented only six farms on the battlefield that had orchards and picket fences near the farmhouses: the Miller, Mumma, Roulette, and Piper farms on the northern part of the battlefield and the Sherrick and Otto farms on the southern part. The Sherrick and Otto farms are not close to where Hooker's men fought, and they can also be eliminated because no terrain exists at either farm that comes close to matching the scene in image 572. For the same reason, I ruled out the Roulette and Piper farms on the northern part of the field; I could not find a convincing site at the Roulette farm, and the banks on the south side of the Piper orchard are to steep.

Civil War photographers often took their pictures in clusters at locations that were close to each other because of the need to park their wagon at a central stationary spot. Most, if not all, of the dead were photographed

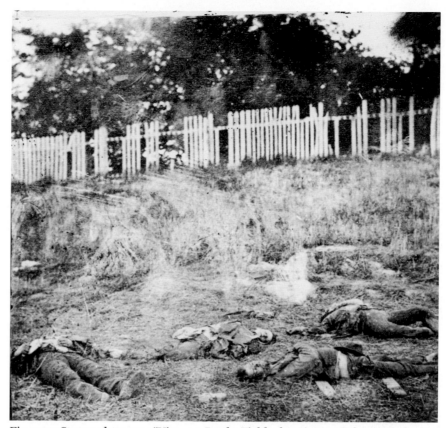

Fig. 7.13: Stereo plate 572: "View on Battle-Field of Antietam: Where Hooker's corps behaved so gallantly; group of Confederate dead." Courtesy Library of Congress (B811-325 right half)

on the northern part of the battlefield in the area bordered by the East Woods, the cornfield, the West Woods, and Bloody Lane. If Gardner had ventured outside of this area, he would have removed himself several hundred yards away from the concentration of the dead, from the subject. This would also have consumed valuable time he couldn't afford to lose, given how quickly the burial details were working.

Since the orchard in the background of image 572 suggests that Gardner was near a farmhouse, it would not be surprising if Gardner also

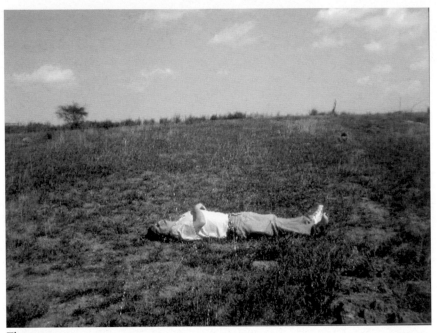

Fig. 7.13a

took a photograph of the farmhouse, considering its close proximity. The Miller and Mumma farms both offer potential camera sites given their similar terrain and location of the orchards and picket fences. The Miller orchard was east of the farmhouse, with the possible camera position facing north.

So how many Confederates reached the Miller farmhouse and were killed there? Other than a skirmisher or two near the Miller house at first light, when the Army of the Potomac launched the First Corps from the North Woods, I cannot find any accounts of Confederate soldiers killed at either the Miller house or orchard. For these reasons, I rule out the Miller farm as the location of image 572. The closest that Gardner actually got to the Miller house was when he recorded the Union burial detail at work in a field across from the Miller cornfield. This site is about 250 yards south of the Miller farm and on the other side of the Hagerstown

Pike. It was not until the following month, when he covered Lincoln's visit to Sharpsburg, that he photographed the Miller house.

This leaves the Mumma house as the final farm to consider, and I believe that image 572 was taken in the Mumma yard. Gardner took this picture of the dead just before or after he took the Roulette farmhouse image. Gardner's camera position was located just east of the new Mumma barn. I took my version of the image on September 25, 2010 (fig. 7.13a). Without a picket fence for perspective, the actual drop of the slope at left is misleading in the modern image. On the crest of the hillock are old posts for a barbed-wire fence, possibly where the picket fence once was located. The apple orchard no longer exists, but its location, according to contemporary maps, would have been in the background of my photo. In Gardner's photo of the Mumma farmhouse, the apple orchard can be seen behind the springhouse. While it is not yet possible to definitively establish this as the photo location, it fits into an area where Gardner and Gibson worked and in fact is in the same field where Gardner took the Roulette farmhouse picture. This was probably the last image Gardner took in the Mumma farm vicinity.

Gardner and Gibson loaded their stereoscopic camera back into the wagon and took the Mumma farm lane northwest a short distance to Smoketown Road, which divided the Miller and Mumma properties. Just after turning left onto the Smoketown Road, they probably found a torn-down section of the fence on the north side of road through which their wagon could pass. Entering a clover field on the Miller farm, Gardner set up his camera and took a shot of two dead Confederates, the first of three images showing dead Confederate soldiers in the Miller clover field that they took before moving a bit further west to the Hagerstown Pike. These three images were recorded sometime shortly after 11:00 A.M. and before 12:30 P.M.

Original camera location: Currently on private property
Gardner's 1862 photographic time: 10:00 A.M.
Modern time: 10:30 A.M., September 19, 2004
Camera angle: 280°
Shadow angle: 318°

It has long been assumed that this image was taken near the Burnside Bridge because Gardner's caption says it was. But not one single area in the vicinity of Burnside Bridge looks anything remotely like the wide, fairly level plane visible in this Gardner stereo view. All of the land south of Sharpsburg from Antietam Creek up to the Harpers Ferry Road is steep and undulating. Moreover, there is an extensive tree line in the background, but from the Boonsboro Pike south to the Otto Farm there were no large woods other than the trees found along Antietam Creek. The base of this tree line is above the two bodies, about eye level with

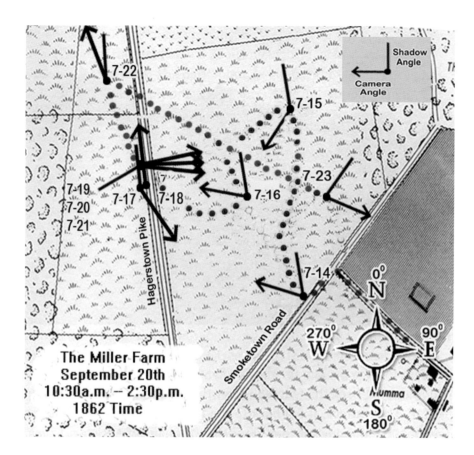

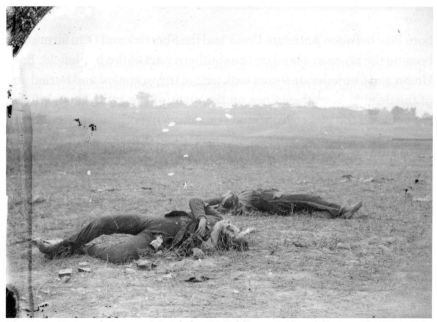

Fig. 7.14: Stereo plate 555: "Confederate Soldiers, as they fell, near the Burnside Bridge, at the Battle of Antietam." Courtesy Library of Congress (B811-555)

the photographer. This means that if Gardner took this shot facing Antietam Creek, he would have had to find a flat area of land *below* creek level, and this is not possible anywhere near the Burnside Bridge or on the Otto and Sherrick farms.

Also, I do not believe Gardner photographed any dead in the immediate vicinity of the Burnside Bridge because of the relatively few number of Confederate soldiers killed there. Defending the heights over Burnside Bridge were approximately 350 men of the 20th and 2nd Georgia of Toomb's Brigade. These two regiments, plus the rest of Toomb's Brigade, lost only sixteen men in the fight from the Burnside Bridge all the way back to the Harpers Ferry Road.[3] When A. P. Hill arrived on

ditions. I shot the next view on September 16, 2007, at 12:00 P.M. (fig. 7.14b). It was sometime between the shooting times of these two modern photos that Gardner took his photo. The next photo, which I also took on September 16, 2007, at 1:45 P.M. clearly shows much darker uniforms, and the soldier's body in the foreground is beginning to cast a dark shadow on the ground toward the photographer (fig. 7.14c).

While there is no boulder or other distinctive feature to allow for easy identification of the location, the landscape features of my site most closely resemble those in plate 555, and the illumination of the bodies in a west-facing shot from that location places the time of Gardner's photograph in proper sequence with the photographs he took before and after as he moved from the area around the Mumma farm to the Hagerstown Pike.

From the position alongside the Smoketown Road, Gardner no doubt could see the burial activity in the vast open field between the East and West woods. The remarkable vista in the background of the Knap's Battery image shows some of that activity, even as it shows that these fields were largely clear of the dead by September 20. Rather than staying on Smoketown Road, which ran west-southwest to the Dunker church, Gardner headed north across the open field in a route that took him across the land just to the right of the area seen in image 555.

Original camera location: Park property; no restrictions on access to site
Gardner's 1862 photographic time: 10:15 A.M.
Modern time: 11:30 A.M., September 16, 2007.
Camera angle: 226°
Shadow angle: 327°

Cutting north, straight through the pasture and skirting the East Woods, Gardner stops near the edge of the Miller cornfield and has soldiers from a burial detail pose with the bodies of their vanquished enemy on one of the many limestone outcroppings. Located on the south side of today's Cornfield Avenue, right next to the road, this outcropping has not changed much since 1862. Photographing the site today does present one major obstacle, however. The trees growing behind the mound are much taller and thicker than they were in 1862, and their shadows completely shade the mound and the land in the foreground as the day progresses. Thus, my versions still face in the same camera

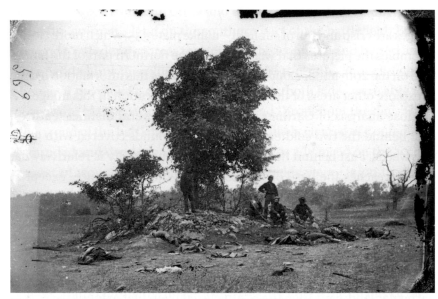

Fig 7.15: Stereo plate 569: "View on Battle-field of Antietam." Courtesy Library of Congress (B815-569 right half)

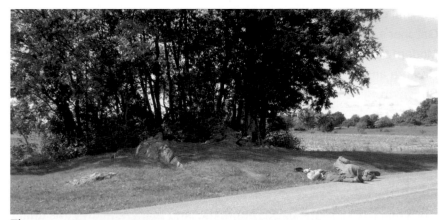

Fig 7.15a

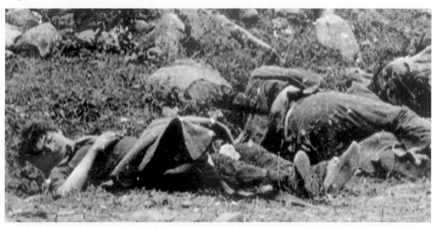

Fig 7.15b

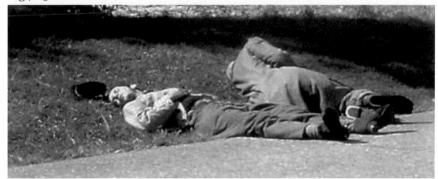

Fig 7.15c

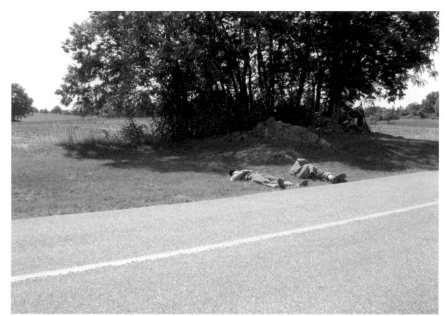

Fig 7.15d

Fig 7.15e

Fig. 7.16c

Fig. 7.16d

the weeds, I had to move the volunteers twenty feet out of the shade into strong sunlight. The second picture clearly shows the shadow from the left arm running across the standing soldier's hip (fig. 7.16c). The third picture was taken within a minute of the second under slightly diffused lighting conditions, and it matches Gardner's the best (fig. 7.16d). Notice how the faces and the uniforms of both volunteers are illuminated and shaded in the same way as the soldiers in Gardner's image.

In the left half of Clark's stereo view is a dead horse with a group of soldiers or civilians standing right above it. This group is standing alongside the long line of bodies that I mentioned earlier. The line extends left to right toward the fence and brush line. In the center of the Knap's Battery image, the line of bodies and the dead horse are possibly visible between the left shoulder of the mounted soldier with the dark vest and white shirt sleeves and the large tree in the middle distance that marks the Clark gravesite (see fig. 7.7). Just to the right of the mounted soldier appears to be a line of bodies on the ground that has fluctuations in the shadings of the uniforms similar to another line of bodies seen in the distant background of figure 7.9. In this picture, a dark object, possibly the dark horse, is a little closer to the tree that designates Clark's gravesite. Unfortunately the more I increased the magnification and zoomed in on this spot, the image became increasingly grainier, making it impossible to make any positive identification that this is indeed the line of bodies or the horse. However, both of these objects seen in the background of Knap's Battery are in the exact same locations as seen in figure 7.16e.

Gardner moved west across the open field toward the Hagerstown Pike where the bodies of dead Confederates lay strewn along a post-rail fence as yet untouched by Union burial details. Gardner knew the burial details would reach this area soon, so he may have been in a race against time to photograph the dead along the pike before the soldiers with shovels showed up. The graphic scene along Hagerstown Pike, with soldiers lying in all manner of death on the battlefield, gave Gardner his best opportunity yet to capture authentic images of the aftermath of battle and the human carnage it wrought.

Arriving at the Hagerstown Pike in the vicinity of its intersection with

today's Cornfield and Starke avenues, Gardner and Gibson probably encountered burial details and civilians milling along on the east side of the pike, as evidenced by the civilian carriage in image 567.

On September 17, around 7:00 A.M., Union general John Gibbon's Iron Brigade advanced through the Miller farm straddling the Hagerstown Pike. To meet this threat, Starke's brigade of Louisianans charged out of the protection of the West Woods toward the Hagerstown Pike. General Richard Starke, mortally wounded early leading the attack, was carried back behind lines, where he died. Starke's men reached the rails of the Hagerstown Pike firing into two Union regiments on the east side. To meet this threat, Col. Rufus Dawes of the 6th Wisconsin wheeled his regiment to the right. Here the opponents fired at each other through the rails of the fence. As Dawes's men kept the Louisianans engaged, two Union regiments hidden in the northern section of the West Woods on the west side of the pike snuck up and opened fire on the flank and rear of Starke's men. Within minutes, Starke's Brigade was decimated in this crossfire and retreated into the West Woods and south down the pike.

By the time Gardner and Gibson arrived on the scene three days later, these dead soldiers had already been picked clean of weapons and personal possessions by either the skirmishers or by the first wave of Union burial details, as evidenced by the way the dead soldiers are all lying on their backs or sides, having been rolled over to gain access to their pockets and personal possessions.

The post-rail fencing bordering the Hagerstown Pike proved to be quite a barrier to both sides during the battle. Accounts from two generals show how the battle played out in the morning hours. Brig. Gen. J. G. Walker, CSA, said:

> The division suffered heavily, particularly Manning's command [Walker's Brigade], which at one time sustained almost the whole fire of the enemy's right wing. Going into the engagement, as it was necessary for us to do, to support the sorely pressed divisions of Hood and Early, it was of course, impossible to make dispositions based upon a careful reconnaissance of the localities. The post rail fences stretching

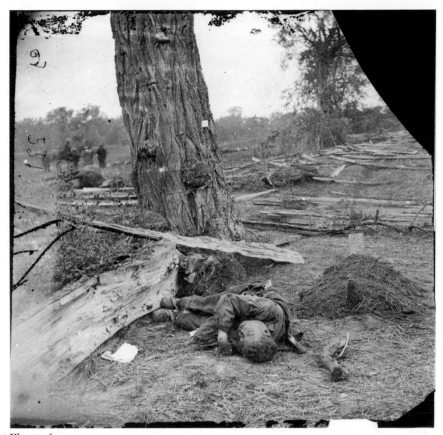

Fig. 7.16e

across the fields lying between us and the enemy's position, I regard as the fatal obstacle to our complete success on the left, and success there would, doubtless, have changed the fate of the day. Of the existence of this obstacle none of my division had any previous knowledge, and we learned it at the expense of many lives.[4]

Union brigadier general Samuel Crawford of the First Division of the Twelfth Corps wrote: "Our line had driven the enemy from Miller's woods across the wheat fields into the woods beyond the Dunkard Church and Hagerstown Road. A fine wooden fence which skirted the road had proved a very serious obstacle to our farther advance."[5]

Original camera location: Park property; no restrictions on access to site
Gardner's 1862 photographic time: 11:30 A.M.
Modern time: 12:30 P.M., September 3, 2006
Camera angle: 140°
Shadow angle: 350°

When I began my photo studies along the Hagerstown Pike in 2003, no post-rail fence bordered the road. Two years later, the area historically recorded in Gardner's five images changed dramatically. A section of post-rail fence was built by the Park Service on the west side of the pike in April 2005, recreating the look of 1862. Originating at Starke Avenue, this new fence extends south along the pike for 360 feet. With this new fence and the help of volunteers to reenact two of Gardner's photos, I have been able to determine when Gardner took these five images.

Several minor issues about the new fence need to be addressed. First, the new fence is several feet from the road, so recreating the scene with volunteers meant having to move back several feet from the original sites. Also, the odds are that when the new fence was installed, the upright posts that hold the horizontal rails probably did not line up exactly with the locations of the upright posts from 1862. In the worst case, my photo locations at the new post-rail fence might be off by a few feet in either direction.

The Hagerstown Pike, which runs in a north-south direction, cuts through the Miller farm. I believe Gardner crossed the pike somewhere just south of this grouping of bodies, which would be just out of the picture to the right in image 556. From here, he worked his way north following the pike, taking image 556 first. This first image faced southeast along the pike. The first of these modern photos I took on September 19, 2004, at 12:00 P.M. without the post-rail fence in the background (camera angle 140°, shadow angle 346° [fig. 7.17a]). The shading and illumination of the volunteers match those in Gardner's image, along with shadows on the ground; close in and tight to the bodies. Remember shadows are the shortest around noon, and shortly after 12:30 P.M. shadows will be cast exactly due north.

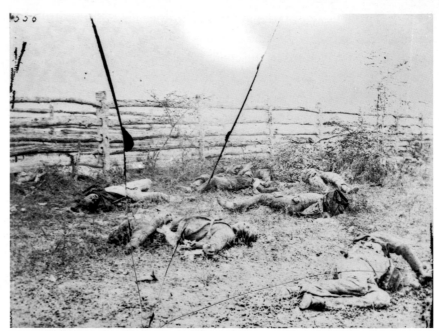

Fig. 7.17: Stereo plate 556: "Confederate Soldiers, as they fell inside the fence, on the Hagerstown road, at the Battle of Antietam." Courtesy Library of Congress (B811-556 left half)

I took more recent versions I took along the pike with the new post-rail fence on September 3, 2006. Starting in the early morning, I shot a series of pictures to illustrate the progression of sunlight and the ever-changing illumination of objects—factors that would ultimately allow me to pinpoint the time Gardner took his photos as well prove that he did not take them at other times. If someone standing at the southern end of the new fence walked north toward Starke Avenue past thirteen sections of fence toward Cornfield Avenue and stopped at the fourteenth upright post, they would be at Gardner's photo site for image 556.

In the first picture, which I took at 8:40 A.M. (fig. 7.17b), the volunteer and the fence are in silhouette, and long shadows are cast from the early morning sun. The next picture, from 10:40 A.M. (fig. 7.17c), shows the fence still in silhouette, but the fence shadow has shortened. The

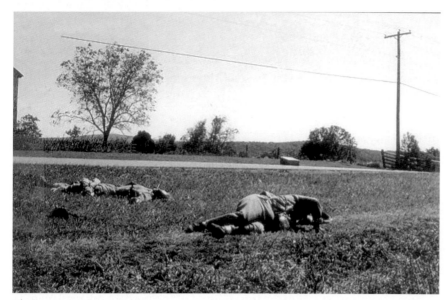

Fig. 7.17a

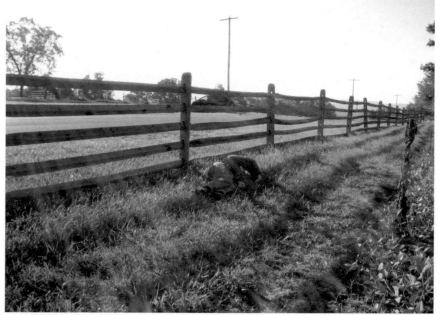

Fig. 7.17b

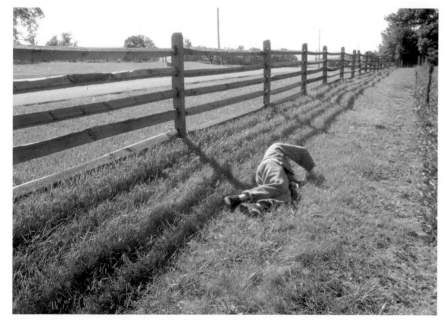

Fig. 7.17c

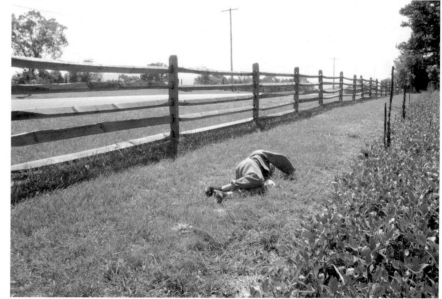

Fig. 7.17d

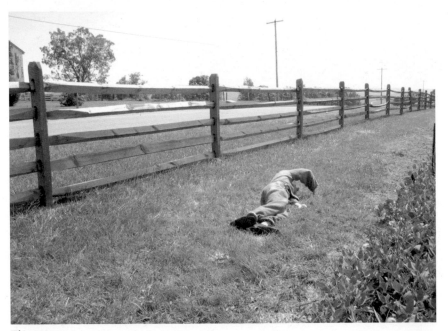

Fig. 7.17e

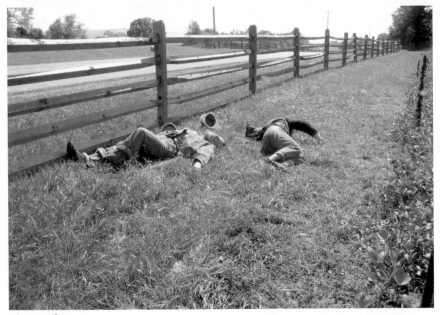

Fig. 7.17f

volunteer's body is now brightly illuminated on the left side while the right side is still in silhouette. I took the next picture at 11:21 A.M. (fig. 7.17d), and it shows the fence rails halfway illuminated, and the fence shadow is really close to the base of the fence. Now the shading of the volunteer closely begins to resemble that of the dead soldier in Gardner's picture. In the last picture, taken at 12:30 P.M. (fig. 7.17e), the sun is directly overhead, and the fence rails are more illuminated and the shadow from the fence is now directly underneath it. It is at this time that the shading and illumination of the volunteer most closely matches the shading and illumination of the dead soldiers.

Within a short time, the shading and illumination begin to change. The shadows cast from the pike move to the other side of the fence and eventually cross the pike. As the sun moves west, the rails on the west side of the pike gradually become fully illuminated, leaving no shading or areas in silhouette. Finally, the shading of the body of my volunteer is reversed as well, with the right half of the body illuminated and the left half in silhouette. Two weeks later, on September 17, 2006, at 12:30 P.M., I returned to this spot and recorded this (fig. 7.17f).

Original camera location: Park property; no restrictions on access to site
Gardner's 1862 photographic time: 11:45 A.M.
Modern time: 12:45 P.M., September 19, 2004
Camera angle: 355°
Shadow angle: 355°

After Gardner took image 556, he turned his camera in the opposite direction and recorded his next view, between what are now the fourteenth and fifteenth upright posts on the new fence. He took the picture facing the north and it shows the large number of dead along the west side of the pike. To the left of the bodies is a farm lane; Gardner probably parked his wagon on this farm lane alongside the pike. On the left side of the lane is another body, and next to this corpse are what appear to be three freshly dug graves with headboards. If these are indeed graves, then they probably hold the remains of Union soldiers killed in the early hours of the battle and interred on the 19th or 20th. Although these images have been reported as having been taken on September 19, I believe they were part of the vast series of photos of the dead that Gardner took on September 20.

Cpl. William Westervelt of the 27th New York wrote that it was not until around *noon* on the 19th that his regiment received the order to advance and then crossed the Hagerstown Pike after leaving the East Woods. It is highly unlikely that Gardner and Gibson would have been at this location at that time, and it's even more unlikely that civilians would be parking their wagons along the pike before Westervelt and his men received the order to advance there. My photographs establish that Gardner began photographing at the Hagerstown Pike at 11:30 A.M. in 1862 (12:30 P.M. DST). The picture I use to represent this view I took on September 19, 2004, at 12:30 P.M. (fig. 7.18a).

Another attempt I made the following year to recreate this Gardner image and the remaining Hagerstown Pike series of pictures with more volunteers was less than fruitful. The weather was uncooperative, and corn on the stalks in the field made it impossible to take pictures facing the fence.

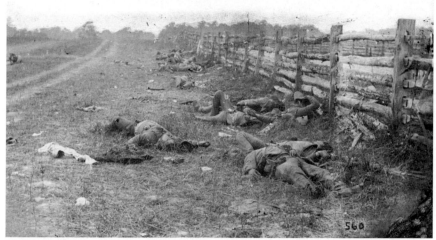

Fig. 7.18: Stereo plate 560: "View in the Field, on the west side of Hagerstown Road, after the Battle of Antietam." Courtesy Library of Congress (B811-560)

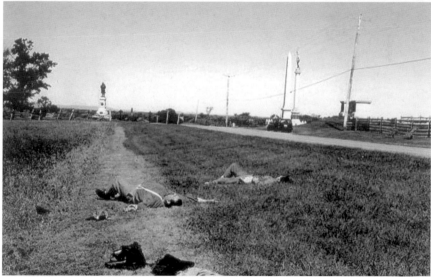

Fig. 7.18a

Original camera location: Park property; no restrictions on access to site
Gardner's 1862 photographic time: 12:00 P.M.
Modern time: 1:00 P.M.

Original camera location: Park property; no restrictions with access to site
Gardner's 1862 photographic time: 12:15 P.M.
Modern time: 1:15 P.M.

After taking the first image at the pike, Gardner moved progressively north with each new picture. I made several attempts with volunteers to duplicate the illumination of this image, but the lighting conditions were far less favorable for matching silhouettes with the bodies. Gardner recorded this image at a spot north of the previous location, between the sixteenth and seventeenth upright posts. Barely visible in Gardner's image, the trees of the East Woods appear through the top two rails of the fence in this and the next two photos.

Gardner moved north from the site of plate 559, to between the twenty-fourth and twenty-fifth upright posts, faced east again, and then took this shot.

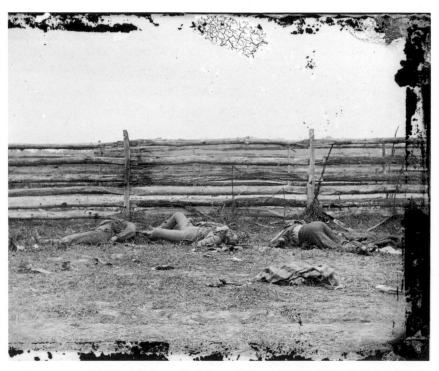

Fig. 7.20: Stereo plate 566: "Confederate Soldiers, as they fell, at the Battle of Antietam." Courtesy Library of Congress (B811-566 left half)

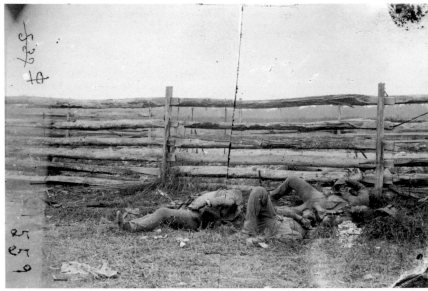

Fig. 7.19: Stereo plate 559: "Killed at the Battle of Antietam." Courtesy Library of Congress (B811-559 right half)

Original camera location: Park property; no restrictions with access to site
Gardner's 1862 photographic time: 12:30 P.M.
Modern time: 1:30 P.M.

Moving a bit north along the fence from the previous picture, Gardner recorded the last image along the Hagerstown Pike between the twenty-fifth and twenty-sixth upright posts. This image shows the civilian carriages parked on the east side of the Hagerstown Pike. After taking this photo, Gardner and Gibson loaded the camera, stayed on the Miller farm lane, and moved north into another field on the Miller property.

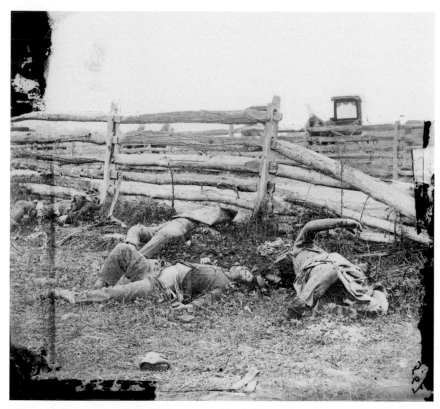

Fig. 7.21: Stereo plate 567: "View on Battle-field; Group of Louisiana Regiment, as they fell, at the Battle of Antietam: The contest at this point had been very severe." Courtesy Library of Congress (B811-567 right half)

Original camera location: Park property; farmed area—check with National Park Service
Gardner's 1862 photographic time: 1:00 P.M.
Modern time: 12:49 P.M., September 16, 2007
Camera angle: 338°
Shadow angle: 0°

Just a few yards northwest of the intersection of Hagerstown Pike and today's Starke Avenue, Gardner encountered a burial crew and asked them to pose for a photograph. On his four-by-ten-inch stereoscopic glass plate, Gardner captured a Union burial detail ready to dig a group grave. It is uncertain whether the casualties are Confederate or Union. The dark coats and light pants of their uniforms indicate that they might

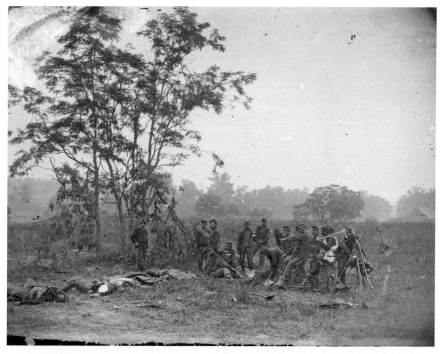

Fig. 7.22: Stereo plate 561: "Burying the Dead, after the Battle of Antietam." Courtesy Library of Congress (B811-561 right half)

be Union soldiers, but there is nothing conclusive to prove that. Colors photograph differently when shot in black and white, and Confederate soldiers wore a wide variety of uniforms. In figures 7.10 and 7.18, some of the dead Confederate soldiers are wearing dark coats and could pass off northern soldiers. Therefore, I cannot say conclusively that these are dead Union troops. One indicator that suggests these might be Union soldiers is the slat of wood from a box or crate that lies on the stomach of the dead soldier at far left; this would appear to be a headboard that was most likely inscribed with the name and regiment of the soldier, if not this whole group. This would have been done by Union troops before the burial crews arrived. It is possible, though, that this slat was simply used to help move the bodies without having to touch them. A fresh grave and headboard is visible by the first tree at left. Was this area cleared of Union dead the day before and that this is a grave of a federal soldier, or was it dug just before Gardner took his picture? As a single grave, was that for the Union soldier who fell here, while the rest are Confederates still to be buried? These questions cannot be definitely answered. So it's anybody's guess as to whether the dead in this image are Union, or Confederate.

The site of this image is in the field directly across from the famous Miller cornfield and is one of the many camera locations found by Frassanito, who identified the barn in the background of Gardner's image as one of the Miller farm barns. This barn still stands on the west side of the Hagerstown Pike, with the Miller house and another barn on the east side of the pike.

I determined the time frame for this picture based on its close location to the preceding Hagerstown Pike series. Unfortunately, crops grown at this location in September 2003–2006 prevented me from taking any usable modern photos. In 2007, a group of volunteers posed at this location, but they were wearing Confederate uniforms. Whenever possible, I attempted to have them wear uniform colors matching those in Gardner's pictures, but as we moved from one site to another, time pressures did not always allow for this.

Fig. 7.22a

Gardner's camera location, easily visible from the Hagerstown Pike, was in a small bowl-shaped depression in the field. I took my photo at 12:50 P.M. on September 16, which is as close to Gardner's as I've been able to get for this site (fig. 7.22a). Gardner took his image an hour to an hour and a half after he began the Hagerstown Pike series, at about 1:00 P.M.

This photograph on the Miller property was taken further north than any of the other images in the Antietam series. It shows a fresh battlefield in transition. One grave has already been made, and the burial detail has begun digging a hole for the dead in front of them. Behind the group of three trees and the soldier standing at left, a bloated body awaits burial.

When you study the Antietam photos as I have, over the course of many years, you begin to see details and elements that help tell the stories of the images. In this image, several soldiers have taken advantage of Gardner's interruption to sit or kneel for a quick rest. One soldier, his head blurred for a moment, has continued digging the grave—or

perhaps is digging at Gardner's request. To the right of this digger, the man who is pointing may be the group leader, or, again, he may be posing at Gardner's request.

Under magnification, I studied the faces of most of the soldiers in Gardner's Antietam images—some blurred, some sharp—and of the many evocative visages I have seen, none stands out like the soldier at far right, resting against the stacked muskets. Most of his face is obscured by his own left hand and by the head of the pick ax held by the man to his left. But the soldier's eyes are not obscured, and they stare directly into Gardner's camera lens with a fierce glare that is far more expressive than any other face in any Antietam photograph. We can only guess at what he was thinking that day, but burial duty on a field like Antietam must have been among the worst assignments, if not the very worse, a Civil War soldier could have. It's hard work, digging holes in pastures. We can only speculate, but his eyes—glaring at the camera—underscore the awful reality that we can see for ourselves in Gardner's image, one spread out right in front of him, battering his senses with the true horror of war.

Fig. 7.22b

This may be the final image showing dead soldiers that Gardner took at Antietam. For six and a half hours straight, from 6:30 A.M. to 1 P.M. on September 20, he shot photos, mostly of the dead, exposing at least twenty-two stereo plates, not including any plates that might have been spoiled for one reason or another. With as much efficiency and speed as a Civil War photographer could muster, and racing against the burial parties, Gardner cut a path back and forth across the northern part of the battlefield looking for the scenes to photograph. With bodies still on the field, Gardner's eagerness to move as quickly as possible and to take as many photos as he could is evident in his use of only one camera, his stereoscopic camera, leaving his seven-by-nine-inch large-plate camera in the wagon. In the coming days at Antietam, and indeed during other battlefield visits, including to Gettysburg, Gardner took the time to use both his large-plate camera and his stereo camera.

By 1 P.M., Gardner and Gibson were no doubt hungry and exhausted from their morning's work. With the last of the dead being interred, and with many graphic images preserved on the glass plates now carefully stored between the grooved notches of the plate box in the wagon, they may have decided to take a much deserved break and replenish their water supply back at the Mumma springhouse. Leaving the Hagerstown Pike area, the two headed southeast through the Miller clover field to the Mumma farm. Before reaching the Mumma farm, Gardner took two more images in the Miller fields.

Original camera location: Currently on private property

Gardner's 1862 photographic time: 1:30 P.M.

Modern time: 2:30 P.M., September 17, 2005

Camera angle: 110°

Shadow angle: 43°

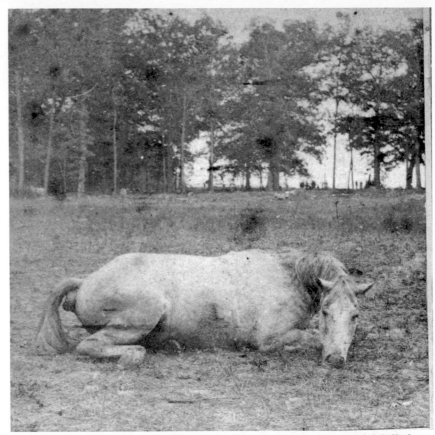

Fig. 7.23: Stereo plate 558: "Dead Horse of Confederate Colonel; both killed at the Battle of Antietam." Original glass plate missing. This view is the left side of an original Gardner stereo card. From the collection of Bob Zeller

Over the years it has been widely accepted, though speculative, that the dead horse photographed belonged to Colonel Henry B. Strong of the 6th Louisiana. The scene at Gardner's photographic site for image 558 is much different today than it was in 1862. The contour of the land has not changed, but the woods in the background—part of the East Woods—is no longer there. Most of the East Woods remains, but this section is now open land. Presently this area is on private property and was cleared for farming many years ago. Markers along Cornfield Avenue and the Smoketown Road are the only indicators of where the original western edge of the East Woods location once was. My research to determine the time of the photo at this site involved matching the illumination of the trees and their shadows in Gardner's image with trees now growing near the photo site along Cornfield Avenue.

With my camera facing the same directions as Gardner's, I took a series of shots throughout the day on September 17, 2005. The first picture, at 8:10 A.M. (fig. 7.23a), shows the trunks of the trees in complete silhouette and their shadows cast toward the camera position (shadow angle 292°). The signpost just to the right of the trees is one of the markers that designate the original boundary of the East Woods during the battle. I got the same results for another view at 11:15 A.M. (fig. 7.23b), the only difference being that the shadows moved to the left (shadow angle 330°). At 2:28 P.M., the trees in my photo corresponded with the same illumination and shadow characteristics of the trees in Gardner's image (Fig. 7.23c). After I took this shot, I moved into the field to the actual location of Gardner's picture of the horse (fig. 7.23d). In my last picture, which I took at 4:50 P.M. (fig. 7.23e), the tree trunks are fully il-

luminated, and the direction of the shadows from the trees does not fall in line with the tree shadows in Gardner's image (shadow angle 80°).

Fig. 7.23a

Fig. 7.23b

Fig. 7.23c

Fig. 7.23d

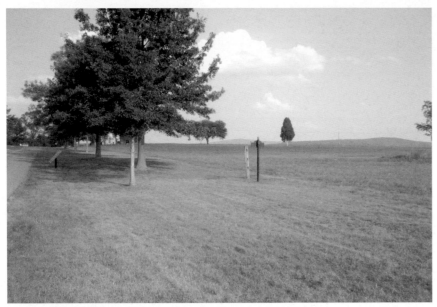

Fig. 7.23e

Morehead, Plate 586

As William Frassanito has noted, the location of the photo of Colonel Morehead sitting on one of the hundreds of limestone outcroppings that dot the battlefield would seem to be one of the easiest of Gardner's sites to locate on the Antietam battlefield. But the location of this image remains a mystery. Morehead's unit was stationed in the vicinity of the East Woods after the battle, and with Gardner and Gibson working the northern part of the battlefield on the 20th, it is probable that the three crossed paths on that day somewhere on the Miller farm. The similarity in the lighting and the "look" of this image as compared with the others taken on the 20th further suggests that it, too, was taken on that day. Since a section of woods looms in the background, I can assume that these trees were part of the East, West, or North woods. The limestone outcropping, because of its unique shape, should be easy enough to find. But after thoroughly investigating areas near the boundaries of

the original wood lines over many years, I cannot say where this picture was taken. Frassanito suggested that the outcropping might have been broken up to use as building material or used as a foundation for one of the battlefield monuments.

With few or no more dead to photograph on the northern part of the battlefield, Gardner and Gibson ended their work on September 20 and camped for the night on the Mumma farm. Although they still had time to take more images, I believe the two had had enough. They spent eight hours on a hot September day—from 6:30 in the morning until mid-afternoon (1862 time)—photographing dead bodies and battling the stench, the putrefaction, and the flies that crawled among the decaying corpses. Gardner no doubt understood the significance of his

Fig. 7.24: Stereo plate 586: "Colonel Morehead, One Hundred and Sixth Pennsylvania Volunteers, on Battle-field of Antietam, Sept. 19. 1862." Courtesy Library of Congress (B811-586 left half)

work; it was the photographic opportunity he and his fellow lens-men had all been looking for. But they had pushed themselves to the limit, and they both knew they already had more than enough to tell the story: some twenty grim stereoscopic tableaus of carnage, all the more gruesome in 3-D, as well as at least five other photos. There is also evidence that they were running out of glass plates for new negatives. So, after eating, and with only a couple of hours of sunlight left, they probably spent the remaining daylight of September 20 evaluating that day's work and preparing for the next day's labors.

Could Gardner, with help from Gibson, actually have had enough time on September 20 to take as many as twenty-three images on the Antietam battlefield? The answer is most definitely yes. With the right temperature, good weather conditions, and experience, photographers could easily process one glass plate from start to finish in ten minutes or less. Gardner and Gibson spent roughly four hours each on the Mumma and Miller farms, which amounts to one image taken almost every twenty minutes. I have walked the route of Gardner and Gibson (figs. 7.1 to 7.23) on the Mumma and Miller farms at a casual pace in an hour or less, This amounts to thirty minutes of traveling time on both farms from location to location. On the Mumma farm, Gardner took thirteen images. If each one took ten minutes to process from beginning to end, it would total 130 minutes, or two hours and ten minutes. Add to that the thirty minutes traveling time to reach a total two hours and forty minutes. This leaves an extra hour and twenty minutes to prep the darkroom wagon, compose the view, etc.—plenty of time for Gardner to record those thirteen images. Also, the Dunker church images were all taken close to one another, as were the photographs recorded by the Hagerstown Pike. Ten of the twenty-three images, almost half of the views taken that day, were recorded at or near these two locations, consuming only a little over two hours total at both sites. This leaves six hours to take the thirteen remaining images. Without having to un-harness the horse at twenty-three different locations, and being able to take many shots at a single site, Gardner and Gibson could work more efficiently and thus more quickly, giving them plenty of time to traverse the route I believe they took.

8 ✠ Sunday, September 21
The East Woods and Sharpsburg

Jonathan Gruber's *Farmers' Almanac* for Hagerstown and area, 1862
> Sunrise: 5:58 A.M. Sunset: 6:02 P.M.

Weather Channel.com, September 21, 2007, for Sharpsburg, Maryland
> Sunrise: 6:57 A.M. Sunset: 7:10 P.M.

Cloud conditions from the Frederick, Maryland, weather station, September 20, 1862, with 1 representing clear skies and no clouds and with 10 as heavy cloud cover and overcast skies

> 7:00 A.M. Degree: 3 Type: cirrostratus

> 2:00 P.M. Degree: 0 Type: 0

> Precipitation: 0

Temperature 7:00 A.M.: 57.5° 2:00 P.M.: 65°
> 9:00 P.M.: 63.5°

Out of the seven dated captions in Gardner's Antietam series, two are dated September 21: view 585 showing federal graves at Burnside Bridge and view 580 showing Gen. John C. Caldwell and his staff in a wooded area. Of the seven, I believe that the only dated caption that is correct is that of General Caldwell and staff. I do not think that Gardner went near the Burnside Bridge until September 22 but was in the East Woods on the 21st and took the shot of Caldwell there.

After getting a much-deserved night's sleep, Gardner and Gibson returned to the battlefield the next morning to find that the fields between the East and West woods had been cleared of Confederate dead. All that remained were a few dead horses and debris. For the third day in a row, everyone was wondering what McClellan was going to do. The answer came soon enough. No federal troops crossed the Potomac that morning; the army sat idle.

After taking the final images on the Miller farm on the 20th, Gardner reached a critical point with his battlefield photography. He had depleted his stock of four-by-ten-inch stereoscopic plates. It is unknown how many

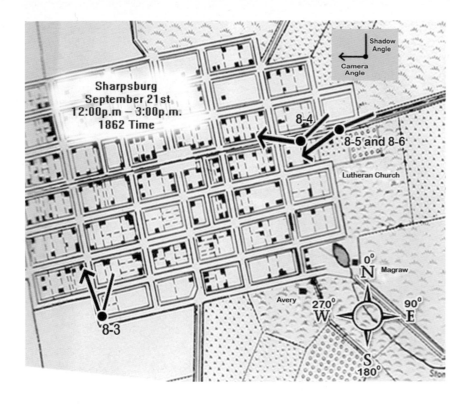

four-by-ten-inch stereo plates and seven-by-nine-inch large single glass plates he started with at Antietam, but he obviously brought many more stereo plates because he took mostly stereo photos. And from the 18th to the 20th, every image he took was a four-by-ten-inch stereo plate.

Running out of stereo plates and not knowing what to expect in the following days, but anticipating more photo opportunities, Gardner gained permission to use the military telegraph to wire to Washington for more stereoscopic glass plates. He was well connected with Mc-Clellan's headquarters staff and probably had little trouble arranging to send the telegram. At 10:00 A.M. on the 21st, the War Department received an urgent message from Gardner addressed to David Knox at Brady's Washington studio: "Send four by ten glass. Got forty five negatives of battle. Tell him deliver as soon as possible."[1] The location of the

headquarters' telegraph station had been at Keedysville, in the vicinity of the Pry house, from the 16th through the 20th. But the location of McClellan's headquarters and telegraph operators after the 20th is a mystery. Any communications sent from McClellan to the War Department after the 21st were vague as to the location of McClellan and were simply addressed "camp near Sharpsburg."

The significance of the location of McClellan's headquarters plays a huge role in determining where Gardner and Gibson were on the 21st. The diary of Robert S. Robertson of the 93rd New York Volunteers Regiment, Second Corps, McClellan's personal headquarters guard, explained why McClellan moved his headquarters and where.

Sept. 20. Saturday. Co's I & D were detached and ordered to report to the H'd Qr's of the Artillery Reserve to guard the ammunition train. We had got ourselves comfortably established in our new camp, when at 12 midnight we were waked & had to march in haste with the train about four miles, to a place beyond Sharpsburg, but could not learn the reason of the movement.

Sept. 21. Sunday. Learned that the movement of last night was made to get in a place of safety, as the rebel cavalry had once again passed around the rear of our army successfully and escaped, going within ¾ths of a mile only from McClellan's Headquarters. We moved camp about a mile, to be near water, & encamped with the Art'y Res. on Smith's farm. The house and barn are used for a hospital and are full of wounded rebels.[2]

The David Smith farm is located approximately one mile west of the center of Sharpsburg on the Shepherdstown Road. Across the road was the Grove farm, which was photographed when President Lincoln met McClellan at General Porter's headquarters on October 4. According to Robertson and other accounts from the 93rd New York, McClellan stayed at the Smith farm until the 27th, when he moved his headquarters three miles south in the direction of Harpers Ferry.

Evidence that tends to support McClellan's new headquarters being at the Smith farm are the telegraph lines seen in many of the Middle Bridge images, which I think were taken on September 23. It is quite possible that telegraph poles and lines could have been run on the 19th or 20th from McClellan's headquarters at the Pry house through Sharpsburg heading toward Shepherdstown. The Confederate army was already across the Potomac, and since McClellan might pursue Lee into Virginia somewhere near Shepherdstown, lines were probably laid even before McClellan vacated the Pry house.

Telegraph poles are visible at both ends of the Middle Bridge and along the Boonsboro Pike heading toward Sharpsburg. This telegraph line can be further tracked up the pike in another photo of the Lutheran church (stereo plate 596; see fig. 8.5). Two more telegraph poles are visible next to the fence to the right of the church. In another photo taken near the Lutheran church, stereo plate 595, the telegraph wire can be seen drooping above the road as it descends toward the house at left (see fig. 8.4).

If Gardner was at McClellan's headquarters on the morning of September 21 to send the telegram, he could not also have been at Burnside Bridge, as suggested by the caption on image 585. Photo research and the sequence of shadows in Gardner's Burnside Bridge photographs indicate that Gardner began taking pictures at the bridge by 7:00 A.M. (1862 time) and, I believe, spent the whole day of September 22, not the 21st, at the bridge.

I must address one other issue about the telegram, a rare piece of documentary evidence about Gardner at Antietam. Gardner says he "got 45 negatives of Battle." However, using the most liberal standards, I can only account for thirty-one stereo negatives out of a total of forty-five that could have been taken before Gardner sends the telegram. I arrived at a total of thirty-one by counting the number of photos Gardner took from the 18th through the 20th. This also includes the two stereo images taken in the East Woods on the morning of the 21st.

It is exciting to think that there might be fourteen more unaccounted for Antietam plates stored and tucked away somewhere waiting to be

Fig. 8.1: Stereo plate 580: "General Caldwell and Staff on Battle-field of Antietam, Sept. 21, 1862." Courtesy Library of Congress (B815-580 right half)

discovered. But that is not likely to happen. The *Photographic Incidents of the War* mail-order catalog that Gardner issued in September 1863 included a specific list of the Antietam images, and he would have had little or no reason to exclude good photographs when his intent was to market them as widely as possible and to sell as many as he could. Another possible explanation for the seemingly missing plates is that Gardner or Gibson may have wasted a few and simply thrown them away; if the glass plates had cracked, or if there were problems with the chemicals in the developing process, they may have been discarded.

Before leaving the vicinity of the East Woods to travel to McClellan's new headquarters at the Smith farm, Gardner took three images, two of General Caldwell and his staff and one of a group of artillery officers. The locations of these three pictures taken in the East Woods are still unknown, but they were probably taken very early in the morning between 6:00 and 8:00 A.M. (1862 time).

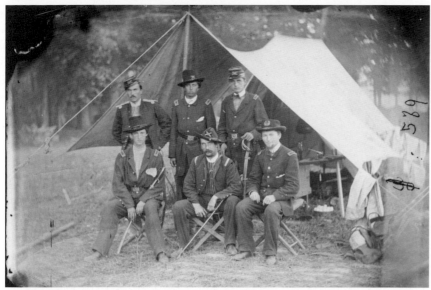

Fig. 8.2: Stereo plate 579: "Group-Artillery Officers on Battle-field of Antietam." Courtesy Library of Congress (B815-579 right half)

Stereo plate 580: General Caldwell and Staff on Battle-field of Antietam, Sept. 21, 1862

Frassanito's research indicates that General Caldwell's brigade of the Second Corps was encamped in the East Woods from the 19th until the 22nd.[3] A bearded Caldwell stands in the middle, surrounded by his staff. Unfortunately for Caldwell, he was not in good graces with the division commander. His brigade relieved the decimated Irish Brigade in the assault against the Sunken Road. Cresting the hill and descending the little slope toward the lane, the division commander, Israel Richardson joined the assault at the head of the brigade, looking for and eventually asking about the whereabouts of his brigade commander. The reply was that General Caldwell was hiding behind a haystack in the rear. Richardson bellowed out, "God damn the field officers!" and then led Caldwell's brigade to a hundred feet of the lane, where it fought the right of Rode's

line.[4] Richardson was later mortally wounded near the lane by a piece of artillery shrapnel and was taken to the Pry house.

Gardner's 1863 catalog includes a listing for a seven-by-nine-inch large-plate, or "folio," image, of "General Caldwell and Staff on Battle-field of Antietam, September 21, 1862." The catalog listing is the only evidence that Gardner took both a large-plate and stereo plate of the general and his staff. This plate negative is lost or does not exist, and there are no known prints of this view. As far as I can determine, this was the first large plate that Gardner took at Antietam.

Stereo plate 579: Group-Artillery Officers on Battle-field of Antietam

There is no way to determine the photographic location of the artillery officers because there is no terrain or identifiable landmarks in the image. The location of this site will probably remain a mystery, but it was very likely taken within a short distance of the Caldwell images. Frassanito identifies artillery officer Lt. Alonzo Cushing in the image; Cushing later died at Gettysburg at the Copse of Trees repulsing Pickett's charge.[5]

Original camera location: No restrictions on access to site
Gardner's 1862 photographic time: 12:25 P.M.
Modern time: 1:25 P.M., September 20, 2008
Camera angle: 322°
Shadow angle: 23°

Leaving the East Woods, Gardner and Gibson more than likely traveled the Hagerstown Pike to Sharpsburg, turned right onto Main Street, and followed it to the Smith farm. After locating McClellan's headquarters and the telegraph station, Gardner sent his short message for more plates. Within two hours of sending the telegraph, Gardner and Gibson were at work again at the west end of Sharpsburg. With a limited supply of stereo plates, the two were selective in the few views they recorded there.

Gardner was at the south end of Hall Street on top of a hill looking in a northwest direction when he took image 599. Gardner seemed to be in a more relaxed mode, as evidenced by his unhitched horse, which

Fig. 8.3a

Fig. 8.3: Stereo plate: 599: "Street in Sharpsburg; Episcopal Church in distance." Courtesy Library of Congress (B815-599 left half)

Fig. 8.3b

Fig. 8.3c

is seen grazing at the end of the stone wall at right. Also in the scene behind Gardner's horse is a soldier with a black dog. In the distance, at the intersection of Hall and Main, is a mounted figure looking back up at Gardner. And just beyond the house at left walking up Hall, a small child also looks back at the photographer. Even though they have been renovated, some of the houses along Hall Street and the stone wall that stood during the battle still exist.

My calculation of the time Gardner took image 599 is based on my observations of a particular shadow cast from the right front corner of the house behind Gardner's darkroom wagon. The house still stands today, though there have been renovations to the front porch and the roof over it. But the angle of the shadow cast from the right front corner of the house has not changed. I shot the modern view on September 16, 2007, from where Gardner stood, but the time is a half hour off. I took this photo at 1:00 P.M. with the camera facing 344° and the shadow angle

at 9° (fig. 8.3a). Also, blocked out of view by vehicles is the shadow cast on the front porch. On September 20, 2008, I took another series of photographs a short distance from the house five minutes apart, starting at 1:00 P.M. (fig. 8.3b). I compared this series with an enhanced Gardner image and conclude that Gardner took his image at 1:25 P.M. (fig. 8.3c).

Original camera location: No restrictions on access to site
Gardner's 1862 photographic time: 2:45 P.M.
Modern time: 3:55 P.M., September 16, 2007
Camera angle: 276°
Shadow angle: 70°

After taking the image from atop Hall Street, Gardner and Gibson traveled back toward the east in the direction of the battlefield, probably down Main Street, and turned left onto Church Street and parked their

Fig. 8.4: Stereo plate 595: "Principal Street in Sharpsburg, Maryland." Courtesy Library of Congress (B815-595 left half)

Fig. 8.4a

Fig. 8.4b

wagon. Church Street continues west out of Sharpsburg and connects with the Hagerstown Pike (today Route 65). In the photograph, Gardner's darkroom wagon can be seen at the intersection, with the horse and wagon facing northwest.[6] Exactly which of the next three images was recorded first is uncertain, but all were taken within an hour of each other. I was able to establish the time frame for these three images by studying the image I took on the north side of Main Street.

Duplicating the time frame for image 595 was somewhat challenging because the houses and buildings have changed from their original appearance. My time frame for this image is based on the shadows cast across the front of the houses falling from the front eves of the roofs

at right. I originally intended to document the transformation of the shadows cast across the front of the houses by finding a modern house at the same site with a roof similar to those in Gardner's and then match the shadows. This failed because trees and their shadows completely blocked out the fronts and roofs of the modern houses where the originals once stood (fig. 8.4a).

In my field investigation, I photographed one house on the north side of Main Street that is a little behind Gardner's original position (fig. 8.4b). Unfortunately, a tree casts its shadow on the front of the house, but the lines of the shadow from the eve of the roof can still be seen through the tree shadows cutting across the windows on the second story.

Original camera location: No restrictions on access to site

Gardner's 1862 photographic time: 3:30 P.M.

Modern time: 4:30 P.M., September 17, 2005

Camera angle: 245°

Shadow angle: 73°

The present location of Gardner's camera position has changed dramatically with the paving of Main Street, the addition of retaining walls and sidewalks, and the absence of the Lutheran church (see fig 8.5a). Of the three pictures Gardner took of Main Street, this was from the north side facing southwest. This view of Main Street as it runs west through Sharpsburg shows the Lutheran church that was heavily damaged by federal cannon fire. The church was eventually torn down and rebuilt on the other side of the road. Given how much shellfire hit the church and the houses behind it, it's amazing that there were no civilian casualties from federal artillery. Under magnification, five soldiers can be seen resting on the front stoop of the church (see fig.8.5b).

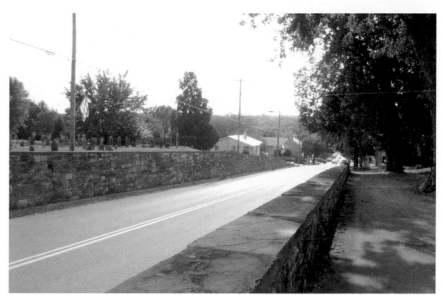

Fig. 8.5a

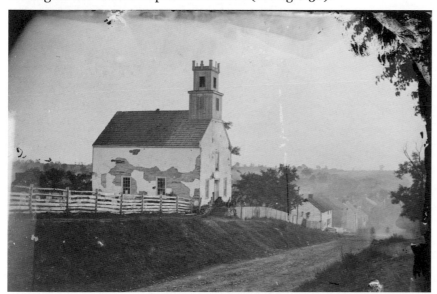

Fig. 8.5: Stereo plate 596: "Lutheran Church, Sharpsburg, Maryland." Courtesy Library of Congress (B815-596 right half)

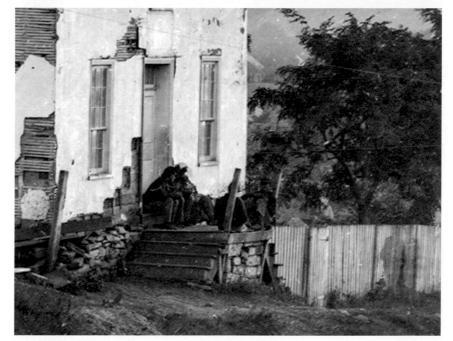

Fig. 8.5b

Original camera location: No restrictions on access to site
Gardner's 1862 photographic time: 3:45 P.M.
Modern time: 4:45 P.M., September 17, 2005
Camera angle: 245°
Shadow angle: 75°

The group of soldiers sitting on the front stoop of the church led to my discovery of a hidden duplicate stereo photograph of the church. Gardner took duplicate stereo plates of several scenes at Antietam, including the Middle Bridge, but the duplicate of the church remained hidden within the peculiarities of the Library of Congress indexing system. Both photographs have been accessible at the Library of Congress, but the fact that two existed has been overlooked because both plates are numbered

596: a whole and intact four-by-ten-inch stereo plate and a stereo plate that had been cut into two separate four-by-five-inch plates. I had long assumed that the cut version was a copy negative of the intact view. After all, both had Gardner's number 596 assigned to it, and at a quick glance they appeared to be the same view, although the left side of the cut plate version has cracks in the plate. The intact stereo version of this image has the five soldiers on the front stoop in their dark-blue uniforms, making the front stoop appear darker. But on closer examination, I noticed that in the cut stereo version there is no dark area on the stoop where the five soldiers sit. After enlarging the front of the church, I could see that only two soldiers sat on the front stoop with their backs to the upright posts, but this photo also had a soldier sitting in the grass below the stoop who is not present in the other image (fig. 8.6a).

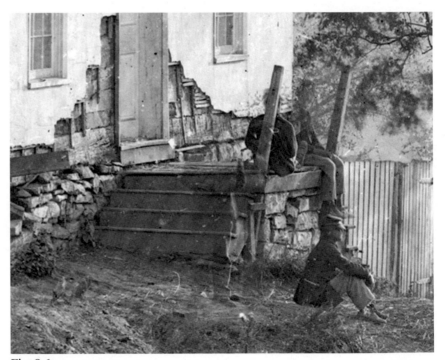

Fig. 8.6a

Fig. 8.6: Stereo plate 596: "Lutheran Church, Sharpsburg, Maryland." Courtesy Library of Congress (B811-596 right half)

Original camera location: Currently on private property
Gardner's 1862 photographic time: 5:00 P.M.
Modern time: 6:15 P.M., July 8, 2009
Camera angle: 330°
Shadow angle: 110°

The David Reel farm is located on the west side of Hauser's Ridge, roughly a half mile north of Sharpsburg on the Taylor Landing Road. The Confederates used the Reel farm as a field hospital and staging area for the attacks that took place in the morning hours of the 17th in the battle near the West Woods. Nestled out of sight and out of reach of the long-range Union artillery on the east side of Antietam Creek, the barn was eventually struck by a shell from closer Union artillery somewhere on the battlefield. When the shell burst, the barn caught

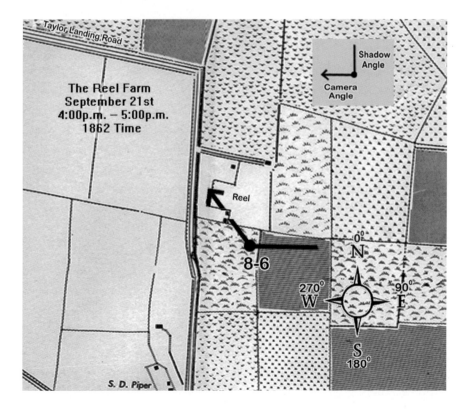

fire. How many wounded Confederate soldiers were inside the barn at the time, if any, and how many may have perished in the fire, will never be known. There are stories of children exploring the ruins of the barn and finding the charred human bones of some soldiers. The barn was gutted to its stone walls but was rebuilt after the war and still stands.

The modern picture here I took on July 8, 2009 (fig. 8.7a). This is one of the few Antietam images that I did not spend a whole lot of energy in

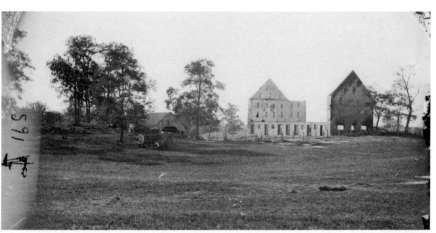

Fig. 8.7: Stereo plate 591: "Real's Barn, burned by the bursting of a Federal shell at the Battle of Antietam." Courtesy Library of Congress (B815-591 left half)

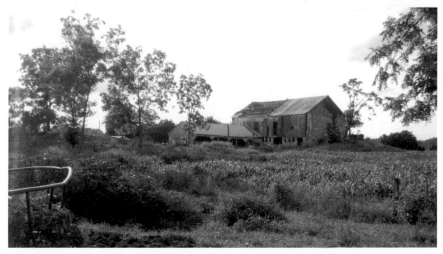

Fig. 8.7a

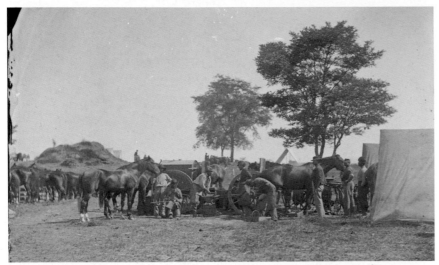

Fig. 8.8: Stereo Plate 587: "Forge Scene at General McClellan's Headquarters. Sharpsburg Sept. 22, 1862." Courtesy Library of Congress (B811-587 left half)

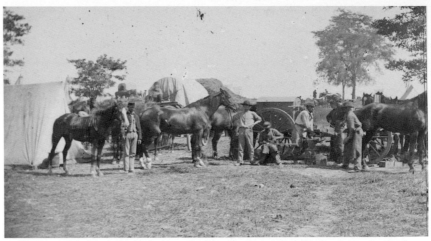

Fig. 8.9: 7 x 9 plate, single image: "Forge Scene at General McClellan's Headquarters." Courtesy Library of Congress (B817-7940)

determining an exact time. In examining Gardner's image, it is easy to see that this is a late-afternoon or early evening picture based on the long shadows cast from the trees in the picture. Several visits to the site over the years confirmed this. Because of its out-of-the-way location, Gardner would have needed extra time to travel there, which is why I believe this photo was shot on the 21st and not earlier. The Reel farm is located just north of the town of Sharpsburg, and it makes sense for Gardner to have recorded this image after taking the street views of Sharpsburg.

Gardner's stereo view 587 and the companion large-plate of the same scene are two of the most peculiar pictures in the Antietam series. It is possible that he took these forge scenes on the 22nd, as Gardner's caption says, but I am skeptical about the claim that he took them at McClellan's headquarters.

Figure 8.9 is almost an exact duplicate of the stereo view except for the small subtle changes in the posture of some of the soldiers who have moved slightly in the time between when the images were taken. If Gardner was at McClellan's camp, he might have taken these two images of a

forge at the Smith farm after sending the telegram on the 21st and then continued on to take the street scenes of Sharpsburg. Gardner, however, lists this image as being taken at McClellan's headquarters on the 22nd. If Gardner had been anywhere near McClellan's camp that day, surely he would have photographed staff officers, soldiers, tents, etc., but there are no images such as these to indicate that he was actually there. Instead, Gardner took two images of a horse being shod. (Though doubtful, it would be interesting if this happened to be McClellan's horse, Dan Webster.) I doubt that these images were taken anywhere near McClellan's headquarters; no other images exist that were taken nearby to directly link these images to McClellan's headquarters.

The fact that these images may not have been shot near McClellan's headquarters does not diminish their impact. One cannot overlook the fact that these two images give a different glimpse into another facet of daily life of the Army of the Potomac. Because of the lack of landmarks or land contours in these images, I doubt the location will ever be found. There is a mound in the background of these images that resembles another mound in the O. J. Smith field hospital views. Under magnification, however, there is no blacksmith and forge visible in the latter scenes.

9 ✠ Monday, September 22
The Burnside Bridge

Jonathan Gruber's *Farmers' Almanac* for Hagerstown and area, 1862
 Sunrise: 5:59 A.M. Sunset: 6:01 P.M.
Weather Channel.com, September 22, 2007, for Sharpsburg, Maryland
 Sunrise: 6:58 A.M. Sunset: 7:08 P.M.
Cloud conditions from the Frederick, Maryland, weather station, September 20, 1862, with 1 representing clear skies and no clouds, and with 10 as heavy cloud cover and overcast
 7:00 A.M. Degree: 0 Type: 0
 2:00 P.M. Degree: 3 Type: cirrocumulus
 Precipitation: 0
Temperature 7:00 A.M.: 56.5° 2:00 P.M.: 73°
 9:00 P.M.: 62°

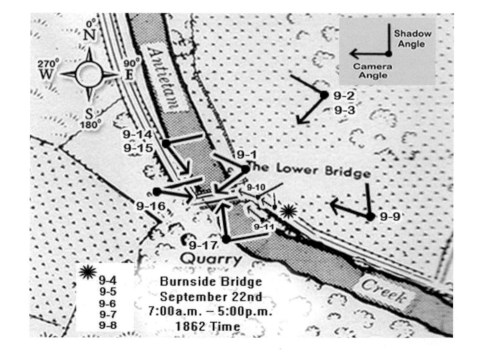

The Burnside Bridge—Morning and Early Afternoon

On September 22 and 23, the fourth and fifth days shooting photographs on the Antietam battlefield, Alexander Gardner and James Gibson began a series of thirty-two images at or near two of the three distinctive triple-arch stone bridges that crossed Antietam Creek, what today are known as Burnside Bridge and Middle Bridge. Based on weather conditions recorded by the Frederick weather station, I can say with confidence that they took the Burnside Bridge images first on the 22nd. Even though weather conditions were perfect for taking pictures on both days, a slight difference in cloud conditions would indicate that Gardner and Gibson were at the Burnside Bridge first. The minimal degree of cloudiness reported on the 22nd is reflected in a few of the Burnside Bridge pictures where there is no strong sunlight and the images are darker. The 23rd was a cloudless day with warm temperatures and nothing but sunny clear skies; all of the Middle Bridge photographs are bathed in sunlight.

Gardner, along with many others, wondered if McClellan would take the offensive. But during the first two hours of sunlight on the 22nd, the Army of the Potomac did not budge or show any signs of moving. It was becoming more evident that McClellan had no intention of taking on Lee any time soon. Based on the number of photographs taken at the bridges, Gardner must have received more glass plates sometime in the late evening on the 21st or early on the 22nd. The photographers were traveling as part of McClellan's entourage, and the glass plates were more than likely delivered by one of Brady's other employees or perhaps by Alexander Gardner's brother, James, or were sent to McClellan's headquarters via military couriers. Apparently fully restocked with plates, I think Gardner began his pictorial series at the Burnside Bridge early in the morning on September 22.

The two photographers arrived at the Burnside Bridge before 7:00 A.M., 1862 time. After crossing the bridge to the east bank, they parked the wagon at the end of the bridge in an adjoining field. There Gardner and Gibson would record most of the fifteen images they took of the famous bridge. They took eleven on the east bank of Antietam Creek, with the sun at their backs, and the remaining four from the west bank, again with the sun at their backs. Up to this point, Gardner shot all the Antietam images. But James Gibson is credited with four of the stereo views of the Burnside Bridge and, the following day, with four of the Middle Bridge. Unfortunately, Gardner did not assign plate numbers for some of the stereo images and all of his large-plates, and his captioning is confusing. For example, in plate 615, Gardner describes the image as a "northeast view." One might think that this is a view facing northeast, but it actually faces southwest.

The times that I have established for Gardner and Gibson's photography at both the Burnside and Middle Bridges were determined by finding one or more images with well-defined shadows cast by fixed objects (such as bridges) that have not changed over time (like trees). The Burnside Bridge series time line was established by my modern versions of stereo plates 614, 600, and 598. The remaining pictures I sequenced based on the progression of shadows and illumination of tree and bridge shadows in the pictures.

Once I placed all the photographs in sequence, from beginning to end, I added or subtracted the time it would have taken Gardner to take and develop one image, move on to the next site, and set up again based on my own times and photos. My presentation provides a very close approximate time frame for when Gardner and Gibson took their pictures.

Original camera location: Park property; no restrictions on access to site

Gardner's 1862 photographic time: 7:00 A.M.

Modern time: 8:00 A.M., September 25, 2010

Camera angle: 220°

Shadow angle: 270°

Two federal attempts to storm the bridge in the morning hours met with disastrous results. It was not until 1:00 P.M. that the 51st New York and 51st Pennsylvania crossed the bridge. Before this third attack, circumstances made the Confederate defense of the bridge untenable. Union forces were on the move north and south of the bridge looking for fords that would flank and envelop Toombs's position. The morning's fight for the bridge began to takes its toll on the few hundred southern defenders. Casualties rose, and without reinforcements every man counted that much more. On top of that, ammunition was running low. A backup plan was made to withdraw to a second defensive line on the Otto farm, and as the last of the ammunition began to run out, Confederate forces evacuated their formidable position. Such was the good luck of the two Union regiments that forced their way across the bridge as the Confederates retreated and regrouped at the Otto farm lane. Their fate no doubt would have been the same as the two previous federal attempts if Confederate ammunition had not run low and they had not begun to withdraw. The image Gardner recorded shows the fresh graves of the dead of the 51st New York who were laid to rest on the east bank of Antietam Creek.

My series of pictures proves that Gardner was at the Burnside Bridge by 8:00 A.M. that day. The first modern picture I took at 8:00 A.M. (fig. 9.1a), and it shows my shadow close to the right side of my body against the side of the stone wall. In the second picture, at 8:15 A.M. (fig. 9.1b), my shadow has moved further away from my body on the side of the wall. The last picture, at 8:30 A.M. (fig. 9.1c), clearly shows how far my shadow progressed over a half-hour period.

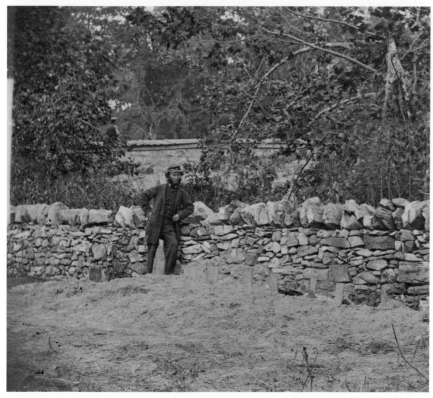

Fig. 9.1: Stereo plate 585: "Graves of Federal Soldiers at Burnside Bridge, Antietam, Sept 21st, 1862." Courtesy Library of Congress (B815-585 right half)

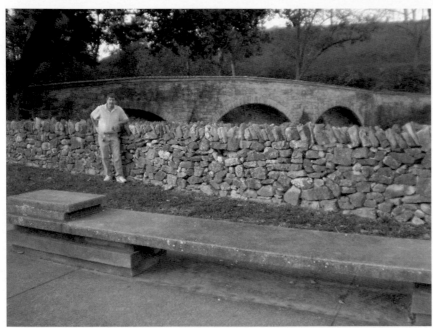

Fig. 9.1a

Fig. 9.1b

Fig. 9.1c

Original camera location: Park property; no restrictions on access to site
Gardner's 1862 photographic time: 8:20 A.M.
Modern time: 8:41 A.M., April 12, 2008
Camera angle: 230°
Shadow angle: 298°

Gardner recorded this stereo view from a hillside on the east side of the bridge looking in a southwest direction. In the background is the steep hillside where Toombs's Confederates wreaked havoc on the Ninth Corps that day. Gardner's wagon is out of view at far left. In taking a re-creation of Gardner's view in September 2005, I was hampered by the shadow of the large sycamore. Two pictures taken on April 12, 2008, show the effects of diffused sunlight. The first (fig. 9.2a), from 8:41 A.M., is shaded by clouds, and the second (fig. 9.2b), just eight minutes later, is in clear sunlight. It is the diffused version that matches Gardner's shot, especially in the shading of the inside area of the arches.

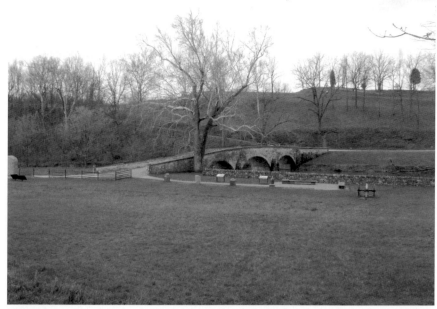

Fig. 9.2a

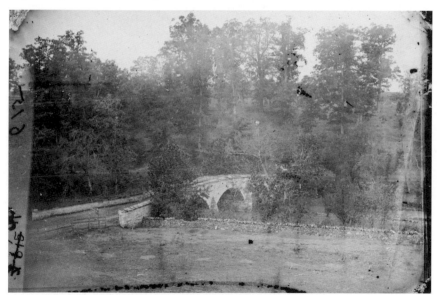

Fig. 9.2: Stereo plate 615: "Burnside Bridge across the Antietam, Northeast view, with graves of Union soldiers." Courtesy Library of Congress (B815-615 left half)

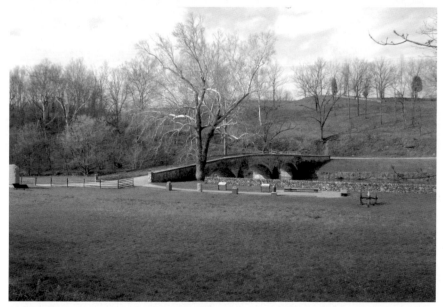

Fig. 9.2b

Original camera location: Park property; no restrictions on access to site
Gardner's 1862 photographic time: 8:35 A.M.
Camera angle: 230°

This folio view was taken from the same spot as stereo view 615, only with the large-format camera and a seven-by-nine-inch single-image plate.

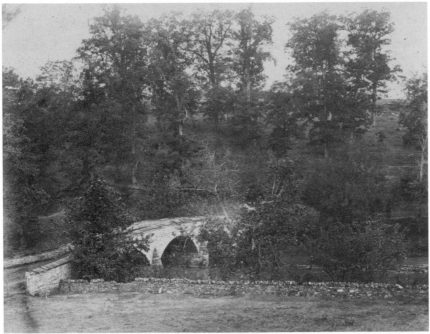

Fig. 9.3: 7 x 9 plate: "Burnside Bridge looking across stream." Courtesy Library of Congress

Original camera location: Park property; no restrictions on access to site
Gardner's 1862 photographic time: 9:00 A.M.
Camera angle: 311°

Gardner took this large-plate image and the following four images from almost the exact same spot. I determined the time frame of the series based on the progression of the tree shadows as they appear on the south side of the bridge and on the ground in front of the photographer on the Rohrbach Bridge Road, or presently known as the Lower Bridge Road.

These five pictures had to be taken before plate 600, which shows tree shadows falling across and covering the left side of the bridge, specifically the entire third arch to the left (see fig. 9.9). In figure 9.4, there are no tree shadows on the left side of the bridge, making this the first of these five shots. The sequence of these five images is also verified by

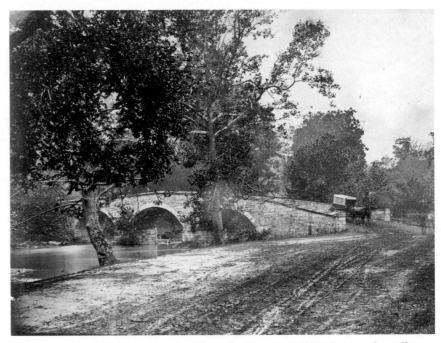

Fig. 9.4: 7 x 9 plate: "Burnside Bridge with wagon on bridge." From the collection of Bob Zeller

Fig. 9.4a

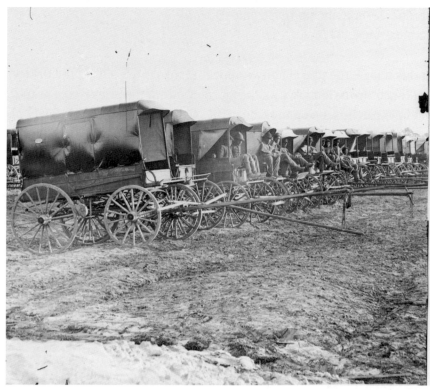

Fig. 9.4b

the progression of tree shadows on the ground as they move in front of the photographer in each photo. In this view, a shadow on the ground next to the tree at far left in the foreground is not yet touching the road that approaches the bridge.

Since I had an approximate time frame for plate 600, I worked backward and subtracted fifteen minutes for each image from the time of image 600 to arrive at my time line for these pictures. Because the growth of vegetation and trees is very different when I was shooting than it was in 1862, I chose only to include one of my modern photos from the same camera location to represent when Gardner took this series of five images.

This photo is one of the rarest of Gardner's Antietam series, and only a single extant print is known to exist. The plate most likely was broken not long after the image was taken. The wagon in the image is not Gardner's darkroom wagon seen in the Mumma farm and Main Street images but more than likely is an ambulance wagon coming from the Otto or Sherrick farm (fig. 9.4a). This style of wagon can be seen in another Civil War photograph titled "Virginia, City Point, Park of Army Wagons" (fig. 9.4b).

Gardner's 1862 photographic time: 9:15 A.M.

Camera angle: 311°

In this image, the tree shadows appear at the far left side of the bridge, just touching the left arch. At the far right side of the bridge, tree branch shadows can be seen on the side of the bridge at the east entrance. Look closely at the shadows from the trees along the Lower Bridge Road in the foreground and notice how they progress through the next three pictures.

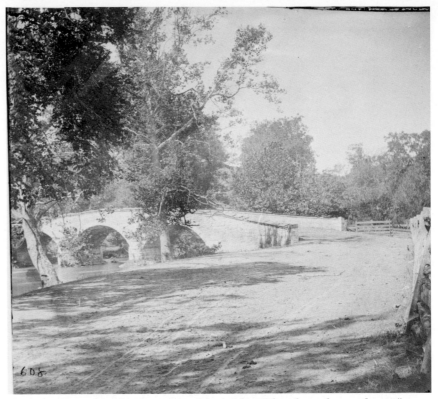

Fig. 9.5: Unnumbered stereo plate: "Burnside Bridge, from the southeast." Courtesy Library of Congress (B811-608A left half)

Gardner's 1862 photographic time: 9:30 A.M.
Camera angle: 311°

In this image, shadows have moved almost to the center of the arch at far left, while the shadows on the wall at far right to the entrance of the bridge are still there but are thicker. The telltale sign of the progression of these images is the large tree shadow on the ground closest to the bridge. Here the tips of the shadows have crossed the middle of the Lower Bridge Road. Gardner took this photograph and then turned the camera over to Gibson.

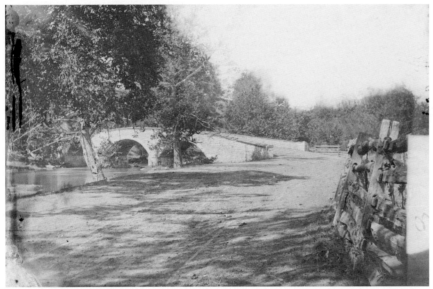

Fig. 9.6: Stereo plate 601: "Burnside Bridge, from the southeast." Courtesy Library of Congress (B815-601 left half)

Gibson's 1862 photographic time: 9:45 A.M.
Camera angle: 311°

Gibson took this image under overcast skies, as determined by the Frederick weather station accounts and the clarity of the remaining images taken that day. Even though Gibson shot under diffused sunlight, the tree trunks in the foreground still show their left sides in silhouette, proving that it was taken with this group of four images.

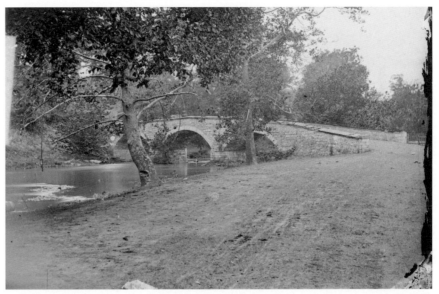

Fig. 9.7: Stereo plate 604: "Burnside Bridge, from the southeast." Courtesy Library of Congress (B815-604 right half)

Gardner's 1862 photographic time: 11:00 A.M.
Modern time: 12:00 P.M., September 16, 2005
Camera angle: 311°
Shadow angle: 350°

In this image, the shadow is almost halfway across the arch at far left, and the large tree shadow on the ground closest to the bridge is now touching the post-rail fence at right. I took my picture on September 16, 2005 (fig. 9.8a).

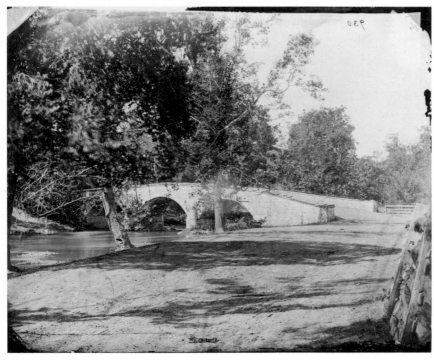

Fig. 9.8: 7 x 9 plate: "Burnside Bridge, from the southeast." Courtesy Library of Congress (B817-7930)

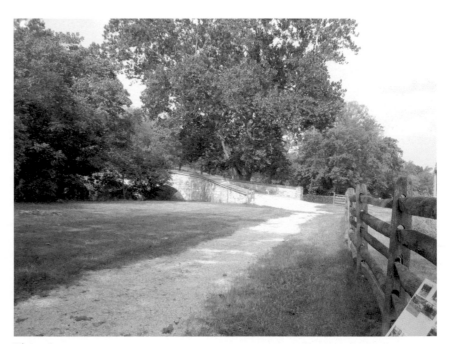

Fig. 9.8a

Original camera location: Park property; no restrictions on access to site
Gardner's 1862 photographic time: 11:20 A.M.
Modern time: 12:20 P.M., September 18, 2004
Camera angle: 288°
Shadow angle: 350°

Gardner moved his camera position to the field at the east end of the bridge and took an image looking northwest. Clearly visible, the tree shadows on the bridge have crossed the arch at far left. At the entrance of the bridge is a shadow cast on the floor from the bridge parapet at left. It was this shadow on the floor of the bridge and the illumination of the fence rails that line the Lower Bridge Road that provided me with a time frame. Immediately to the left of the monument of the 51st New York Infantry is where the photographers parked the darkroom wagon. I took my picture on September 18, 2004 (fig. 9.9a).

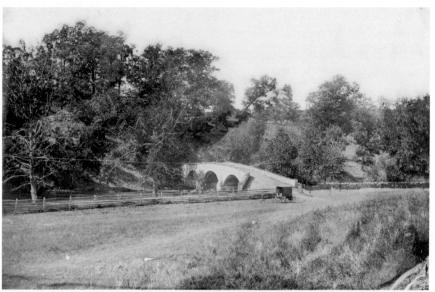

Fig. 9.9: Stereo plate 600: "Burnside Bridge, southeastern view." Courtesy Library of Congress (B815-600 right half)

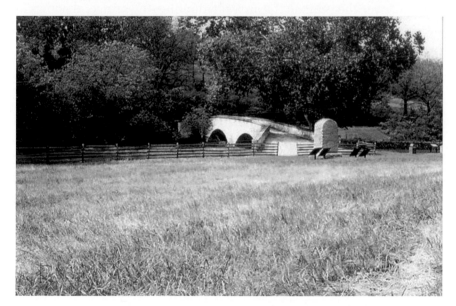

Fig. 9.9a

Original camera location: Park property; no restrictions on access to site
Gibson's 1862 photographic time: 1:15 P.M.
Modern time: 2:00 P.M., September 17, 2006
Camera angle: 285°
Shadow angle: 32°

Gibson moved the camera close to the east entrance of the bridge and took this image with a group of soldiers sitting and standing on the bridge (a 125-foot, three-arch span that was built for $2,300 in the 1840s).[1] The shadows on the arch at left have moved and are touching the middle arch. Shadows are cast from the soldier sitting on top of the bridge with his legs hanging off the side as well as from the soldier leaning against the inside north wall of the bridge near the sycamore tree that still stands—another witness tree. But the shadow cast on the floor of the bridge from the left parapet on which the soldiers sat gave me a really accurate time for this image. Because the vegetation has changed over the years in the area surrounding the bridge, shadows in the modern pictures are different than they are in Gibson's shot. Again, over years, I took a series of pictures with volunteers within two weeks of the time when Gibson recorded this image. This modern view I took on September 17, 2006, at 1:55 P.M. Gibson's recorded his view between 2:00 and 2:30 P.M. (fig. 9.10a).

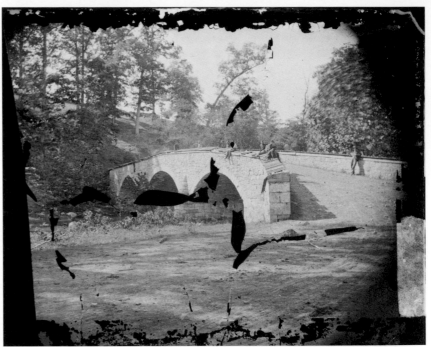

Fig. 9.10: Stereo plate 614: "Burnside Bridge across the Antietam, eastern view." Courtesy Library of Congress (B811-614 right half)

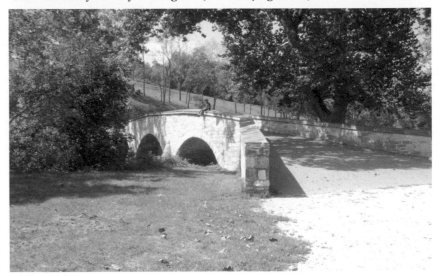

Fig. 9.10a

Original camera location: Park property; no restrictions on access to site

Gibson's 1862 photographic time: 1:30 P.M.

Modern time: Not applicable

After moving to a new position slightly back from where Gardner took the five views looking northwest, Gibson took plate 584, one of the most distinctive images of the bridge. The tree shadows on the side of the bridge are finally touching the arch at right. Off to the far right side of the image area is a figure standing next to the bridge, and immediately to the right of this figure is a dark horse. (Could this be Gardner's un-hitched darkroom wagon horse?) Vegetation has overgrown this site and affected the shadowing, so I did not include a modern view.

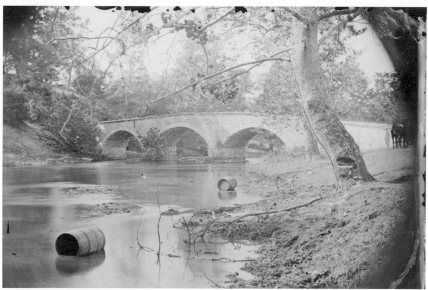

Fig. 9.11: Stereo plate 584: "Burnside Bridge, Antietam, looking upstream." Courtesy Library of Congress (B815-584 right half)

Original camera location: Park property; no restrictions on access to site

Gardner's 1862 photographic time: 2:32 P.M.

Modern time: 3:32 P.M., September 25, 2010

Camera angle: 360°

Shadow angle: 64°

After Gibson took plate 584, it appears that the two photographers decided they were finished shooting the bridge and moved on to new sights. With the cameras and equipment stowed on the darkroom wagon, the two crossed back over the bridge and proceeded westward on the Lower Bridge Road roughly a half mile to the Otto farmhouse, where they stopped. Gardner again unloaded the camera and equipment and took a shot across the road showing the Sherrick house. It is rather

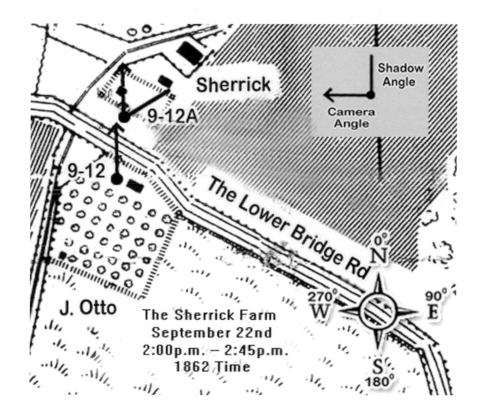

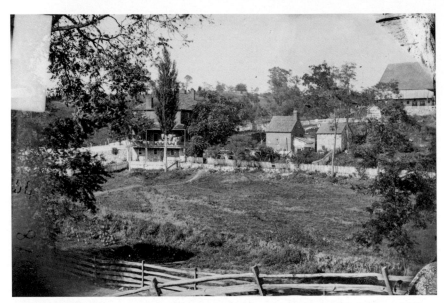

Fig. 9.12: Stereo plate 598: "Sherrick's House, near the Burnside Bridge, Antietam." Courtesy Library of Congress (B815-598 right half)

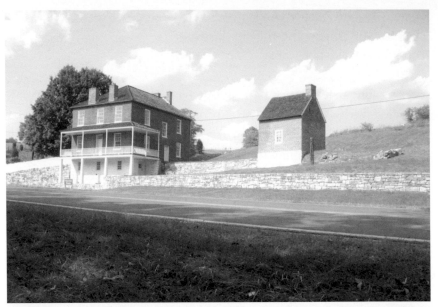

Fig. 9.12a

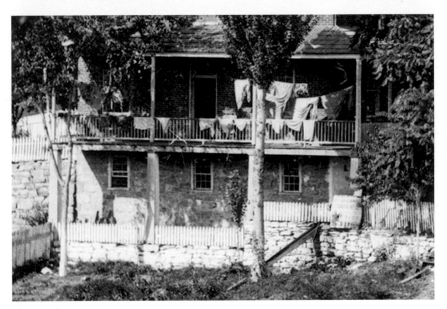

Fig. 9.12b

odd that he did not simply turn around and also shoot the Otto house, especially when he was within seventy-five feet of it.

Having had another early start on the battlefield, and after spending five hours taking photographs at the Burnside Bridge from every conceivable angle, the two photographers may have well been hungry. Since both the Sherrick and Otto houses were hospitals serving the 79th New York Volunteer Infantry and other units of the Ninth Corps, and since Union troops were camped in the vicinity, this would have been the closest place to find a hot meal. Perhaps Gardner graciously returned a favor for a hot meal by mentioning them in the caption for plate 571, one of the longest captions in the Antietam series: "View on Battle-field of Antietam near Sherrick's House, where the 79th New York Volunteers fought after they crossed the creek; group of dead Confederates."

There is a two-hour gap from when Gibson took the last view of the bridge, plate 584, from the east bank until he took his first picture on

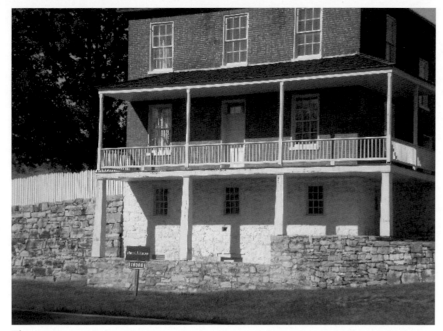

Fig. 9.12c

Stereo plate 571: View on Battle-field of Antietam near Sherrick's House, where the Seventy-ninth New York Volunteers fought after they crossed the creek; group of dead Confederates

William Frassanito found what appears to be an excellent potential photographic location on the Sherrick farm for this Gardner image of two dead Confederate soldiers. The caption mentions the Sherrick House; Gardner was in the vicinity of the Sherrick House, at the Otto House, and the terrain in Frassanito's modern picture somewhat fits with Gardner's image. But as Frassanito points out, there are discrepancies between his photo site and Gardner's image.[2] Maps show that there was an apple orchard there during the battle, yet in the image there are no apple trees in the field where the two bodies are lying. Another glitch is that maps of

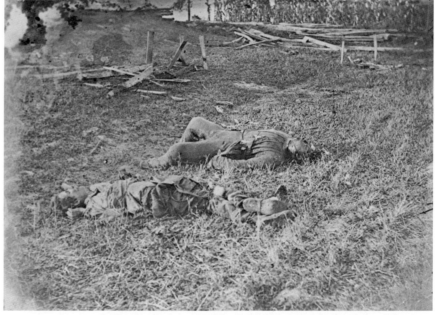

Fig. 9.13: Stereo plate 571: "View on Battle-field of Antietam near Sherrick's House, where the Seventy-ninth New York Volunteers fought after they crossed the creek; group of dead Confederates." Courtesy Library of Congress (B811-571 left half)

the west bank, and the times I have established for the shooting of the last four views of the Burnside Bridge suggest that he did indeed return to the bridge. These two hours would have given Gardner and Gibson plenty of time to leave the bridge, take the picture of the Sherrick house, eat, and return to the bridge to take the last four images.

Unfortunately, many of the photo sites are now obscured by trees and vegetation. Such is the case with Gardner's photo site near the Otto house, where trees completely block the view of the Sherrick house. Therefore, I had to move my camera position much closer to the Sherrick house. On September 25, 2010, I took a series of images every minute starting at 3:15 P.M. in an attempt to duplicate the shadows on the bottom level of the house (fig. 9.12a). My photo proves that Gardner took his shot between 3:28 P.M. and 3:34 P.M. (figs. 9.12b and 9.12c).

the battlefield show this orchard surrounded by a stone wall. Gardner's image, however, shows this section of fence line as mainly comprised of fence rails, with some rock foundation showing underneath the rails.

I have strong reservations about the location of this photo simply because the dead of both sides would have been buried long before Gardner and Gibson arrived in the area of the Burnside Bridge. Finding dead Confederate soldiers to photograph on the Sherrick property would have been highly unlikely given how few southern soldiers were killed on the Sherrick farm. Throughout the entire day of the 17th, Jenkins Brigade fought to maintain control of the Sherrick farm along the Lower Bridge Road. They were engaged with the much larger federal brigade under Christ's command. Twenty-one soldiers from Jenkins's Brigade were killed.[3] It is important to note that Frassanito's proposed site is more than a couple hundred yards behind Confederate front lines when fighting stopped on the evening of the 17th.

The location of this site was situated between Confederate artillery on the high ground, where the National Cemetery is located, and the Sherrick stone mill that was used as a field hospital on the 17th and 18th. It is highly unlikely that these two bodies would be carelessly overlooked by their own comrades in such an open area between these two positions. According to the usual method of removing the dead on the field, both sides buried their own dead first behind their lines of battle after the fighting stopped. This gave the Confederates the night of the 17th and the following day to clear this area of their own dead. The National Park Service has a marker along the park road on the ridge overlooking the Sherrick house designating where the Confederate front lines were on the 17th and 18th. This is the same ridge seen above and behind the Sherrick house in Gardner's image.

The best piece of evidence suggesting that the Confederate dead were buried before Gardner arrived comes from the Confederate officer in charge of defending the Sherrick front. Col. Joseph Walker commanding Jenkins's Brigade wrote: "Changing the front of my brigade again toward Antietam Creek, and at right angles to the turnpike and the ravine, I threw forward a line of skirmishers to a fence near the timber

Fig. 9.13a

on the creek, and bivouacked for the rest of the night. This position the brigade, alone and unsupported, held during the 18th, burying the dead and caring for the wounded, the skirmishers the meanwhile keeping up a brisk fire upon the enemy."[4]

I have walked the perimeter of the Sherrick cornfield on the slopes of the hill leading up to the National Cemetery and cannot find any other potential camera locations for this image on the Sherrick property. Presently, most of this area is enclosed by wire fence and is often heavily overgrown with vegetation. The picture I took in April 2008 includes Frassanito's site (fig. 9.13a). From this view, it appears that the stalks of corn in Gardner's image should have been shorter or lower, because the section of the cornfield at this site sits below the edge of the orchard. The easiest way to access Frassanito's camera location is through the National Cemetery. On the south wall of the cemetery, there are steps that allow you to exit the cemetery, where Confederate artillery was once located. From the cemetery, walk south downhill toward the Sherrick mill. My conviction that the two dead soldiers in this image were recorded elsewhere on the battlefield led me to explore other areas for potential photographic sites.

The Burnside Bridge—Late afternoon

Original camera location: Park property; no restrictions on access to site

Gibson's 1862 photographic time: 4:05 P.M.

Modern time: 5:05 P.M., September 25, 2010

Camera angle: 150°

Shadow angle: 80°

Assuming Gardner and Gibson took all of their photographs on the same day, the 22nd, which I believe was the case, they returned to the stone span to take four more images on the west bank. Why they chose to return to the bridge after having already taken eleven pictures perplexes me, unless it was because he knew that he would have the sun to his back the rest of the afternoon while shooting from the west bank. In any event, it is obvious that Gardner found the bridges compelling, given the amount of time he spent at them and the number of plates made of them over two days.

In the afternoon, Gibson manned the camera and took another picture of the bridge, facing south from the west bank of Antietam Creek. I intended to duplicate the narrow band of sunlight under each arch in Gibson's image and took my version on September 25, 2010 (fig. 9.14a). I matched Gibson's shot where the strip of sunlight touches the mortar joint of two stones of the arch at left: one stone is brightly illuminated, and the stone to the left of it is dark in shadow. The same two stones are visible at the waterline of the arch at left in both Gibson's and my views (figs. 9.14b and 9.14c). It is apparent that the water level was lower in 1862 than when I shot my pictures in 2010. I was able to document this by counting the same layer of stones that make up the foundation for the arch at left.

A closer look inside the arch at left in Gibson's image reveals the same barrels seen in stereo plate 604 (see fig. 9.7). But what caught my eye is a family posing in a wagon in the center of the bridge (fig. 9.14d). Standing at the front end of the wagon, a gentleman wearing a dark hat is looking back at the photographer. Sitting on the bench immediately

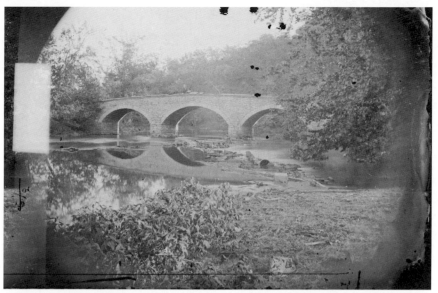

Fig. 9.14: Stereo plate 612: "Burnside Bridge across the Antietam, northeast view." Courtesy Library of Congress (B815-612 right half)

Fig. 9.14a

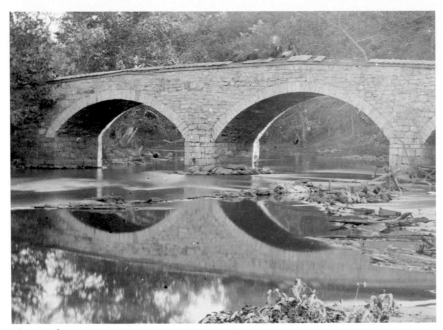

Fig. 9.14b

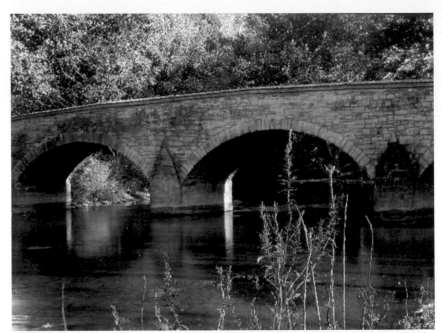

Fig. 9.14c

in front and to the right of the man appears to be a young boy. To the right of the boy is a woman wearing a dark bonnet. Here, within days of the battle, Gibson captures on glass some of the civilians visiting the battlefield for a firsthand look.

After Gibson took his stereo view, Gardner then manned the camera and took a large seven-by-nine-inch plate from the same location. A plate listed in Gardner's *Photographic Incidents of the War* catalog is said to show "Burnside Bridge looking downstream." Unfortunately, there is no picture to match this caption. The original glass plate is missing, and it is not known if any versions reproduced from the original of this image exist. Following Gardner's track record of photographing the seven-by-nine-inch plates with an accompanying stereo view, I assume that this view was recorded from the same spot as the previous image.

Fig. 9.14d

Original cameral location: Park property; no restrictions on access to site
Gardner's 1862 photographic time: 4:40 P.M.
Modern time: 4:00 P.M., October 4, 2004
Camera angle: 100°
Shadow angle: 70°

Gardner recorded the last three images on the west bank near the bridge late in the afternoon, and they fall nicely into the sequence of pictures taken on the 22nd. With the wagon parked near the west entrance to the bridge, Gardner scaled the hill on the west side of the bridge until, halfway up, he turned the camera and took the image looking down on the bridge. From this view, it is easy to see why the lightly defended Confederate positions overlooking the bridge were so formidable (fig. 9.15a).

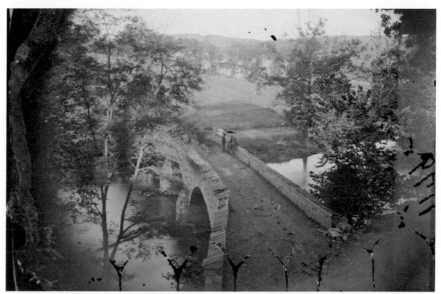

Fig. 9.15: Unnumbered, untitled stereo plate; "view taken from tree?" written by Library of Congress on plate sleeve. Courtesy Library of Congress (B815-1179 left half)

Fig. 9.15a

Original camera location: Park property; no restrictions on access to site
Gardner's 1862 photographic time: 5:00 P.M.
Modern time: 5;15 P.M., March 20, 2011
Camera angle: Not taken
Shadow angle: Not taken

Still on the west bank, Gardner took his camera south of the bridge to record this view; he placed his camera by the edge of the creek and faced north, looking upstream. This camera location is just on the opposite side of Antietam Creek from where he recorded plate 584 (see fig. 9.11). The view is a very late afternoon image, evident in how it's encased in shadows from the hill and trees on the west bank. I took my view at 5:15 P.M. (DST) on March 20, 2011 (fig. 9.16a).

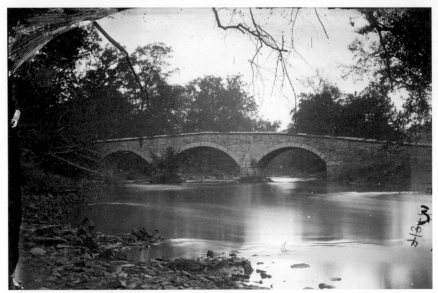

Fig. 9.16: Stereo plate 613: "Burnside Bridge across the Antietam, southwest view." Courtesy Library of Congress (B811-613 left half)

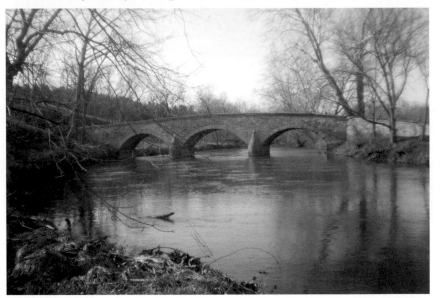

Fig. 9.16a

10 ✠ Tuesday, September 23
The Middle Bridge

Jonathan Gruber's *Farmers' Almanac* for Hagerstown and area, 1862
 Sunrise: 6:01 A.M. Sunset: 5:59 P.M.
Weather Channel.com, September 23, 2007, for Sharpsburg, Maryland
 Sunrise: 6:58 A.M. Sunset: 7:08 P.M.
Cloud conditions from the Frederick, Maryland, weather station, September 20, 1862, with 1 representing clear skies and no clouds and with 10 as heavy cloud cover and overcast
 7:00 A.M. Degree: 0 Type: 0
 2:00 P.M. Degree: 0 Type: 0
 Precipitation: 0
Temperature 7:00 A.M.: 56° 2:00 P.M.: 72.5°
 9:00 P.M.: 63°

By the morning of September 23, it was becoming increasingly obvious that McClellan would sit on his laurels, confident that he had done enough by saving the day and driving the Confederates from Maryland. With plenty of time and plates, Gardner and Gibson spent the day taking photographs of another three-arch stone bridge, the Middle Bridge, located about a mile north of the Burnside Bridge.

The series of pictures of the Middle Bridge and the immediate vicinity is comprised of sixteen known images—thirteen stereographs and three large-plates. Unfortunately, the sites of Gardner and Gibson's camera locations around the Middle Bridge have all changed and became overgrown by trees and other foliage that completely block the sites, negating any chance to capture pictures like those taken at the Burnside Bridge in 1862. I attempted to photograph Gardner's sites in the fall and spring, when trees are bare of their leaves and the foliage is gone, but trees have grown in so thick in these spots that it is still impossible to even see the bridge. Compounding the problem is the fact that the original

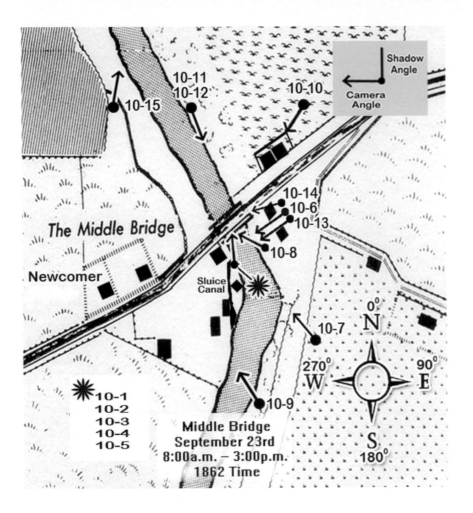

three-arch stone bridge was destroyed by a flood in 1891. The Reverend B. R. Carnaham had just crossed the bridge on his way to Keedysville to preside over services at his church when the bridge, without warning, suddenly crashed into Antietam Creek.[1] The original appearance of the banks on both sides of Antietam Creek was altered by the construction of the new bridge, most noticeably the east bank.

There is enough illumination in Gardner's images, however, to use the shadows to set approximate times and to create a chronological order for each Middle Bridge shot. Three Gardner stereo images in the Middle Bridge series revealed an approximate time frame; these are plates 610, 608, and 583 (see figs. 10.6, 10.7, and 10.13). As with the views at the Burnside Bridge, I sequenced the remaining images at the Middle Bridge by comparing shadows and how the bridge was illuminated differently during the day. So as not to be repetitive with a description of the changes in each image, I have summarized the illumination transition by focusing on certain elements of the bridge and landscape.

From the first picture at the Middle Bridge in the creek to the last image of the civilian wagon at the end of the bridge, my sequence shows when the first tree shadows touch the bridge, traverse the side of the bridge, and, finally, exit off the bridge. On either side of the center arch, the bridge supports are rounded, conical, resembling an upside-down ice cream cone. In the first five of Gardner's images, no shadows are cast to the right or left from the rounded supports. It is not until Gardner is on the east bank taking pictures that a shadow "grows" on the right side of these supports.

Original camera location: Park property; inaccessible
Gardner's 1862 photographic time: 8:10 A.M.

On the west bank of Antietam Creek, the two photographers stopped near the Newcomer mill and unloaded the cameras. Gardner recorded this and the next three images facing in a northerly direction from a spot on the west bank. At first it appears that Gardner waded into the creek to take these views of the bridge, but actually he just walked across a footbridge, keeping his feet dry. When the mill was built, a sluice canal was dug, creating a small man-made island in the creek. At the entrance of the canal closest to the bridge, a sluice was added to control the flow of water that operated the wheel in the mill. Under magnification, the footbridge and the sluice are seen in several other images taken from the east side of the Middle Bridge. The canal is still there today, hidden among the trees that line the west bank of the creek. I took my photo in the afternoon on September 19, 2009 (fig. 10.1a).

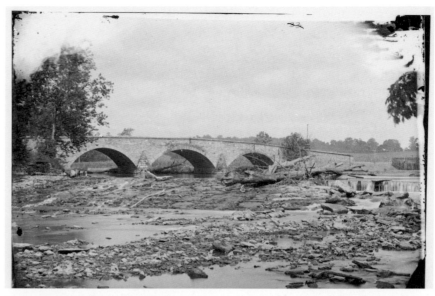

Fig. 10.1: 7 x 9 plate, single image: "Antietam Bridge, on the Sharpsburg and Boonsboro Pike, southeast view." Courtesy Library of Congress (B817-7214)

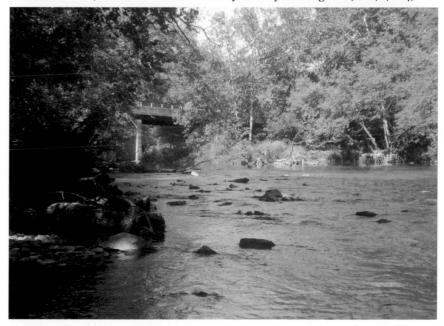

Fig. 10.1a

When Gardner recorded this series at and near the Middle Bridge, traffic on the Boonsboro Pike was extremely busy with the supply wagons of the Army of the Potomac. On top of the bridge, above the two arches at left, one of these wagons heading east can be seen. For unknown reasons, Gardner was fond of this shot and, in addition to the large-plate photograph, he exposed three almost identical stereo plates from this same camera spot.

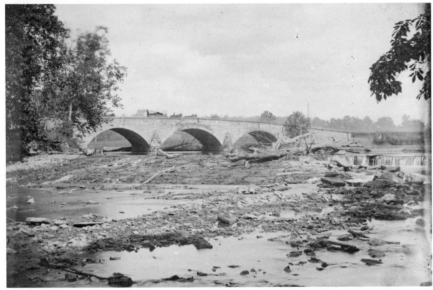

Fig. 10.2: Stereo plate 578: "Antietam Bridge, on Sharpsburg and Boonsboro Turnpike; looking upstream." Courtesy Library of Congress (B815-578 right half)

The only difference between this and the previous view is that the wagon is not on the bridge. Still at the same spot, Gardner shifted the camera just slightly to the right.

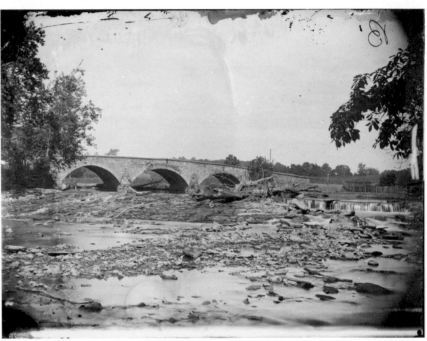

Fig. 10.3: Unnumbered stereo plate: "Looking upstream." Courtesy Library of Congress (B811-572 right half)

Original camera location: Park property; inaccessible
Gardner's 1862 photographic time: 9:15 A.M.

Notice that the leaves at the right edge of the image are blurred, indicating that there was a slight breeze when Gardner took this picture.

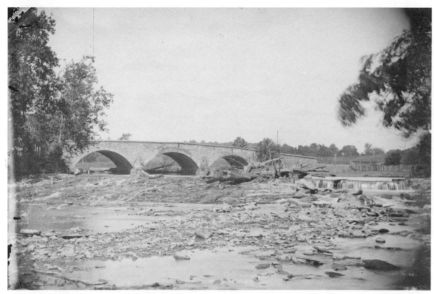

Fig. 10.4: Unnumbered stereo plate: "Looking upstream." Courtesy Library of Congress (B815-572 left half)

Original camera location: Park property; inaccessible
Gibson's 1862 photographic time: 9:30 A.M.

After taking these four images of the bridge, Gardner turned the camera over to Gibson, who moved to the right of the previous images toward the middle of the creek. In this last picture, shadows are finally seen against the wall of the west end of the bridge at far left.

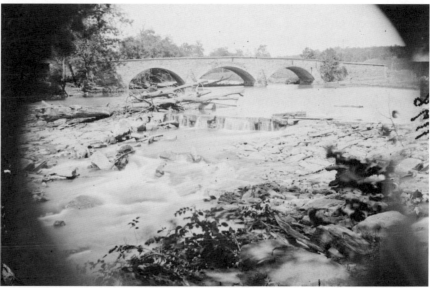

Fig. 10.5: Unnumbered stereo plate: "Looking upstream." Courtesy Library of Congress (B815-1178 left half)

Crossing over the Middle Bridge and traveling east, Gardner and Gibson took the Ecker farm lane that rises to the top of the high bluff overlooking Antietam Creek on the east side. On the way up, the two stopped at a bend in the lane, where Gardner took a picture of the bridge and the Boonsboro Pike. The side of the one-story house facing Gardner is fully illuminated from late-morning sunlight; notice the direction of the shadow from the chimney that points northwest. The three structures—the stone house and the two sheds in the foreground—are no longer there. Across the creek on the west side of Antietam Creek are the Newcomer farm buildings. One structure in particular is the small shed next to the west end of the bridge. Its shadow, as well as the trees' shadows next to it along the creek, is also pointing in the same direction, northwest.

At the left side of the image through the trees on the bank is the Newcomer mill. Between the shed and the mill can be seen the small sluice canal from the creek going to the back of the mill. The sluice and the little wooden footbridge that spanned this canal are easily identified in the last two pictures in this series. The gate is long gone, but the canal is still there. A modern picture I took from the east bank of the creek in September 2007 shows where the sluice gates were once located on the west bank (fig. 10.6a). Seen just above the mill is the large Newcomer barn. To the right of the barn, and directly above the chimney of the house, are the two Newcomer houses, the residences of Joshua Newcomer and family and of his son William and his family. Only one house and barn remain standing.

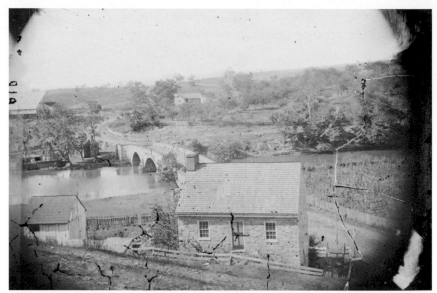

Fig. 10.6: Stereo plate 610: "Antietam Bridge, eastern view." Courtesy Library of Congress (B815-610 right half)

Fig. 10.6a

Original camera location: Currently on private property
Gibson's 1862 photographic time: 11:00 A.M.
Modern time: 11:25 A.M., November 7, 2004
Camera angle: 320°
Shadow angle: 360°

Traveling further up the Ecker farm lane, the two photographers made their way to the top of the hill overlooking the creek. Gibson again manned the stereo camera and took a fantastic view looking due north. From this vantage point, you get a true sense of how hilly and steep the terrain is around Antietam Creek. Outnumbered by the arriving Union army, Confederate forces originally held the top of the ridge overlooking Antietam Creek until their withdrawal on the 16th.

Two army wagons can be seen entering the bridge on the west side, and visible through the trees on the steep hill at left in the background is a fence running down to the creek. Further in the distance is a farm lane bordered by a rail fence with what appears to be several mounted soldiers almost halfway up the hill. Just above them, in the center horizon, is the East Woods; on the far right horizon are the M. Miller farm and woods. Below is a large barn and farmhouse belonging to the Neikirk family.

Just under the arch at right, next to the small tree growing against the bridge, is a jon-boat that will be the main prop in Gardner's next image. There is another lighter version of this image in the Library of Congress, taken from the same glass negative of this view, that reveals another boat under the arch at far left.

One shadow in this image gives an indication as to when Gibson took it. On the east end of the bridge, a shadow emerges onto the Boonsboro Pike from the wall at the end of the bridge. The locations of three other Gardner camera positions are found in this picture. Gardner's camera position for image 597, "View on Antietam" (fig. 10.15), can be found on

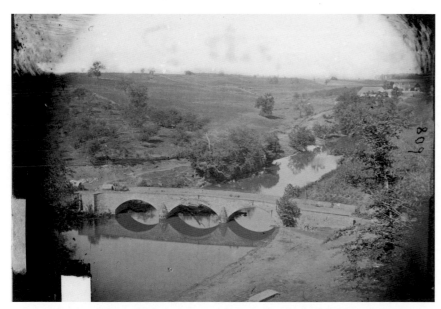

Fig. 10.7: Stereo plate 608: "Antietam Bridge, on the Sharpsburg and Boonsboro Pike, southeast view." Courtesy Library of Congress (B811-608 left half)

Fig. 10.7a

the west bank above the center arch where the dark worm fence above the farm lane touches the row of trees on the bank directly above the bridge. Gardner also took two more pictures (figs. 10.11 and 10.12) on the east bank looking southwest at a point directly across the creek from the camera location of view 597.

The picture I took in the fall of 2004 shows how much the foliage has grown in at almost all of the camera locations at the Middle Bridge (fig. 10.7a). Looking closely, you can see the modern bridge in the bottom center of the picture; it appears as a horizontal band of gray.

Original camera location: Park property; accessible, but heavy foliage
Gardner's 1862 photographic time: 12:00 P.M.

This is a most unusual photograph in its concept. For Gardner to have two women pose while eating hardtack in a small jon-boat along the banks of Antietam Creek is quirky. Sitting and posing in the boat would have been one thing—but the idea of them having a "picnic" in a boat docked on the bank is odd. The women appear to be visitors to the battlefield, but the thought of them having a picnic party on Antietam Creek less than a week after the great battle—when the stench of the dead still permeated the area and when every nearby farm was a field hospital where men died daily—is hard to imagine. This scene has also caught the attention of three soldiers, who are on top of the bridge watching Gardner and Gibson set up the shot.

The time frame that I have come up with is based on the shadows from the rounded bridge supports. In the previous image, shadows are just beginning to form on the right side of the supports. In this view, the shadows are considerably darker, with almost half of the supports in silhouette, which would indicate that this picture had to be taken after the two images were recorded on the hillside. The buggy and horse cast a shadow in a northeast direction. If it was a late-afternoon shot, the shadows from the horse and buggy would be pointing more to the right.

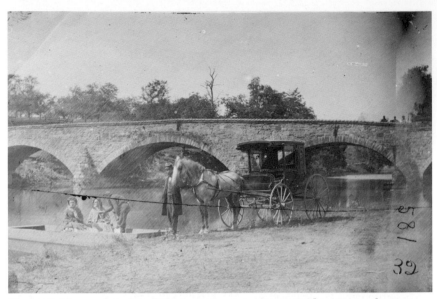

Fig. 10.8: Stereo plate 581: "Picnic Party, at Antietam Bridge, September 22, 1862." Courtesy Library of Congress (B815-581 left half)

Original camera location: Park property; accessible, but heavy foliage
Gardner's 1862 photographic time: 12:20 P.M.

Gardner took his stereo camera south along the east bank to a point opposite the Newcomer mill to take this photograph. In the background above the small shed next to the creek is one of the Newcomer farmhouses. I took my photo during the afternoon of September 19, 2009 (fig. 10.9a).

Fig. 10.9: Stereo plate 582: "Newcomer's Mill near Antietam." Courtesy Library of Congress (B811-582 right half)

Fig. 10.9a

In this image of the bridge, all the major buildings around the Middle Bridge come into view, though the smaller shed to the left of the house is out of sight. I found another small barn not seen in any of the Middle Bridge series and not listed on the maps (fig. 10.10a). This barn is visible just above and between the wagons entering the bridge at left. This barn would have been in front of the Newcomer mill on the man-made island created when the canal was built. Gibson took this image of the house, which still stands, and adjoining building en route to the next location.

Fig. 10.10: Stereo plate 607: "Bridge across the Antietam, northeast view." Courtesy Library of Congress (B815-607 right half)

Fig. 10.10a

Original camera location: Currently on private property
Gardner's 1862 photographic time: 1:10 P.M.
Stereo plate 609: Antietam Bridge, looking down stream

Back in the wagon, Gardner and Gibson skirt the cornfield north of the Boonsboro Pike until they come to the creek bank. This camera location is just across the creek where image 597 was taken. The illumination of the bridge and the trees in silhouette on the west bank, and the shadows of the small trees on the hillside in the background, indicate that this is an afternoon image.

Fig. 10.11: Stereo plate 609: "Antietam Bridge, looking down stream." Courtesy Library of Congress (B811-609 left half)

Gardner's 1862 photographic time: 1:30 P.M.
7 x 9 plate, single image: Antietam Bridge, looking down stream

This single-image large-plate photograph was recorded just a couple of minutes after the previous image and from the exact same spot.

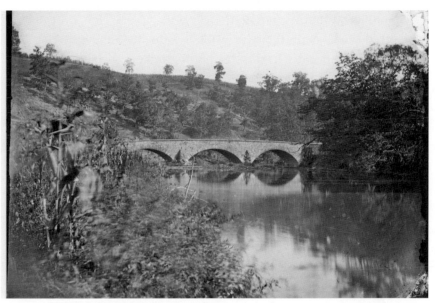

Fig. 10.12: 7 x 9 plate, single image: "Antietam Bridge, looking down stream." Courtesy Library of Congress (B817-7093)

Original camera location: Park property; inaccessible
Gardner's 1862 photographic time: 1:50 P.M.

This and the following picture were taken from almost the same spot as plate 608, the first image of the bridge taken from the east side of the creek. It is quite obvious how much time has passed from when Gardner took the first image from this spot to when he took his last. Note the direction of the tree shadows on the west bank and the little shed, casting their shadows onto the water toward the photographer. The sluice and canal leading to the Newcomer mill can be seen on the west bank of Antietam Creek above the roof of the shed at left. I enlarged this view to bring out the detail of the sluice (fig. 10.3a). I photographed a gate similar to the one in Gardner's image at Beaver Creek State Park in Columbiana County, Ohio (fig. 10.3b). The gates at the Newcomer mill regulated the water volume necessary to move a water wheel that operated the machinery in the mill. The more gates that were opened, the faster the wheel moved. There were five gates that controlled the water flow at the Newcomer mill; all were in a closed position. In the modern picture I took of the sluice gates at Beaver Creek State Park, three of the gates are in an open position.

Fig. 10.13a

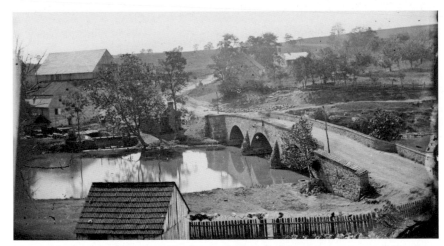

Fig. 10.13: Stereo plate 583: "Antietam Bridge, looking across stream." Courtesy Library of Congress (B815-583 right half)

Fig. 10.13b

Gardner's 1862 photographic time: 2:10 P.M.
Modern time: 3:10 P.M., September 1, 2008
Camera angle: 235°
Shadow angle: 55°

At the east entrance of the bridge in the bottom right of this photograph, there is a civilian wagon that is commonly misidentified as Gardner's darkroom wagon. This is definitely not Gardner's wagon. As evident in the images taken at Hall Street and at the Mumma farm, the driver of Gardner's darkroom wagon had to enter the driver's seat through the front, behind the horse. The wagon or carriage in this photo has side entrances. What is amusing in this image is that Gardner has all the drivers from the four wagons and some soldiers posing along the bridge wall—bringing traffic to a halt on the Middle Bridge.

I based my time for this image on the direction of the shadow from the bridge abutment and the shadow from the horse and carriage at the east end of the bridge. Standing and facing east at the east entrance of the Middle Bridge, you face 55° with 0° as due north. Turning completely around, you will are looking west at 235°. It is obvious that the shadows are facing northeast at 55° at 3:00 P.M. (2:00 P.M. in 1862 time) in this picture that I took on September 1, 2008 (fig. 10.14a).

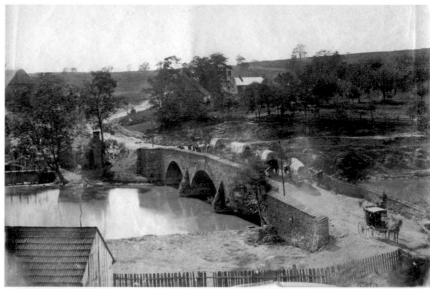
Fig. 10.14: 7 x 9 plate: "Antietam Bridge, looking across stream." From the collection of Bob Zeller

Fig. 10.14a

Original camera location: Currently on private property
Gardner's photographic time: 3:00 P.M.

Gardner and Gibson cross back over the bridge to the west bank where Gardner takes the last photo of the series. The two turn right into a pasture between the bridge and the Newcomer house. They stayed on the west side of a worm fence above the farm lane heading toward the Neikirk farm, following it several hundred feet before stopping. Gardner aimed his camera in a northeast direction and exposed this view at a bend in Antietam Creek. This image shows a fence coming down from the hillside to the creek at left and a sandbar—still there today—between the two trees on the west bank of the creek closest to the photographer. Both of these are visible in stereo view 608 (see fig. 10.7). I took my view at 2:15 P.M. on March 20, 2011 (fig. 10.15a). Presently at the photo site there is a house that casts its shadow; it was not there during the battle. In both Gardner's and my photo, the shadows on the ground and way in which the trees are illuminated clearly indicate that this was a midafternoon picture.

There is one photograph taken by Gibson at the Middle Bridge that remains a mystery as to where and when the image was recorded. Listed in Gardner's *Photographic Incidents of the War* catalog as stereo plate 611, "Antietam Bridge, south view," there is no picture to match this caption. The original glass plate is missing, and it is not known if any versions reproduced from the original of this image exist.

Fig. 10.15: Stereo plate 597: "View on Antietam." Courtesy Library of Congress (B811-597 left half)

Fig. 10.15a

11 ✢ Thursday, September 25
The Smith Farm

Jonathan Gruber's *Farmers' Almanac* for Hagerstown and area, 1862
Sunrise: 6:03 A.M. Sunset: 5:57 P.M.
Weather Channel.com, September 25, 2007, for Sharpsburg, Maryland
Sunrise: 6:04 A.M. Sunset: 6:04 P.M.
Cloud conditions from the Frederick, Maryland, weather station, September 20, 1862, with 1 representing clear skies and no clouds and with 10 as heavy cloud cover and overcast
7:00 A.M. Degree: 0 Type: 0
2:00 P.M. Degree: 0 Type: 0
Precipitation: 0
Temperature 7:00 A.M.: 50° 2:00 P.M.: 63°
9:00 P.M.: 52°

The weather on September 24 was far from favorable for taking pictures. The Frederick weather station recorded that it rained in the late morning into the early afternoon. September 25–29 all had excellent weather conditions for photographing, and so it was on one of these dates that I believe Gardner photographed the Smith farm hospital images. Though speculative, my dating does fill in some of the gaps of what we know about what Gardner and Gibson were doing in the week before Lincoln's surprise visit of October 1–4. After Lincoln's visit, Gardner took more images in Maryland near Burkittsville and at Berlin and a few more photos that November in Warrenton, Virginia. From early September until November, Gardner took credit for exposing every negative taken in Maryland and Virginia, except the eight photos Gibson took at the Burnside and Middle bridges.

The locations for the four pictures of the Smith farm field hospital can be found off the present-day Mansfield Avenue, one and a half miles east of the intersection of Mansfield Avenue and the Smoketown Road behind the East Woods. Presently, the location sites of these images are on private property. Even though none of the Smith farm buildings in Gardner's images is standing today, the area where these photographs were taken can be seen from the roadside looking due south.

Gardner took three of these images from atop a plateau at the base of

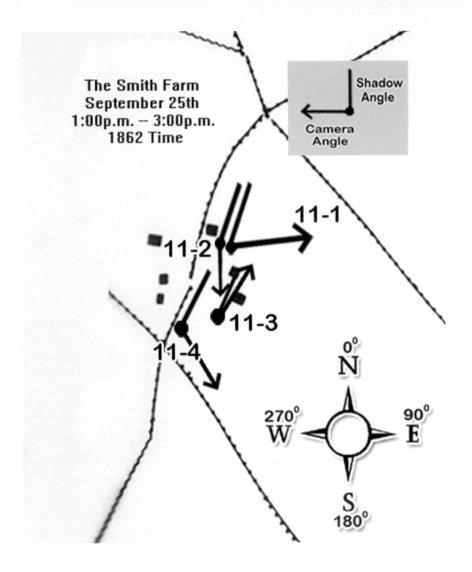

The Smith Farm
September 25th
1:00p.m. – 3:00p.m.
1862 Time

Shadow
Angle

Camera
Angle

11-1

11-2

11-3

11-4

0°
N

270°
W

90°
E

S
180°

the approximate time I believe Gardner to have started. I present the photographs I took at the Smith farm in 2007 only for perspective purposes.

While I can establish the time frame for Gardner's images at the Smith Farm, exactly which day they were taken is more puzzling and is thus unresolved. On the 18th, Gardner and Gibson could have stopped there en route to the Pry house, but my photo research indicates that Gardner and Gibson recorded the Smith farm hospital scenes at about the same time of day as when the artillery reserves were photographed at the Pry house, thus ruling out the 18th for the Smith farm images.

Nor do I think that these pictures were taken on the 19th, because if Gardner was at the Smith farm mid-afternoon, he more than likely would have entered the northern part of the battlefield behind the East Woods late in the afternoon, taking his death series in the area of the three large woods. But none of the photos in this series was taken late in the day, except for the Bloody Lane pictures; the rest are all morning or early afternoon images. For these reasons, I have ruled out the 19th.

On the 20th, Gardner and Gibson were on the northern part of the battlefield shooting the death series and were closer to the Smith farm than on any of the other days within a week after the battle. But I cannot see them traveling a mile and a half each way to the Smith farm to record four views of a Confederate field hospital when practically every farm and house on the battlefield had been turned into a hospital. Therefore, I can easily dismiss the 20th as the date of the Smith farm photos.

On the 21st, and running low on plates, Gardner started the day in the East Woods and then spent the rest of the day at Sharpsburg. Again, he is close to the Smith farm in the morning, but, as before, he could not have been in two places at the same time: The Main Street pictures were taken at the same time as the Smith series. This eliminates the 21st as well.

On the 22nd, Gardner is at the other end of the battlefield, more than three miles away, taking pictures of the Burnside Bridge at the same time of day as when the Smith farm pictures were shot. And I also rule out the 23rd since Gardner finishes his pictures at the Middle Bridge at around 3:00 P.M., the same time he ends the Smith farm pictures.

a steep hill 150 yards from the road, and the fourth image site is out of view on the south side of the plateau. Facing east, Gardner took this series in a clockwise motion. I have established the time frame for these four images as between 2:00 and 4:00 P.M. DST strictly based on a shadow found in one picture I took in 2005. As before, I worked backward from this last picture, deducting twenty minutes from each photo to arrive at

Original camera location: Currently on private property
Gardner's 1862 photographic time: 1:10 P.M.
Camera angle: 80°

The Smith farm served as the main field hospital for the Union Second Corps during and after the battle; Confederates troops were treated here as well. Gardner began this series of pictures slightly to the left of the Smith farmhouse, which no longer stand. In the right half of the stereo view, part of a building comes into view at right and is seen in its entirety in the subsequent image.

This is another of the many Gardner photographic locations Frassanito discovered.[1] This view shows Anson Hurd, the chief surgeon of the 14th Indiana Volunteers, standing among tents sheltering Confederate wounded. The picture of one of my volunteers that I took at 1:20 P.M. on September 22, 2007, is where Anson Hurd stood (camera angle: 80°, shadow angle: 15° [fig. 11.1a]). The photos I took in 2007 of the Smith

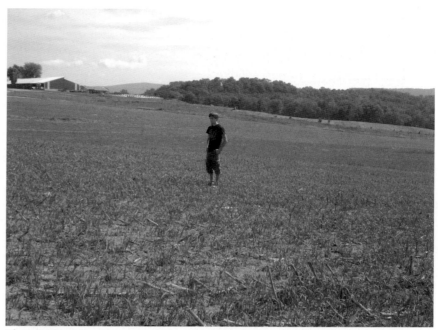

Fig. 11.1a

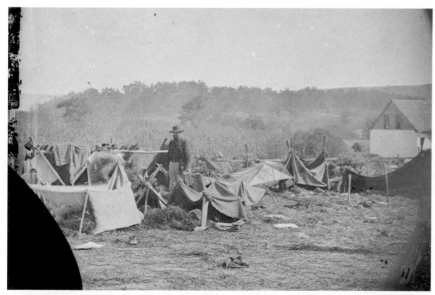

Fig. 11.1: Stereo plate 588: "Confederate Wounded after the Battle of Antietam, at Smith's Barn: Dr. A. Hurd, Fourteenth Indiana Volunteers in attendance." Courtesy Library of Congress (B815-588 left half)

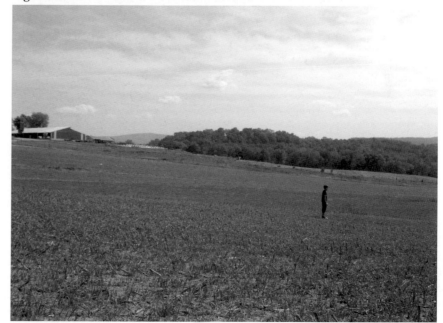

Fig. 11.1b

farm are approximately an hour to an hour and a half before Gardner's time frame. This was not a planned visit to the site. But even though I knew my shadows would not be correct, I was able to have someone stand in the pictures for perspective.

On the same visit to the Smith farm hospital site in September 2007, I discovered the foundation site for this house: a square depression in the field on top of the plateau. In the picture I took on September 22, 2007, at 1:17 P.M., my volunteer is standing at the back left corner of where the Smith house stood (fig. 11.1b).

Original camera location: Currently on private property
Gardner's 1862 photographic time: 1:30 P.M.
Camera angle: 180°

Looking south, this next image shows the Smith farmhouse and two of the Smith barns. The house and one barn are on top and at the edge of the plateau with the barn at right at the bottom of the plateau. The mountain peak above the house at left is Red Hill. I photographed my version on October 1, 2005, at 3:05 P.M. (fig. 11.2a)

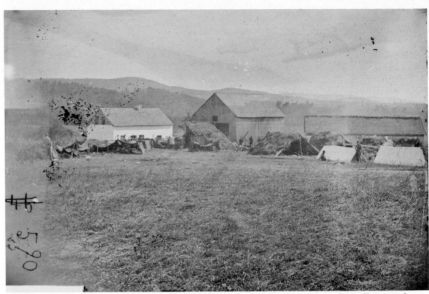

Fig. 11.2: Stereo plate 590: "Smith's House and Barn, near Keedysville, used as a hospital after the Battle of Antietam." Courtesy Library of Congress (B815-590 right half)

Fig. 11.2a

Original camera location: Currently on private property
Gardner's 1862 photographic time: 1:50 P.M.
Modern time: 1:50 P.M.
Camera angle: 36°

Gardner took his camera to the right of the tent that is at far right in the previous view. Standing on the slope of the plateau, he shot this picture of the barn at the base of the plateau facing northeast. My camera position should be back approximately another 50 feet, but this does not take away from the overall look and effect of what Gardner photographed in 1862. I took my picture at 1:50 P.M. on September 22, 2007 (fig. 11.3a).

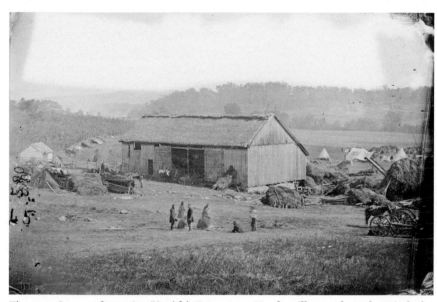

Fig. 11.3: Stereo plate 589: "Smith's Barn, near Keedysville, used as a hospital after the Battle of Antietam." Courtesy Library of Congress (B815-589 right half)

Fig. 11.3a

Original camera location: Currently on private property

Gardner's 1862 photographic time: 2:10 P.M.

Modern time: 3:10 P.M., October 1, 2005

Camera angle: 150°

Shadow angle: 52°

The last view of this series Gardner took slightly to the right of the previous image facing southeast. I used this view to determine the time frame for this series of four images. A heavy, dark shadow is cast from the soldier standing in front of the haymow at the bottom left in Gardner's image; this is the shadow I used to calculate the time frames for these images (fig. 11.4a). In 2005, I posed my volunteer in the same field and faced in the same camera direction as Gardner did when making plate 592 (fig. 11.4b). I took another version on September 22, 2007, at 1:27 P.M. (fig. 11.4c).

Fig. 11.4a

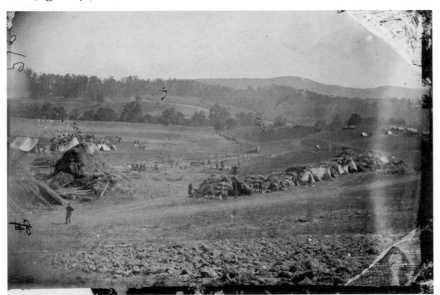

Fig. 11.4: Stereo plate 592: "Straw Huts, erected on Smith Farm and used as a hospital after the Battle of Antietam." Courtesy Library of Congress (B815-592 right half)

Fig. 11.4b

Fig. 11.4c

12 ✝ Other Postbattle Photographs

The Grove Farm

Original camera location: Currently on private property
Gardner's 1862 photographic time: 2:00 P.M. October 3, 1862
Modern time: 3:00 P.M., September 20th of 2008
Camera angle: 110°
Shadow angle: 55°

Lincoln's October visit to confer with McClellan came as a total surprise to everyone in Washington. On Wednesday, October 1, Secretary of the Navy Gideon Welles went to see Lincoln at the White House but found he was not there. No one in Washington knew where Lincoln had gone except for his wife, Mary, and the few select officers and bodyguards that accompanied him. Pinkerton, McClellan, Brady, and Gardner and Gibson had no idea that the president was on his way to Sharpsburg.

Lincoln first stopped at Harpers Ferry and arrived late in the afternoon at Sharpsburg. The next three days Lincoln visited with soldiers, toured the battlefield, and laid out his plans to McClellan for another offensive campaign. With Lincoln at Sharpsburg, it presented Gardner several opportunities to photograph Lincoln with McClellan.

Gardner goes to great length to mention the officers surrounding Lincoln in his caption, but the order in which they are listed is incorrect. According to Frassanito, standing left to right are Colonel Sacket, Captain Monteith (background), Lieutenant Colonel Sweitzer, General Morell, Colonel Webb, General McClellan, an army scout named Adams, Dr. Letterman, unknown, President Lincoln, General Hunt, General Porter, unknown (background), Colonel Locke, General Humphreys, and Captain Custer.[1] Gardner took this image at the Grove house, located just west of Sharpsburg on the Boonsboro Pike. The house still stands but is now privately owned. The National Park Service has built a small parking facility off of Route 34 from which visitors can view the house.

My attempt to duplicate Gardner's image from his camera location was foiled by shadows from the cluster of trees surrounding the house and corn growing right up to the photographic area. Because of this, I

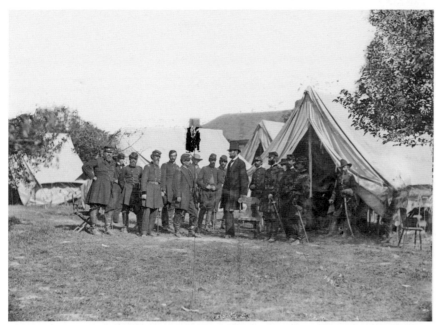

Fig. 12.1: 7 x 9 plate: "Group. President Lincoln. Generals McClellan, Porter, Morell, Hunt, Humphrey, Colonel Sackett, Lt. Cols Sweitzer, Webb, Locke, Dr. Letterman, Captain Custer &c., at Headquarters Fitz-John Porter, Antietam, October 3, 1862." Courtesy Library of Congress (B817-7951)

Fig. 12.1a

Fig. 12.1b

moved some 300 yards to the park's parking facility to record the shadows seen in Gardner's image. In my views, the Grove house is hidden by the cluster of trees in the far background. The house, though unseen, is situated in the trees directly above the left leg of the park marker at left. In duplicating the time frame, I used the shadow from the officer standing at far left in Gardner's picture, Col. Delos B. Sacket. The first view I took, on September 20, 2008, at 3:00 P.M., best records the time of Gardner's picture based on Sacket's shadow (fig. 12.1a). My next picture, taken an hour later, shows how the shadow has progressed, and the shadow angle (70°) does not line up with Sacket's shadow (fig. 12.1b).

The 93rd New York

William Frassanito brings to light that regimental commander Col. John S. Crocker reported back for duty from leave on October 3, 1862, at the same time that Lincoln was visiting McClellan in Sharpsburg.[2] This means that the following three images could not have been recorded prior to October 3. In the first stereo plate, number 630, titled "Col. John S. Crocker, Lt. Colonel Benjamin C. Butler, and Adjutant of 93rd New York Volunteers," Gardner photographed subjects in camp, with what may or may not be Red Hill looming in the background. These three men also appear in the following two images (fig. 12.2).

In the large-plate format titled "Antietam, Maryland, 93rd New York Infantry Headquarters Army of the Potomac" (fig. 12.3) the adjutant is seen on horseback above the soldiers at far right, and to the adjutant's left is Colonel Crocker. Both of these men are easily located in the enlarged right section (fig. 12.3a). Standing in the foreground at bottom left

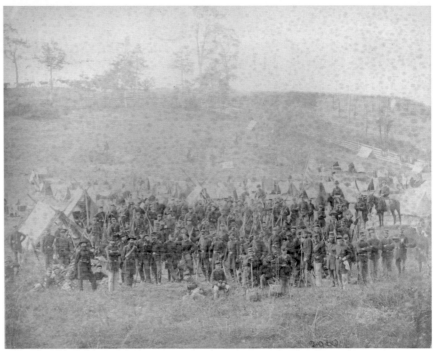

Fig. 12.3

Fig. 12.2

is the heavily bearded Lt. Col. Benjamin Butler. His uniform is darker than those on the troops around him.

In the next version, titled "93rd New York Infantry, Antietam, Maryland Sept., 1862," the regiment has shifted around and is facing the camera, with drummers at the bottom left (fig. 12.4). An enlarged section of the left side of this picture reveals that in the back row on horseback, behind the drummers at far left, is the adjutant; to his right is Colonel Crocker. Standing in the front row just to the right of center is Lt. Colonel Butler in dark pants, and to his right is another officer resting his sword on the ground (fig. 12.4a). This is another erroneous caption found on an original contact print of McClellan's headquarters guard, the 93rd New York Volunteers. Gardner took the photo and Brady published it.

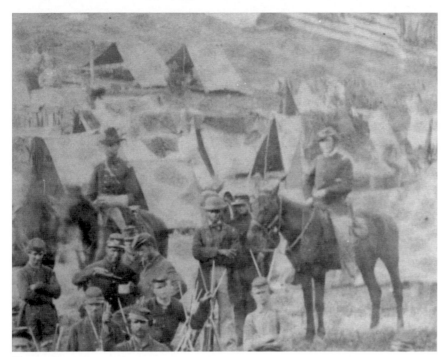

Fig. 12.3a

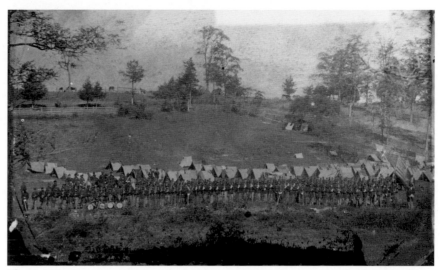

Fig. 12.4

In Gardner's catalog, the caption assigned to this plate is "General Mc-Clellan's Headquarters Guard, Ninety-Third New York Volunteers, at Antietam, September 16th, 1862."[3] When and where these three images of the 93rd New York were taken remains an unsolved mystery.

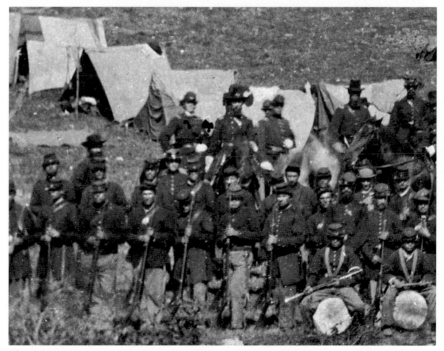

Fig. 12.4a

Epilogue
The Photographic Legacy

In October 1862, the Antietam battlefield photographs went on display at Brady's New York gallery on Broadway under a sign that read "The Dead of Antietam." In late October, Brady made a trip to the field and camped at Berlin before joining McClellan and Burnside as the army marched across the pontoon bridge leading into Virginia. In Warrenton in November, Gardner took several photographs that were printed and issued on Brady mounts. But soon after, Gardner and Brady parted company. The reason for the professional split is unknown, although there has been much speculation about it. Many assume that Gardner left Brady because he was not properly credited for his work, when in fact Gardner's name appeared in the copyright line on the front of photos and stereo views as well as on the mounts of large-plate prints issued by Brady in 1862, with an explicit credit of "Gardner, Photographer" with Brady listed as "publisher."

Most likely, the breakup was due to Gardner realizing the profits made by Brady while he was in the field away from home doing all the photography. There must have been a high degree of mutual respect for one another even as competitors, because the separation was an amicable one. When Gardner left, he took all of the Antietam negatives and most of the other stereo negatives taken in the field under Brady's name in 1861 and 1862. By the spring of 1863, Gardner had opened his own studio in Washington and was selling the Antietam photos with his own "Photographic Incidents of the War" label instead of the "Brady's Album Gallery" label of his old employer. Gardner also took most of Brady's staff with him, employing his brother James as well as James Gibson and Timothy O'Sullivan.

When, in the summer of 1863, Gardner, Gibson, and O'Sullivan went to Gettysburg, the notion that a rift still existed between Gardner and Brady is disputed by a telegram Gardner sent during the campaign telling O'Sullivan that he had run into Brady's operators at Gettysburg. "If they come your length I hope you will give them every attention," Gardner wrote, spending valuable telegram space to urge hospitality toward his former employer's crew, even though he was now competing against them in the war photo business.

At the end of that summer, Gibson returned to Brady's gallery and continued to take images of the war. In 1864, he became Brady's equal partner in the business. On January 4, 1867, Gibson sued Gardner over unresolved issues of the termination over their brief partnership in 1862. How the lawsuit was settled remains unclear. Late in 1867, after declaring bankruptcy, Brady's Washington studio closed, thus ending Brady's and Gibson's partnership. Brady repurchased the studio a year later and reopened it, making it a commercial success once again. Gibson, however, fell into obscurity. He died in 1905 at the age of seventy-seven.

Even as Gardner's Washington studio thrived, he continued to work for Pinkerton's Secret Service on the side. After Lincoln's assassination, he took a series of photos of the surviving conspirators and their hangings at the gallows in the courtyard of the old Arsenal Prison in Washington. He published his *Photographic Sketchbook of the Civil War* in 1866. In 1867, Gardner kept his gallery open but closed his studio and traveled west to make a profitable living as photographer for the Union Pacific Railroad. The following year he photographed the signing of the Fort Laramie Treaty between the U.S. government and many of the great American Indian tribes. He returned to Washington in 1873 and did photography work for the Washington police department, copying different-sized photos of criminals into a standard, uniform size. Alexander Gardner retired from photography in 1879.

From 1874 until his death in 1882, Gardner committed himself to charitable organizations, some of which he cofounded. In an attempt to help the poor in Washington, he and fellow Masons created the Saint John's Mite Association charity. In 1877, he formed the Washington Beneficial Endowment Association to help the working class find affordable housing in Washington. Throughout his years in America, Gardner was affiliated with the Masonic Mutual Relief Association, which had been established to help defray funeral costs and expenses for fellow Masons. Shortly after becoming president of that organization on November 22, 1882, Alexander Gardner fell ill and died on December 10 at the age of sixty-one.

Of the many pursuits and activities in Gardner's rich life, none was more significant and none gave him a greater legacy than his photographic work behind his wet-plate cameras. And of all of his photographic work before, during, and after the war, the Antietam series is the accomplishment that stands above all others. At Antietam, Gardner became the first photographer to capture images of fallen American soldiers on a freshly scarred field of battle, and those images brought the reality of the war to the home front for the first time in the country's history.

Notes

Preface

1. Library of Congress Prints and Photographs Online Catalog at, http://www.loc.gov/pictures/
2. Joseph L. Harsh, *Sounding the Shallows: A Confederate Companion for the Maryland Campaign of 1862* (Kent, Ohio: Kent State Univ. Press, 2000), 20–25.

1. Wednesday September 17: The Bloodiest Day

1. *Voices of the Civil War: Antietam* (Alexandria, Va.: Time-Life Books, 1996), 18.
2. Ibid., 20.
3. *The Bloodiest Day: The Battle of Antietam* (Alexandria, Va.: Time-Life Books, 1984), 28.
4. *Voices of the Civil War: Antietam,* 34.
5. John Michael Priest, *Antietam: The Soldier's Battle* (New York: Oxford Univ. Press, 1989), 20.
6. *Voices of the Civil War: Antietam,* 68.
7. Ibid., 69.
8. Ibid., 95.
9. Ibid., 77.
10. Ibid., 108.
11. Ibid., 112.
12. Ibid., 108
13. Ibid., 123.
14. Ibid., 125.
15. Ibid., 130.

2. Clearing the Fields

1. *The War of the Rebellion: A Compilation of the Official Records of the Union and Confederate Armies,* Series 1, vol. 19, pt. 1 (Washington D.C.: Government Printing Office, 1881–1901), 972 (hereafter *OR*).
2. *Voices of the Civil War: Antietam,* 136.
3. *OR,* 981.
4. Reilly, *The Battlefield of Antietam,* 19.
5. Stephen W. Sears, *Landscape Turned Red: The Battle of Antietam* (New York: Warner Books, 1983), 339.
6. *OR,* 330.
7. Ibid.
8. *Voices of the Civil War: Antietam,* 136.
9. Oliver T. Reilly, *The Battlefield of Antietam* (Hagerstown, Md.: Hagerstown Bookbinding & Printing, 1906), 22.
10. John Michael Priest, *Antietam: The Soldier's Battle* (New York: Oxford Univ. Press, 1989), 338.
11. Reilly, *The Battlefield of Antietam,* 27.
12. Steven R. Stotelmyer, *The Bivouacs of the Dead: The Story of Those Who Died at Antietam and South Mountain* (Baltimore: Toomey Press, 1992), 5.
13. Reilly, *The Battlefield of Antietam,* 22.

3. Pandora's Box

1. William A. Frassanito, *Antietam: The Photographic Legacy of America's Bloodiest Day* (Gettysburg, Pa.: Thomas Publications, 1978), 168–70.
2. Ibid., 95.
3. David Nichol's diary, Harrisburg Civil War Round Table Collection, U.S. Army Military History Institute (USAMHI), Carlisle Barracks, Pa.
4. Gen. Alpheus Williams, www.bhere.com/plugugly.
5. *The Bloodiest Day,* 111.
6. D. Mark Katz, *Witness to an Era: The Life and Photographs of Alexander Gardner, the Civil War, and the West* (New York: Penguin, 1991), 16.
7. William A. Frassanito, *Gettysburg: A Journey in Time* (New York: Charles Scribner's Sons, 1975), 186–95.

4. Alexander Gardner and Battlefield Photography

1. The biographical information in this chapter and the epilogue was obtained primarily from two books: Bob Zeller, *The Blue and Gray in Black and White: A History of Civil War Photography*; and D. Mark Katz, *Witness to an Era, the Life and Photographs of Alexander Gardner, the Civil War, and the West.* The information about the photographic process employed by Gardner and Gibson at Antietam comes from on-site interviews over the years with Gettysburg resident and professional wet-plate photographer Rob Gibson.
2. Katz, *Witness to an Era,* 25.
3. Zeller, *The Blue and Gray in Black and White,* 102–3.
4. Katz, *Witness to an Era,* 28.
5. Ibid., 39.

5. Thursday, September 18: The Pry Farm

1. Harsh, *Sounding the Shallows,* 21.

6. Friday, September 19: Bloody Lane

1. Reilly, *The Battlefield of Antietam,* 20.
2. *The Bloodiest Day,* 103.

7. Saturday, September 20: The Mumma and Miller Farms

1. Frassanito, *Photographic Legacy,* 107.
2. Ibid., 199.
3. Priest, *The Soldier's Battle,* 321.
4. *OR,* 917.
5. Ibid., 485.

8. Sunday, September 21: The East Woods and Sharpsburg

1. Zeller, *The Blue and Gray in Black and White,* 71.
2. Charles N. Walker and Rosemary Walker, eds., *Diary of the War by Robert S. Robertson, 93rd Regt. N.Y. Vols.* (N.p.: Robertson, 1861), 57, USAMHRI.
3. Frassanito, *Photographic Legacy,* 269.
4. *The Bloodiest Day,* 100.
5. Frassanito, *Photographic Legacy,* 271.
6. Zeller, *The Blue and Gray in Black and White,* 190.

9. Monday, September 22: The Burnside Bridge

1. Reilly, *The Battlefield of Antietam,* 22.
2. Frassanito, *Photographic Legacy,* 251.
3. Priest, *The Soldier's Battle,* 321.
4. *OR,* 907.

10. Tuesday, September 23: The Middle Bridge

1. Reilly, *The Battlefield of Antietam,* 20.

11. Thursday, September 25: The Smith Farm

1. Frassanito, *Photographic Legacy,* 215–23.

12. Other Postbattle Photographs

1. Frassanito, *Photographic Legacy,* 276–78.
2. Ibid., 272–74.
3. Katz, *Witness to an Era,* 49.